The Master Con Man

The True Adventures of Slippery Syd Gottfried

by Robert Kyriakides

Critical Vision An imprint of Headpress

A CRITICAL VISION BOOK
Published in 2003
by Headpress

Headpress / Critical Vision
PO Box 26
Manchester
M26 1PQ
Great Britain

Tel: +44 (0)161 796 1935
Fax: +44 (0)161 796 9703
Email: info.headpress@zen.co.uk
Web: www.headpress.com

Printed and bound by The Bath Press

THE MASTER CON MAN
The True Adventures of
Slippery Syd Gottfried
Text © Robert Kyriakides
Title page artwork © Richard Kyriakides
This volume copyright © 2003 Headpress
Layout & design: Walt Meaties
World Rights Reserved

British Library Cataloguing in
Publication Data
A catalogue record for this book is
available from the British Library.

ISBN 1-900486-27-X

CONTENTS

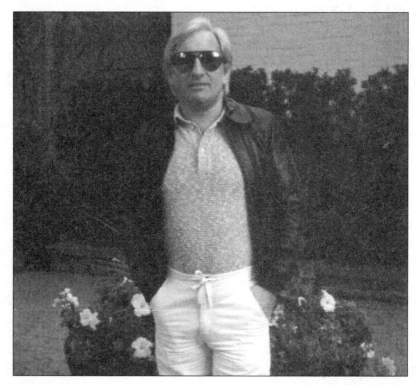

Syd Gottfried, 1984.

PROLOGUE

I FIRST MET SYD GOTTFRIED IN 1978 when I was a young lawyer practising in Great Portland Street. Syd ran and, as I later found out, owned what was supposed to be a members' dining club but was really a drinking and gambling club called the Marie Lloyd. The Marie Lloyd was located next door to my office in Little Portland Street and it had been established for many years as a genuine enterprise but at the tail end of its existence Syd had got hold of it. Highly respectable people ate and drank there — in theory it should have been run and owned by its members, but Syd had acquired it by some sort of osmosis. He did not want to turn it into a proprietor's club (a more attractive proposition as he then would have had an asset which he could sell) because the rules about getting a drinks' licence for a members' club were lax and no court in England would ever give Syd a drinks' licence for a proprietor's club any more than they would give him a licence to sell guns.

Because we were next door and because we employed his gorgeous girl friend as a secretary, Syd used us for his bits and pieces of commercial work. It was nothing earth shattering or significant and made no difference to our law practice, but meeting Syd was always highly entertaining.

He was a pleasant man, highly personable and charming, he told a good joke. Although he had a girlfriend, he also had a wife and two boys, Mark and David. David was his youngest boy — in those days only eleven or twelve years old — and he was a bit of a tearaway who was always playing truant. But David adored Syd and he loved his father so much that he was like a shadow. At meetings with his father David would be waiting outside and Syd would send him out to buy coffee, McDonald's or cigarettes, tasks that David loved to do. When he bought hamburgers for us in a meeting, he would run all the way there and all the way back. He seemed a nice kid.

Syd was into various forms of skulduggery mainly as a confidence trickster, but I handled his legitimate business interests. I don't think that Syd would have trusted me with his defence in a criminal case. I know of no reason why this should be the case because when he was tried he was usually, as I discovered later, found guilty.

He had been brought up in Dublin and he had a way with words — perhaps the two things are not inconsistent. Syd cracked jokes and generally made you feel happy to be with him. He said that his father was an Austrian Jew and his mother

was Irish; I guess he inherited the worst and best of both worlds.

He once told me that he had lived the most incredible life and done things that would make a fabulous book, so I told him that if this was what he wanted to do I would write it for him but I heard no more from him on this subject for several years. By that time he had left England, opened and closed several businesses and run away to America.

He came back in devastating circumstances and contacted me. From then on I spent many hours with him listening to his life story. I probed and questioned him on what he was telling me and even though a lot of what he told me was harrowing I still enjoyed the hours that we spent together. He vanished again and I was told by his elder son, Mark, that Syd had died. By then I had only completed about a third of the book, so I consigned it to the archives and got on with the practice of law. Syd had always had heart problems and the story was that he had had a massive heart attack in prison. I feared that it was true but hoped that it was another one of Syd's cons.

Twelve years later, one fine spring morning, my assistant told me that there was a personal phone call for me from someone who would not give his name but said that he was an old friend. I took the call. It was a familiar voice that I had not heard for years — it was Syd.

He was surprised that I recognised his voice. I could not fail to recognise it, having listened to it for so many hours. He told me that he had served more time and had paid all his debts to society. I told him that his son Mark had recently left a message with my office asking that I hand over the book about Syd but I had not bothered to return the call. Syd said that I had done the right thing, and called Mark a low life, which was one of his favourite expressions of abuse. Of course, Syd had got Mark to ring me up and ask for my manuscript on the pretext of being the deceased's heir.

Syd promised to ring me and fix up a meeting. He asked if I still had the book and I told him that a few weeks back I had found it while going through some archives for destruction and had retained it. That was some coincidence! He was pleased and promised to give me some more material for the book. After he put the phone down, I tried to trace the call, but couldn't. Syd had taken precautions.

I found the half finished manuscript and reread it. I had spent many hours listening to Syd telling me his stories and as I read them I could hear his voice in them, half scornful, half boastful and very intelligent.

Two weeks later he turned up, out of the blue, saying that the last twelve years of his life had been unbelievable and that he had lots more to tell. Of course, he said, he wouldn't tell me everything because there were things he could not reveal, like how he had once robbed a princess. But he could tell me lots of things.

He expressed concern about his extended family as he now had two small children with Legia. He looked well, but he had become very barrel-chested and while his bravado was as high as ever he was physically restricted by five bypass operations. Walking upstairs was difficult for him. He said that he did not have much longer to live, or so he thought, and he wanted to take care of his kids.

His hair was completely grey and longer than he had worn it before. His physical presence was still there and his mind as sharp as ever. If Syd had joined a merchant bank as a messenger boy after he left school I have no doubt that he would have been a millionaire many times over, one of the lauded rich. If he had gone into politics he would have made it to cabinet rank with many loyal supporters. He was good to be with.

Instead, he spent his life doing the things that now follow. He did them for money. But the money was soon gone. He did them for the excitement, but hours of excitement were followed by years in prison. Most of all, I think, he did them for the sheer joy of seeing if he could succeed in doing them, to see if they worked.

I will let Syd tell you all about it.

IT WAS A WARM MIAMI NIGHT. My wife Legia and I stepped out of the car and entered our apartment. I was bringing her back from an appointment with her doctor. It was January 1984.

I flicked the light switch, but nothing happened. I thought there was a power cut. I had already noticed that the front door to our apartment was open and was worried that Karla, who was only ten years old, had gone out to see a friend when she should have stayed at home. I then saw that the bedroom light was on. This was wrong. I walked into the bedroom and saw a suitcase with clothes on the bed. I was confused. Had we been burgled? Legia then said "Syd, Syd, come out here." Her voice was breaking with agony.

Legia had turned the kitchen light on, which shone on to the back of the couch. Then I saw the blood. My first thought was that Karla had cut herself and gone to a neighbour for help. I then remembered that I didn't see my shotgun — I opened the drawer where I kept the other guns and couldn't find them. Then Legia went to Karla's bathroom. She couldn't open the door. I went in thinking someone was hiding in the bathroom. I was ready to fight the burglar who was hiding in my bathroom. But as I pushed hard against the door it slowly opened. No burglar was there.

There was Karla, curled up on the floor with her legs against the door. She was lying down. I picked her up. Her nose was missing where a bullet had blown it off. She had been stabbed many times. Her clothes were absolutely saturated with blood. It was like picking up a wet rag. She had been thrown down and blood covered the bathroom. I sent my wife, who was screaming, to get an ambulance, get a doctor, get the cops, quick, hurry please, but as soon as I picked up Karla I knew she was dead. She felt like a warm sponge. There was so much blood. And her dead eyes were open. Those dead eyes stared at me out of her face without a nose. She still looked beautiful. Legia and I were both hysterical.

As Legia dialled 911 I kept tight hold of Karla in my arms, talking to her. I told her that everything would be all right, that she shouldn't worry. The rescue squad arrived, put her on a machine and confirmed she was dead. The police came, took us to the station where they took samples from our fingernails, our spit and our clothes and they fingerprinted us. They asked us where we had been. They

suspected Legia and me, I understood that much. A cop who gave us directions when we got lost earlier that evening in south Miami remembered us and at four or five in the morning we were released. They told us not to worry; they would get the person who did it. They told us they thought it was a burglar or an intruder. Our ten-year-old little girl had just been brutally murdered. How could you not worry?

I thought that someone had broken into the house and killed her — some stranger, some nut case. The police handled it in a way that I thought was kind. They obviously thought we were suspects and of course they had to do the tests to clear us.

That morning Legia and I couldn't go into the apartment so we stayed with my secretary, Lola. The next day we checked into a hotel — we still did not want to go back home. I went to my office just to tell everyone I wouldn't be in for a while. Everyone knew about Karla's death and they were very kind to me. I told the staff just to give me a week or so to get myself sorted out and to keep the business going for me.

On the morning after the murder my best friend Roman flew into Miami to see me. He didn't know anything about what had happened. He checked into his hotel and turned on the television. And then he saw on the news that Karla had been killed.

How did all this start? What had my wife and I ever done to deserve this? A ten-year-old child dying is a curse for the parents, who expect their children to outlive them. A ten-year-old child being murdered is a double curse for the parents who would be able to cope better with death caused by illness or accident. Those things have a kind of logic. Murder in these circumstances does not. But the worst curse of all is to discover the murdered child because the images you see are burned into your brain all your life and they haunt you every day and you can't put them out. Why should Karla die and who would murder her? For what reason? I didn't know. How did it all start? What journey led me from Ireland to Miami over forty-five years to the state where I would be holding a wet limp rag who was once a person?

A CON IS BORN

We leave Florida and travel back to Britain fifty years ago. The war had ended but the effect of it upon relationships, families and people's lives was still there. London became a magnet for men and women from Britain's colonies and for the vast numbers of Irish people who could not get a decent job. Everyone came for work that was easy to find. However austere England was, it was still better than where these people had come from. Not only did they leave poverty behind to make a fresh start, most also abandoned the baggage that they could not easily carry into their new life, whether physical or emotional.

There was plenty of work for everyone and people were encouraged to come to Britain so they came, not only from Ireland but also from the West Indies, Pakistan, India and Cyprus. They all came with their own special case histories for a new beginning, happy to work and earn enough to keep body and soul together, and in some cases looking for the chance to earn a lot more than that.

I WAS BORN IN IRELAND IN 1937 IN TRIM. It is only a village. I left there when I was eight. I used to go back there on holiday with my mother and stepfather and I loved fishing and swimming in the river; it's a nice little place. My father was an Austrian Jew, called Joe Gottfried. I don't know what an Austrian Jew was doing in Trim apart from screwing my mother. My mother and he lived in sin, they had children without being married. That was considered terribly immoral, almost a serious crime in a small place like Trim, where everybody knew everybody else's business, and even quite a serious irredeemable offence in the big city of Dublin.

People from Trim used to go the Isle of Man to work in the hotels in the summer. During her summer working there my mother got involved with my dad. She fell for him, he screwed her and that is how I came along and then came my brother Eric.

By the time I was three my father was no longer around. I was told that he got shot during the war. He volunteered for the army, fought like a lion but the Germans shot him dead. My father was a war hero, so the story went but that was just a story. The truth was that he buggered off to Manchester. For years and years I believed he was a real hero.

Later on my cousin in Manchester told me that my father got fed up with

9

looking after his wife and kids in Trim and ran away. My mother never saw him again. She adopted his name, Gottfried, and set off to establish a new life in London after the war.

There was plenty of work for her in those days. She told everyone that she was a war widow and no one guessed the truth about her marriage. We lived in a basement flat that used to be servants' quarters but it was a palace compared to Trim because we now had wooden floors, not dirt floors. I went to a Catholic school in Fulham and was brought up as a Catholic.

Almost as soon as we got to London my mother married. My stepfather was a kindly man, when he was not drinking, but he was hardly a big influence on my life. I adored my mother and listened to her, not him.

I found that schoolwork was easy and I was especially good at arithmetic but I left when I was fifteen years old, in June 1952. Everybody I knew left school at fifteen in those days, that was the normal thing to do. I was, I think, just a normal well-behaved child. I never got into any squabbles and I was the leader of my friends at school. My brother Eric was the opposite — he wouldn't go to school and was always getting in trouble. I will tell you all about Eric later.

I GOT A JOB IN PUTNEY IN A RADIO SHOP which paid me £2 5s 6d per week. There was nothing to do all day but sit around the shop and wait for the people to come in to serve. But the actual work was easy. The manager was entirely clueless and he got the sack for shortage of stock. Head office sent another manager who was even more clueless.

There were good reasons for shortage of stock. I would arrange for a mate to come in and buy something cheap. I would then slip something into his shopping bag — a toaster, an iron and anything else I could get away with. I became a thief. In those circumstances not stealing seemed stupid.

After work I used to go into the snooker hall and I got to be quite a good player. I thought I could win a quid or two a day playing snooker instead of earning by working. My only expense was my share of the cost of the electric light. After snooker I would go to Park Royal greyhound racing to spend my winnings. I always spent whatever money I had as soon as I got it. I knew that I was smart enough to earn some more money tomorrow, so why should I save today?

It's strange that the habits you develop when you are young stay with you all your life. Some people I know develop a habit of saving every penny they can, trying to screw every ounce of value out of their money, checking every penny they part with. Before you know it you're dead and then you're the richest man in the graveyard, at least that was how I looked at it. I went the other way. If I had it I'd spend it and enjoy spending it.

I met Benny Kelly, a Scot. We got into a few fights in the snooker hall from time to time. We could both look after ourselves — I got a bit nastier as I got older and if things didn't go how I wanted them to go I would give someone a slap. I was never like that as a child but that part of my character developed in that snooker

hall. There was something about the snooker hall that made me a different sort of person and gradually I got worse, more violent. I grew to be indifferent to other people's feelings if they stood in my way. In truth, I think that I began to enjoy fighting and got a kick out of hurting people. It made me feel in control.

It was all part of always wanting to be the best, best at school, best at snooker, best at thieving, best at fighting and drinking. If it meant that to show everyone that I was the best someone else had to have a slap, well that was their hard luck.

I am not proud of having been violent. As I grew up I found it harder and harder to control my temper and I got into fights over meaningless, stupid things. Although I could take care of myself, I was never proud of fighting but felt that in some circumstances I had to fight. I could not control my temper and that made me violent. I would burn up inside and lose control over what I was doing. I became addicted to violence.

Benny and I had a lot in common. He was a Scots Catholic who came from a tough part of Glasgow where men are really hard. I was from South London, where people are not quite as blindly violent but where they can be very slippery. Benny, like me, was not the tallest of men but he was terrifically broad and strong. If he hit you, you stayed hit.

I bought a bunch of skeleton keys — double-enders is what we called them. It was the era of the glass shop doors and skeleton keys would open them easily. We could walk into most locked shops with them — alarms were very rare in those days.

We would drive around in a stolen van until we located a suitable shop with the right kind of merchandise and the right kind of doors. We usually turned up late at night or early in the morning, opened up the glass doors, got inside the shop and locked the doors with us inside. When we were locked in, we would sort out what we wanted to take away, get everything by the door, then open the back of the van and load the stuff into the van. We would sell the stuff to any one of a number of local fences we knew and go out spending the loot.

One day at Putney I was coming back from selling goods that I had previously stolen when I got stopped at Putney Bridge by a police roadblock. The police asked for my name and address. This was my first brush with the law. I gave them an invented name. Whose car was it? I said that it was mine. They asked where I lived and I gave him some address in North London — about the furthest place I could think of at the time. They asked for the logbook. I said it was at home. They asked for my driving licence. I didn't have one so I said that it too was at home, I would produce it for them later.

They said they would like to take me to the police station to sort things out. I said "You're not taking me anywhere."

"OK," they said, smiling, "we'll drive round to your house and find the log book."

I said, "OK, that's what we'll do."

They put me in the back of their police car and asked me to direct them to my home and the false address was five or six miles away from where we were. They

drove me all the way up there and I directed them, making up the route as I went. I kept on directing them while I tried hard think how to get out of the mess that I was in.

After having been driven round in circles for hours the policemen said "I think we have had enough of this, going round in circles, don't you agree?"

I had to.

They charged me with taking and driving away a motorcar without the owner's consent. I admitted my offence and I got three months — it was a harsh sentence for a first offence even in those days. I was sent to a youth offenders' prison in a place called Geldhurst; it was like a borstal but worse. It was supposed to be a short sharp lesson for young people like me who got into trouble and the authorities hoped that it would stop young offenders getting into trouble again. Some hope!

They had a policy at Geldhurst of making the inmates run everywhere at the double. They made me run to do PT, run to work, run to breakfast, run where I was working, work like a bastard and run back to supper but they fed me well and there was a lot of sport.

I don't think that any prison sentence would have stopped me from carrying on with a life of crime. Nothing could have reformed me. That short, sharp, lesson did not make me a better person or get me to change my ways. And all the time I was in Geldhurst I just could not wait to get out to go out with my new girlfriend called Ann. I had just discovered how good love was. Every night in prison I thought about Ann.

When I got out of Geldhurst, I carried on with the same lifestyle of stealing, drinking and betting on the greyhounds. Except for Ann. She didn't seem as good in the flesh as she was when I was dreaming about her in Geldhurst. It was so easy to pick up life from where I left it that I didn't even think of an alternative.

AT THE AGE OF EIGHTEEN I had to do two years national service. The law forced me and tens of thousands of other young men to lose two years of our young lives in order to "protect" our country. I didn't want to join the armed services, it was a waste of my life. I found out that certain jobs were exempt from conscription and if I joined the merchant navy I could avoid national service altogether.

So I joined the merchant navy as a cook. I enjoyed seeing different countries. I ended up as a pretty good cook and enjoyed cooking. I would have stayed in the merchant navy because I liked it so much but something happened. In Cyprus I met a lovely girl called Androulla. She fell in love with me and she begged me to stay there with her; she would cry and say how she didn't want me to leave because she wanted me to marry her.

If I had married her, my life would have ended up very differently. I was madly in love with her. She was the first girl I went out with who did not have the same South London background as me. She was unusual, beautiful and exotic. I might well have stayed in Cyprus and married her but for what happened next.

Androulla and I were cuddling in a quiet corner of a bar when in came my

ship's Chief Steward with three of his pals. He made himself busy looking at my girl but I tried to take no notice of him. I had had a few drinks myself by this time and I was steaming. I wanted to give him a smack but I kept telling myself "I'm drunk, let it alone, it don't matter".

The Chief came over to the table and he said to me "Don't forget two eggs for breakfast and do them medium this time, not too hard."

He waited a bit. "Don't burn the toast, Cookie. This bloke here is the best washer up on the ship! D' you use your tongue to get 'em so clean?"

My temper rose and rose. He carried on like this trying to make me look small. I had had enough. I said "That's it, you" and I gave him a smack. He staggered back.

I left with Androulla and eventually got back to the ship at four in the morning. I went down to the mess and in I go. There was the Chief sitting at the head of the table. "I've been waiting for you" he said and aimed a huge punch at me. He missed.

I was still half drunk but I thought to myself, "I've got to do him here and now. He's an officer and he can make my life miserable for the rest of the voyage. I've got to stop him now."

All the sailors wanted to see the fight, as men do. I didn't wait. My temper just took over as I lost self-control. The only thought in my head was that I had to really hurt the Chief. Before the Chief knew what was going on I kicked him, hit him, punched and bit him and I beat the crap out of him. He had no crap left. Eventually the other sailors restrained me and they put me in a straightjacket. If they hadn't done that I would have killed him.

When I saw him the next day, his face was in a mess. His eye was hanging out, his lip, his nose, his teeth and his ear were all messed up. I went bog side that time. I was half drunk. I injured the Chief so badly that he couldn't work for the rest of the voyage.

I never saw Androulla again — the ship sailed away from Cyprus with me in a straightjacket. The sailors washed and fed me like an animal. They kept me like that for four days. When they finally let me out they kept me under guard in the kitchen and in my cabin until the ship reached Liverpool.

When you get discharged at the end of a ship's voyage the shipping line stamps your seaman's book with "VG" which stands for very good. Virtually everyone got this stamp, almost no matter how badly they had worked. The shipping line stamped my book "DR" which meant that they declined to make a report about me. Now with "DR" on your ship's book you cannot work. It does not say what you did but the people hiring for ships know from not getting a "VG" that something has happened. "DR" meant that whatever I had done was so bad that they declined to give me a reference. If your last ship has refused to report on your conduct, it must have been very bad so no one will take you on.

I finally got a job on the cross channel ferry for six months but I got fed up with that. I didn't like it. I couldn't get back to the real merchant navy so I left the sea altogether.

If I had not had the fight I might still be in the merchant navy. I liked the life; I enjoyed seeing different people and different countries. I do not like work, no one does, but at least in the merchant navy I worked knowing I was going to be in Tangiers or Cyprus or somewhere else exotic at the end of my work. It gave me something to look forward to. After living most of my life in South London, doing things or simply being in Casablanca or Piraeus or Naples opened my eyes to the big wide world that I never knew existed.

I expected that my time in the merchant navy would earn me an exemption from National Service but I miscalculated. I got my call up papers for the Army. I had to report to Aldershot Catering Corp on December 8. I worked out another scheme to get out of national service. I went down to the barracks two days early. In I go.

I said to the sergeant, "Here I am; I'm ready for you."

He said, "You're not due here till the eighth."

I said, "I am here now; can I start early?"

I asked if I could get all the formalities over quickly as I was keen to start as soon as possible. They told me I had to see the army doctor and told me where to go. I went to see him for my medical.

I kicked the doors of the doctor's room open and said "Here I am; give me a gun. I'll go straight to any war anywhere in the world. I want to fight the enemies of my country. I'll kill them, sir. I'll use a gun and if you don't give me a gun, I'll use my feet, sir; I'll kick them to death. If they cut off my feet, sir, I'll use these two hands and I'll tear their throats out. If these hands are cut off I'll bite them to death and if I lose my teeth, if I've got no teeth I'll shout and scream at them so loud I'll deafen them to death."

"You're crazy" said the doctor.

"Does that mean I can't join up?"

Unfortunately he pronounced me sane enough for the army. If he had believed that I genuinely wanted to kill people he wouldn't have let me in.

The first week was training with guns and rifles. Here was I, a crook who had served time and the army were showing me how to use guns, how to look after them and teaching me how to fire them, turning me into a marksman! Who was mad? The army trained me how to look after weapons and how to load them and most important of all, how to fire them accurately. They turned me into a decent marksman. Without their training I would have probably blown a foot off the first time I tried to use a gun.

I resented the time that I spent in the army as much as I resented being in prison. I thought that I had not done anything to deserve losing a bit of my life to the army. My country was not at war with anyone and it seemed to me then that if we did have a war with Russia it would be all over after three atom bombs were dropped. National service just wasted my time. They didn't really teach me how to defend my country. My country would have been in a right state if it relied upon my fellow conscripts and me. National service was abolished later so that people did not have to lose part of their short youth being humiliated by the

army. And it was humiliating. They treated us like a schoolboys, but I suppose it did keep me out of crime for a short while.

I was especially unlucky because I was under the charge of a certain corporal, a Scottish ginger haired man. Right from the first moment he saw me he did not like me because I was Jack the lad. I had been in the merchant navy and I was two years older than the other conscripts. One day I was out there in the middle of the freezing cold parade ground with no gloves. The corporal gave me a 303 rifle and told me to take it apart and then put it back together again. It wasn't for me, not in the freezing cold. I had had it.

"Fuck you and your fucking 303! Stick it up your arse," I said.

He said, "I'll put you on report."

"I'm on report am I, you cunt?"

My temper became uncontrollable. I hit him as hard as I knew how in front of all the people on parade. I beat him up and not one of the conscripts lifted a finger to help him. I then bunked off as quickly as I could. I didn't know what the army would do to me and I didn't want to hang around to find out. They caught me three months later in a club in the West End called The Mambo — someone had grassed me. I got a short term in military prison. When they let me out, I ran away again. This time I managed to stay free for about six months and I went back home to my mother.

One day two military policemen came to the door and asked for me. My mother said that I was not in. Yes, they told her, they knew I was here because they had been watching me from the car park and I had just come in.

She said, "No, I'm telling you, he ain't here."

One of the MPs pushed past her. She screamed. I heard this so I flew out of the room where I was hiding and saw the MP. My temper started to flare up at the thought of him pushing my mother. I ran at him, knocked him over and went to hit the second MP but instead I managed to put my hand through the glass door. I was badly cut and my thumb was almost hanging off, there was blood every-where.

After a struggle the MPs captured me and took me back to my old camp. From there I was transferred to a Royal Engineers camp where there were only sixteen of us, including the major in charge of the camp. He made me his cook. I liked cooking and did my best for him because he treated me decently. In fact he ran the whole camp nicely; no one had to wear uniform and we could more or less do as we pleased. I did not have anything to do, except cook.

The major said that he had never tasted such good food and promoted me to corporal and I served out the last few months of my national service peacefully as a full corporal on full corporal's wages, not doing anything bad and not getting into trouble.

OUT OF THE ARMY AT LAST, I restarted my life. Benny Kelly was still around and we teamed up again. Tesco had just started to open supermarkets that quickly became very popular. Benny and I shared a flat and had to fend for ourselves.

One day we were in the supermarket and when the girl cashier opened the till when I paid for the goods, and I saw an awful lot of money in it. I said to Benny "Look at that, all caked up. All we have to do is pull the money out and it would be all over."

So I plotted to rob supermarkets. I had to figure out the best way to do this as I didn't want to get caught. This was the method I devised. I would go in to a supermarket with Benny. I would buy a can of baked beans. At the till I would give the girl on the till the can of beans and a £1 note. As soon as she opened the till I would grab all the money and stick it in my pocket. Benny would mind my back and prevent me from being grabbed by anyone from behind. He would have a basket full of cans so people would be reluctant to queue behind him, because he had so much stuff. It wasn't rocket science but it worked. We used to run away on foot and then go down the underground or hop on a bus.

I did about ten of these jobs. Benny and I were getting £200, £300 or £400 a crack. We planned a job in West Kensington in a dodgy spot because there was nowhere you could run to quickly round the corner. You couldn't do a few back doubles and get on a bus or underground. But it had plenty of money, more than the usual supermarket took in the poorer parts of London.

In I go. I had my usual can of beans and took it to the cashier, showed her the beans and gave her a £1 note. She was a young girl, and no more than fifteen or sixteen and she had probably just left school; she opened the till so I pushed her away in order to grab the money. As I pushed her away, she slammed the till drawer hard with my hand inside. I did not panic but my hand hurt. I got the till open again and she started screaming. I said "Shut up! I've hurt myself." And I made it a point of honour to get every penny from that till. I usually only bothered with the notes. This time I got all the silver, all the coppers and even all the cheques, which were of no use to me.

The manager was big and fat with greasy hair. He came haring down the store because of the screaming, saw what was going on and made a valiant attempt to capture me. Benny, who was standing behind me with his wire basket full of shopping turned round and hit the manager hard with his basketful of cans. Cans from Benny's basket flew all over the shop. We both ran out and the manager followed us. Everyone else started screaming.

We had to run about a hundred yards just to get around the corner followed by Fatso who was sweating buckets. Fatso was faster and harder than he looked. He had been given a vicious blow by Benny but was closing in on me. I thought that I would be captured but suddenly to my relief he gave up.

We robbed a few off-licences and public houses. We did one pub in Fulham and as we were loading up the gear we had robbed into the van the publican woke up to see what the noise we were making was about. It was Benny clunking a case of scotch. The publican snuck up on him and whacked Benny right across the head with a lump of wood. While he was hitting Benny I snuck up on the publican and hit him with a bottle as hard as I could. That laid him out. We managed to escape but were worried that the publican might recognise us because his pub was in

Fulham, which was on our patch.

Benny and I knew a copper called Arthur Fox and Arthur was semi-crooked. Many policemen were in those days and probably still are. The routine with a semi-crooked copper in those days was to give him £10 when you saw him. The money was for nothing in particular, but if you looked after him he would generally see that he looked after you. If you were in serious trouble, you had to bung Arthur £100 — a huge sum then. Arthur called Benny and me over one day while we were quietly drinking in our local pub and said:

"I would like to have a little word with you, Syd and you, Kelly." He always called me Syd and Benny, Kelly. He said, "I think you were on that pub job" in whatever the street was.

"Pub? What you are talking about?"

"The one where the manager got a slap."

"No, no, not me."

"Well you have to come down the old Bill shop where I can question you," said Arthur.

They did the usual routine, with one good cop and one bad cop. Arthur played the good guy. They did not get anywhere with questioning us so they gave us a couple of slaps and let us go because they did not have any evidence. A little while later someone stole the mayor of Wandsworth's chain of office out of the mayor's chamber in the town hall. It was not I, but someone put it into the old Bill that Syd and Benny had the chain. Once again Arthur took us down to the old Bill shop but beat the crap out of us; this time he gave us a real seeing to even though we hadn't stolen it.

I guess the reason why the police went in so hard was because they viewed it as a matter of professional pride. The chain of office was not that valuable. It might have had intricate workmanship but was only worth scrap value to thieves. But the fact that it had been stolen reflected badly on the local cops. They wanted to pass a message on that we were not to make them look foolish. That would not be tolerated.

Although I did not like getting beaten up it was all part of the life that I had chosen to lead. I never dreamed of complaining. No one would have taken me seriously. There wasn't even a proper complaints procedure in place.

Benny and I then "graduated" to robbing cigarettes. They were a fashionable thing to steal because you always got ready cash for cigarettes. I got arrested for robbing a cigarette shop and I was captured red-handed so I had to plead guilty. It was a pretty crude crime, the sort of thing you do when you are young, brainless and think that you will never be caught.

They took me to Wormwood Scrubs prison on remand — I was twenty-two. It was the first time that I had ever been inside a proper prison. It was a dirty, stinking, filthy and depressing place. I couldn't wait to get out but I stayed there right up to my trial.

I spent a lot of time thinking about the best way to handle my case. I thought that a guilty plea and a good speech by a very good lawyer would persuade the

court to be lenient. I might even get off with six months, although the tariff for what I had done in those days would be between twelve and eighteen months. The trouble was that I didn't know a very good lawyer; I didn't know any kind of lawyer.

I was given a dock brief. There was no free legal aid in those days like there is now. Young lawyers trying to learn their business hung around the court dressed in their gowns and wigs. If you picked out one they would defend you for nothing. You picked one out when you stood at the dock when you told the judge that you did not have a lawyer. That is why they were called "dock briefs". I picked a barrister out of a whole bunch of them.

He was a pleasant and sympathetic looking fellow. I picked him because of his looks. He spent some time with me listening to my side of the case and then went into court to speak up for me in front of the judge. He spoke in a loud clear upper-class voice. He looked very nice. He spoke well. He told the judge about my father, the war hero, who died serving his country and how young I was. How I was being brought up by a hard-working mother and how I needed an opportunity to go straight. The problem was, he told the judge, that I was untrained. If I had learned a trade I could get a job. But I had never learned a trade. He pointed out my one previous conviction for stealing a motorcar and asked the judge to give me another chance in life.

The judge listened carefully to my barrister. The judge then calmly said that he would give me a chance to learn a trade and become a useful member of society. I would spend, he said, the next three years in corrective training so that I could learn to become a useful member of society. Next case!

Three years! At twenty-two that is a lifetime.

I will never forget the face of the barrister who represented me. I was very upset with him. I wanted to hit him. Hard.

I said "You're fucking stupid, what you done up there I could have done myself, you done me no good whatsoever."

He said, "No, no, let me explain. You are not going to prison. You are going to training. If it had not been for me you could have got a prison sentence of twelve months or even longer."

I could have got a twelve month sentence and served at the most eight months or possibly six months in prison taking into account time off for good behaviour. Now I had to do three years corrective training and the idiot was acting as though he had done me a favour. I was punished not only for my crime but also for the incompetence of my lawyer. That didn't seem fair to me. I suppose that the young incompetent barrister may have turned out to be a leading lawyer in later years. He might have even become a judge. But he was an idiot and it would have been better for me to do the case myself than use him.

CORRECTIVE TRAINING WAS THE WORSE thing they ever brought out because it was no different from ordinary jail except that you learned a trade and spent longer there than you would in a normal jail. In my case they taught me painting

and decorating.

I found when I did my sentence later that inmates I met in there would be in and out four or five times on short sentences while I was doing my one sentence. And they all came back.

I was in prison for two years and sixty days and met a lot of people. I talked with them and I got on with them. I learned new ideas and new techniques about crime. When I did come out, I couldn't wait to put them into practice. I got caught again stealing cigarettes but this time there was a pitched battle with the police at which I was captured. I was only out about six months before I got another three years. Then I was in another real prison, Wandsworth, where they shaved your head, you were not allowed to talk when you were working; you could not turn round, you had no radio, you had nothing. It was a real dump. You had to be there three months before you were allowed to see a film or the TV set and then you were only allowed to watch something once a fortnight. It was terrible.

I was in the mailbag shop to start with, then I was in the clog shop and then they put me into the laundry. That was a sweet little job and just as I got used to the laundry, they decided to ship me out to another jail at Chelmsford.

What a difference! Getting out of Wandsworth and going to Chelmsford was like going to a holiday camp. It was easy. No one gave me a hard time. I got a job in a tin shop making things with tin, I liked that. The two people running the tin shop were civilians, not screws and it was really easy because there they did not behave like screws. They were decent types. Most of the other prisoners were really nice people.

I ran a betting business in jail just like a regular bookmaker. Despite what you may have thought most other prisoners were reliable and did the right thing amongst themselves. I didn't get into too much aggravation and could even give the customers credit facilities. All bets were taken in "snout" which is what we called tobacco.

Running a book meant taking bets on everything, especially horse racing and dog racing. We got papers every day in jail. I used to get little packets of tobacco from my mother who would slip me some when she visited me. I started with maybe three or four ounces and I played the bookie just like a normal book-maker. Everything was done on a percentage basis.

I could eat well. If I bet with you and you lost I could say "I don't want any more tobacco because I've got plenty now; when you go to the canteen this week I want you to get me jam or sweets, margarine or ham." Those were luxuries to me then.

My cell was always full of goodies. The screws knew what I was doing and didn't mind at all as long as no trouble was caused. I didn't cause any trouble, quite the contrary, I offered a facility for recreation which was harmless and which those who bet enjoyed. It gave them something to think about and a way of making time pass more easily. The prisoners used to study the racing pages of the papers and spent hours trying to predict a winner. They had this to look forward to and it kept them out of trouble.

One pal of mine worked in the prison hospital. He wore a red armband signify-ing that he was allowed to walk around the jail and do exactly what he liked. He was going to be released in three months.

He said to me, "I'm going to get you the job as a red band in the hospital. It's a doddle. You can have all the pills you want, the medicine; you cook your own food, you've got your own TV in the ward and it's a piece of cake. It's the best job in the nick. You can also walk all around the nick and talk to all your pals."

"Cor," I said, "that'll do me! Stick me up for it." He put my name up to the screw who came and saw me. I passed the first interview and then I had to see the Chief. He told me that I had the job.

I loved it. The hospital screws were a different class. I had a pretty good life there in the hospital, considering that I was in jail, but being greedy I still kept the bookmaking business going. There seemed to be no good reason why it should stop and my duties as red band did not prevent me from doing the book, but rather made it easier.

One prisoner owed me 200 ounces. That was a lot of tobacco. He said, "I can't pay now. What I'll do is I'll send the money to your mother from the outside."

I agreed and said that I would tell my mother about the deal on her next visit. I had entered into similar arrangements with other cons and never had any trou-ble.

He said "fine" and we agreed how much that would be. I think it amounted to £80 or thereabouts which was maybe then about two weeks' wages for a working man. I wrote down my mother's address on a scrap of paper so he would know where to send the money. He then went to the prison authorities and claimed that I was threatening to kill him to cut his throat if he did not pay me. He used my writing down my mother's address as evidence against me. That was all untrue. What he said about me was unbelievable — he simply didn't have the money and did not want to pay.

No one believed me. I had no hope of being treated fairly by the prison au-thorities. I learned that life does not have to be fair. So I lost three months remis-sion for that and was taken out of the hospital and put into a terrible job. I also got twenty-one days bread and water. That meant three days on bread and water, one day off, for three weeks.

Do you know what it is like being on bread and water with a decent a meal only every fourth day? It's a killer. You say to yourself that you will never eat the bread but when the bread came I used to tear it to pieces. One of the screws from the hospital used to come over and see me. He would slip me a sandwich, a chocolate bar, or something. He was a nice guy. It would be, "Cop that, Syd. Here we go, bacon sandwich" or whatever he could lay his hands on. He was a nice guy, a real nice guy.

TITBITS

IN LONDON IN THE SIXTIES Syd would witness a transformation. Britain was becoming less disciplined and people had less respect for the great institutions. Young people were starting to rebel and grow their hair, experiment with drugs and generally make a nuisance of themselves. In Vietnam American military advisors transformed boys into soldiers, all out war ensued and students in swinging London protested.

The spirit of the times led young people in a move towards greater freedom. I suppose that when Syd was growing up during the middle times of an austere ethic, people had to be disciplined and curtail their own desires for the common good. This became a matter of habit and so people continued to be prepared to respect society and curtail their own freedom after the reasons for doing so had gone. As the younger people such as Syd grew up, they rebelled against the habits of their parents. Young people were perfectly comfortable working out their own morality and living with it.

Great prejudices were re-examined in the sixties. Homosexuality became lawful between consenting adults. Abortion was legalised and practised more and more. Government ministers became involved in sex scandals, the details of which were gleefully reported in the press. Satirical magazines and television programmes taught us to be cynical of others, whereas before we were taught to respect them.

If Syd noticed this he did not care too much. He was young and strong, but still learning his craft of crime. He kept making mistakes, but then again, so did we all when we learnt our jobs. Why did Syd stay so resolutely off the straight and narrow? There was full employment and in London the evening newspapers were stuffed with adverts for jobs. He was a personable young man with brains, but no education. He could have got a job at a humble level but in no time at all he would have worked his way higher and higher until he was earning good money. But he didn't even think of it.

The truth is that every day Syd spent as a criminal made it that much harder for Syd to reform. While his peers were renting council houses, holding down steady jobs and starting life insurance policies, Syd was living in the shadows away from the harsh light of respectability and hiding in the darkness of evil. It was almost impossible to come out. He couldn't give references for a job application; he

hadn't paid any stamps so he couldn't get social security. His network of friends and acquaintances had one thing in common — prison. He was used to splashing money around, it was a symbol of his virility. He didn't hoard it — there was always tomorrow.

Prison developed his contacts and fashioned his lifestyle, it provided him with his learning and his education. He had never regarded his stepfather as a role model so he had to struggle to create an idea of who he should be and then try to live up to it. He was inventing himself. He looked around at the hard men in prison and copied them, he saw the remorseless villains in the streets and copied them. He saw the fear and respect that villains were held in — he wanted that.

He was also fighting his own private war against society as ruthlessly as he knew how. Some battles he won but by this time he was losing more than he was winning and had to rethink his strategy, as you will see.

I HAD A GIRLFRIEND who worked in an office near the law courts in the Strand. The Strand is right in the middle of central London and all the big civil cases are heard there. Very close to the law courts are solicitors' offices, barristers' chambers, banks, insurance companies and similar businesses. She worked in a big office and in the early sixties companies used to pay wages in cash. Few office workers had a bank account.

My girlfriend told me about her office's arrangements to pay their wages. They sent their chief cashier and his assistant to the bank to collect the wages. They always travelled along the same route. I found out that they were both old and believed that they could hardly give any trouble so I planned a wages snatch. I had not done one before but realised with the inside knowledge that I had it should be easy.

The bank concerned was almost directly on the opposite side of the Strand to the law courts. The old cashier and his even older helper had to walk about four hundred yards with the cash to take it from the bank to the office. They did this every Friday at exactly the same time and followed exactly the same route walking very slowly.

I dressed up in a business suit, wore a bowler hat and carried an umbrella. I wore a blue silk scarf around my neck. I tried to look like every other businessman in the area. In those days they mostly wore bowler hats and carried tightly furled umbrellas, and although the blue silk scarf was a touch too much, it was a touch that I liked. I put a flower in my buttonhole and wrapped up my umbrella very tightly and perfectly, in the style of a traditional city gent. I might have overdone it but I enjoyed playing the part.

In a van parked right outside the office was Benny and a driver called Blind Tom. Of course, Tom wasn't really blind but he drove as if he were. He drove over pavements, over roundabouts and through red traffic lights. For all that, he was a great getaway driver. He was well over fifty years old — that seemed ancient to Benny and me who were half his age. He wore glasses and was a

typical cockney. He lived at the Borough and I met him at Buster Edwards' flower shop and was introduced to him through Buster. Buster went on to reach criminal stardom in the Great Train Robbery. Buster would buy anything — he was a great fence and a lovely guy. I was sorry when I read that they found him dead, having hanged himself in his lock up. But I digress.

As the cashier and his aged assistant came out of their offices, I followed them on foot and Benny and the driver followed in the van. The cashier and his lady assistant went into the bank. The cashier and the assistant came out of the bank. For some reason she was carrying the money. I thought that this would be even easier than I planned. I waited till Tom got the van close by to them at the pavement. Benny's job was to mind me. Tom was supposed to mind Benny.

I reached out and grabbed the briefcase containing the money from the old woman. In her surprise she nearly let it go but managed to hold on to it with more strength than I thought she was capable of. She refused to let it go. It was incredibly heavy — it must have been full of silver. The van was near with its doors open. All of a sudden a dozen passers-by (mainly wearing city suits, bowler hats and carrying rolled umbrellas) saw what was going on and attacked me. My minder Benny tried to beat them off by hitting some of them on the head but there were so many.

In the end I wrenched the briefcase out of the old lady's grasp and tried to throw it into the back of the van, but I was grabbed by the public spirited people. Benny said "Come on", but how could I "come on" when I had about ten people at that stage all round me hitting me with umbrellas and grabbing hold of me? I struggled, managed to get myself free and headed for the van's open back doors.

Blind Tom helped. He reversed the van at top speed and in his anxiety knocked me over. I could have jumped into the van if he hadn't backed into me. As I tried to get up all the city gents jumped on me again. My right hand, holding the briefcase full of money had not yet been grabbed so I slung the briefcase into the back of the van and Blind Tom drove off as fast has he could. Benny, seeing it was hopeless, scrambled to get in the van and when he made it he had to hang on for dear life, with his legs sticking out as Blind Tom drove off.

By this stage the public-spirited passers-by (we called them Dick Bartons after the fictional radio detective) had kept me on the ground by sheer weight of numbers. Most of them were bowler-hatted gentlemen, just like me.

I shouted, "You idiots. They are getting away. You fools, I'm trying to save it, look, there's the robbers, and I'm trying to help." This caused some confusion but not enough. "Look, they're getting away, the robbers are escaping." Some of the Dick Bartons let me go, but others said that I was one of the robbers. I insisted that I was merely trying to help, just like them and kept on insisting until the police arrived.

This was my defence. I stuck to this story. I was arrested, put in prison on remand and employed a lawyer whose name was Ralph Hyams who was beginning to make a reputation at that time. I told him I was innocent and stuck to the story even with him. The police held an identification parade with all the witnesses

they had. Not one of them actually picked me out and not one could actually say that it was me that stole the money.

Unfortunately they all said that they had restrained me. When I came to read the witness statements you would not believe the descriptions they gave of me. I still stuck to my story that I was trying to prevent a robbery. The only thing that got me convicted in the end was I had no excuse to be where I was at the time. If I could have found one I could have got away with it.

As it was the Jury was out for about seven hours before they brought back a guilty verdict — so I nearly got away with it. My story was that I was going to this particular company in the Strand because somebody told me they wanted some painting done and being that I had learned the trade in jail I wanted to see if I could get the contract. That was the only story I could think of that would stick but the company I named said that they did not want any painting done and that they had never asked me to come.

The other problem was that choosing to rob outside the law courts was not sensible. There were just too many Dick Bartons around there. All those public-spirited people couldn't mind their own business.

My mother saw a news report about the robbery in the Strand on television and knew it was me. She saw on the six o'clock news three robbers had robbed a payroll in the Strand and one of them got caught. She knew it was me at six o'clock even though I never used to get home until after midnight.

When I was found guilty the judge, His Honour Judge Reginald Seaton (he was a very ugly judge) told me I had an appalling record; I had already done three months and then three years in corrective training and then two more years but if I wanted to lead a life of crime then I had to pay for it. He said the courts had been lenient with me in the past. He sent me to jail for three years. I was as sick as a parrot. The other three years I got when I pleaded guilty wasn't so bad because I said I was guilty, but with this one I was sure in my own mind that I was going to get away with it.

My partners never got caught but they didn't get a penny. What happened was this. When Tom accelerated the van to get away he drove so fast that the briefcase containing the money fell out onto the street. Tom stopped the van sharply and Benny jumped out to try and retrieve the briefcase. When he did this he saw an army of city gents acting the Dick Barton charging at him with umbrellas and Benny, hard as he was, thought "fuck the bag". He just about managed to escape by jumping back into the van as Tom drove off at top speed.

It was pretty tough when I got sentenced. I told myself that it would be two years before I got out with remission for good behaviour provided that I didn't do anything wrong in jail. That is two Christmases, two birthdays, two real years of my life. Gone. Wasted. Vanished. Locked up in prison. That was how I felt.

I did appeal but the appeal was rejected. I lost ninety days because in those days they never counted the time you were in prison while you were appealing as part of the time you served. So in the end it was two years and ninety days, the last being a punishment for appealing against the conviction.

I had a big write up in *Titbits* magazine with a whole spread over two pages. It came out about a month after I went to jail, where somebody said to me "Here look, you're in the paper". *Titbits* called me "the yellow-scarfed bandit" because they said that I wore a yellow scarf. I did not have a yellow scarf. I had a blue scarf, but they called me the yellow-scarfed bandit. I felt kind of famous.

I WAS SENT TO WANDSWORTH PRISON AGAIN. They shaved my head. I was not allowed to talk without permission. Prison wardens, known to convicts as screws, are just like everybody else in the world. Some are greedy horrible people and others are fine respectable people. Some just need money. Almost everyone in prison is a low life, the scum of the earth. Sometimes it is easier to talk to a screw than it is to a convict because the conversation with a convict tends to repeat itself again and again and again. And again.

After two or three months of opening our cell doors every day one screw called Sharpe, but known as Sharpie, could see that my cell mate Roy Demaseo and I were not stupid. One day Sharpie came into the cell at night and shut the door behind him, giving the impression to anyone passing outside that the cell door was locked. He sat on my bed.

"All right boys," he said, in a low soft voice, "is there anything you need?"

In those days radios were not allowed. "I could do with a radio," I said.

"I can arrange that. Anything else?"

"Razor blades." The stuff they gave you to use were blunt, for fear that you'd cut your own throat.

"I can arrange that. In fact I can arrange anything you want but it is going to cost you."

He asked us to write out a list, which we did. He wrote the prices down on the list. Everything was double the normal price. Our list contained very basic things. I think the most exotic thing on the list was aftershave lotion. In the end we spent about £100. Sharpie asked how he was going to get the money. I said we would get someone to bring it to his home. He said that he couldn't have that, so I suggested that my mother would bring him the money in a pub.

My mother met him in the pub and gave him the £100. Sharpie, she reported afterwards, drank the £100 there and then. But he was as good as his word and he brought us the stuff the following day. From then on Demaseo and I were the Kings of Wandsworth Prison. We could sell all the luxuries to the prisoners, such as chocolate, razor blades, tobacco that we bought from Sharpie and we always sold them at a profit. We even had booze. Whenever there was a "turnover" or search of the cells Sharpie would warn us. He would then take all the illicit stuff, hide it in his pockets, walk around the prison doing his duties until our cell was searched and reported in order and then he'd give us our things back.

No one knew about our arrangement with Sharpie. We never told anyone how we got the stuff that we sold. We never told anyone that we had a radio. It was very easy to be grassed up in prison.

The radio that Sharpie brought was a crystal set. You listened to it through an

ear phone but it didn't need batteries. I used it to pull off my only scam in jail.

In Wandsworth we were allowed a daily paper that was delivered to our cell. My cell overlooked the exercise yard. All the cells had bars on the windows, going horizontally and vertically and thick glass between the bars. The only ventilation was by two squares of glass in the centre, one of which slid across to allow a few square inches of air. In the winter the cells were unheated, so you were glad of the thick glass. In the summer the conditions were stifling and the cells with three to a cell became smelly. Everyone pissed and crapped into the slop bucket and in the heat the smell was terrible. At this stage you punched out the glass and hoped that the prison would fix the window round about November when it started to get cold. If they did not then you froze throughout the winter.

The bars on the window made a pattern like a noughts and crosses board, so I arranged with Demaseo a little coup that we worked against the prison bookie. Demaseo would listen to our secret crystal radio set while I exercised in the yard. The bookie exercised in the yard at the same time as me. I would start talking to him, saying that I wanted to be "on" a horse in the race that was just about to start. In fact the race had finished (with Demaseo listening to it on our secret radio set) but the bookie knew it had only just ended and that there was no way that I could know the result because I had been exercising with him in the yard. But in fact Demaseo had already signalled the winner to me. When he knew the winner he put a piece of paper in one of the cell window squares; a pre-arranged code. If horse number three in the race won the paper would cover the third square. All I had to do was memorise the starters before I went out, then look up discreetly to figure out what horse had won and place the appropriate bet.

Next day when the newspapers were delivered the bookie found that I had won and paid me off in snout. I did this quite a few times but from time to time made sure that I lost because I did not want to arouse his suspicions by winning every time I placed a bet.

Part of Sharpie's duty was in the prison censor's office, censoring the incoming and outgoing prisoners' mail. Relatives would send small amounts of money to the prisoners in their letters to make their life a little easier. The amounts were small — ten shillings or a pound but it made a difference to their lives. They could buy little luxuries like tobacco, chocolate and nice soap. Sharpie started stealing the money from the letters. There were a lot of complaints and so, not being stupid, the authorities worked out that the money went missing only when Sharpie was on duty. So the prison set a trap. They put some marked notes in some letters and Sharpie nicked the notes.

So in the end Sharpie went to prison for stealing prisoners' money. He was very unpopular and ended up being transferred to different prisons every few months all over the country. When he came out he got a job as a security guard.

Sharpie was an exception. Most of prison life revolved around conflicts between the screws and the prisoners. For example, there was in the next cell to me an Irishman who was dying to crap. In those days we had slop buckets in the cell that we were supposed to use for going to the toilet. We were locked up for long

periods in our cells with two other people. We were not let out to go to the toilet, but had to use the pots in our cells, which were no more than small buckets, in front of our cellmates. It was disgusting at first but in the end you got used to it. Every morning we had to slop them out. It was degrading and unhygienic. If we were not antisocial enough when we went to jail, this whole slopping out business made us resent society more. The smell in the morning was terrible. That was the worse thing in the world but like everything else you can get used to it.

At first they gave us tin pots that we used for toilets. The urine made a kind of foul smelling scale, like a furred up kettle and they were impossible to keep clean. Eventually they gave us plastic pots that we could keep cleaner than the metal ones, but the smell was just as bad.

The Irishman dying to crap rang the bell, kicked the door and made a noise until the screw came. The screw asked him what was the matter.

The Irishman said, "Officer, sir, please sir, I want to have a shit."

The screw replied "Use your fucking pot; what do you think this is, a holiday camp?"

"But sir" said the Irishman, "I filled it up to the top already".

"Well," said the screw kindly, "pat it down with the back of your spoon."

Nice little story isn't it? But it is true and I was there when it happened.

Wandsworth held one lunatic called Shitty Thompson. He got his name like this. Every night at about seven o'clock the prison officers used to open up our cells to give us cocoa and a cob.

One evening Thompson took all his clothes off and emptied his pot that was full of shit all over himself, rubbing it on every part of his body. When they opened the door of the cell to give Thompson his cocoa and cob, he leapt out, grabbed the nearest screw and rubbed himself all over the screw covering the screw in shit. He grabbed the screw so tightly that it took three or four people to get him off. They too got covered in shit.

After that, the screws beat Thompson senseless. In Wandsworth they did not mess about; they gave you a real seeing to. And when it was all over we called him "Shitty Thompson".

The cell I shared with Roy Demaseo was C17. Demaseo and I decided that we could throw shit at the screws through the bars in the window while they were passing, if we could wrap up the shit. Hitting the screws with the shit would be especially pleasurable because it was summer when all the screws wore their white summer jackets. Apart from asking the wardens for ice cream when they passed the cell door (two choc ices up here, please) there was only so much entertainment that we could get from their white summer suits. My scheme, hatched on the spur of the moment, would improve on.

We got some newspaper, shat in it, loosely wrapped it up and then threw it out of the window at the screws when they were passing. We did not dare to look out of the window but could hear the cries as the shit splattered five or six screws. We laughed our heads off. There was no way that they could know which cell the shit came from and we felt safe.

A few hours later our cell door opened and in marched five screws who seized Demaseo and dragged him off. They gave him a beating. I could not figure out how they knew it was him, because we did not tell anyone what we were going to do. We had simply hatched the plan on the spur of the moment.

They moved Demaseo to another cellblock so it took me several months before I could find out why they caught him and how come they did not capture me. We had wrapped up the shit in Demaseo's newspaper. When newspapers get delivered to the cells they write the name of the prisoner and the cell number on the top of the paper. All the screws had done was to read "Demaseo C17" from the top of the paper that had been used to wrap up the shit.

After a year in Wandsworth, they sent me to a different prison on the Isle of Wight. My mother used to visit me there. The prison was surrounded by a kind of dry moat and next to the moat inside the jail was the prison pigsty. They kept about fifty or sixty pigs in the pigsty which they used to kill and cook. Two prisoners were detailed to look after the pigs. They couldn't escape because of the moat that was fifty or sixty foot deep so I don't know why the pigs needed looking after. Once the pigs were fed and watered, the pig keepers had nothing to do but lounge around. That meant that they had plenty of time to collect "Joeys" or parcels that were thrown into the pigsty from friends and relatives of other prisoners.

To cheer me up, mother promised to send me some goodies, which she would throw over the wall into the pigsty where they could be retrieved and passed on to me. I told the pig keepers that a Joey would be on its way for me and arranged with them that they could have a part of the Joey as their fee for bringing it to me bit by bit.

My mother decided that this would be her Christmas present to me. So that Christmas she brought a hot water bottle filled with whisky, a hot water bottle of brandy, a hot water bottle full of gin, razor blades, after shave lotion, the whole nine yards. She put the booze into rubber hot water bottles because the rubber would not break when it landed in the pigsty. She had to throw the stuff over a moat wall into the pigsty area, some fifty feet below.

She hadn't started to throw the stuff over the wall when she heard whistles and saw screws emerging from hiding. They called her to stop but she turned away and ran as fast as she could, dropping my presents as she ran. They chased over the fields and caught her as she tried to hide in a barn.

They arrested her for trying to smuggle stuff into the prison. She denied it. Blatantly, she said the stuff was not hers. She had never seen it before and did not know whose the stuff was. She said that she would not dream of trying to smuggle stuff in for me. Not in a million years.

At midday that day, the Governor called out to me at lunch "Are you expecting a visit today?"

I knew something was wrong because the Governor did not usually come to lunch.

I said "Today? No I don't think so."

"Are you sure?"

"Yes."

"Is your mother coming?"

"Not that I know of."

"We've got your mother next door," said the Governor, smiling.

"Oh, wonderful!"

"No, no, we've arrested her for attempting to drop you a parcel."

"You're crazy!" I answered. "My mother wouldn't drop me a parcel if I paid her a million pounds."

"Well, you may say that," he said, "but we found whisky, cigarettes, other stuff."

"My mother would not do that in a million years," I said.

"Well," said the Governor, "do come and have a look."

They took me into a cell. They had my Christmas presents all laid out.

I said, "You know that's not for me. If you've got my mother and she said that she dropped that for me she's a liar and if she did drop it, it's for somebody else in here. It's not for me because you don't have my mother, because she's not even here."

The Governor opened the door. There was my mother.

I said, "Hello Mum, did you drop this stuff?"

"No, Syd, I didn't," she solemnly promised.

"There you are, see that Governor?"

Anyway within the next couple of days, she got off the charges against her because there was no evidence. They didn't have enough proof. They caught her too quickly. If they had waited a little longer they would have actually caught her throwing the presents over the wall. I lost a couple of months remission for slagging screws off because they had caught my mother.

MY MOTHER ALWAYS LOOKED AFTER ME. I lived at home until I was twenty-seven when I married Carol. Mother always stood by and lent me money. When I woke up in the morning, I would find one or two pounds, or a couple of packets of cigarettes by my bed. I never repaid her loans but at Christmas once I bought her a packet of twenty cigarettes and took all the cigarettes out of the packet, and stuffed the packet with money.

I gave her the cigarettes, saying that I was sorry, mother, but all I could afford was a packet of snout. "That's all right, son" she said. When she opened the packet she cried.

She worked in one of the gentlemen's clubs in the West End as a waitress. I think it was the Army & Navy. That was where she met my stepfather who was a barman. But he was a drunk. When she left the clubs she became a cashier and she used to steal money from the tills.

When my mother came from Ireland with her two young boys and no husband, she soon met and married my stepfather. He was always nice to me and to my brother Eric, but he was lazy and liked the bottle. They seemed to be quite happy together but I am sure that my mother loved Eric and me far more than him.

At the end of her life she spoke with a south London accent. There was still a

slight hint of the Irish brogue in her voice, but only very slight. She loved a good joke and she was very witty. Not only did she care for Eric and me but she was fiercely loyal to us. No one was allowed to say anything against us and although she was not crooked like Eric and me, she accepted that if we were crooked she would stand by us.

I am sure that my crookedness rubbed off on her, rather than the other way around.

She brought us up properly, and although we were street kids she did not want that. She told us that everybody was no good, except us. None of our neighbours was good enough for her. She died of lung cancer. I spent loads of time with her when she was ill. We laughed about the Joey incident before she died, about her running through the fields with all the screws chasing after her blowing whistles.

OUT OF PRISON, I LINKED UP WITH BENNY YET AGAIN. As before, I used to plot the crimes while Benny provided the muscle. Benny also provided the applause. I became driven by the need to show off how clever I was. The concept of a challenge, a victory or a "coup" was forming in my mind. If I pulled something off it would become a coup and as well as earning some money for me it would be satisfying just to prove to myself that it worked.

I knew that lots of crooked publicans, off-licence owners and restaurant owners loved to buy cheap Scotch whisky. I had stolen it from pubs and off-licences myself and had to resell it at a fraction of its price to other pubs and off-licences. Whisky has always been incredibly expensive because of the tax charged on it. If a publican could buy it for one third of its normal price he could make huge profits selling it in his pub. Although everyone knew buying stolen Scotch was wrong many people thought that they were entitled to buy Scotch cheaply because of the huge amount of tax charged on it. It was the same with cigarettes.

I noticed from earlier that whenever I sold the Scotch I stole, the person buying it would not pay too much attention to the product. He would be keen to get the transaction over quickly and the evidence out of sight. He never asked for names and addresses, any more than I would.

I devised a plan. It involved buying, at normal prices one case of real Scotch whisky. I then had to get hold of fifty boxes of empty Scotch bottles. It took some time to buy the empties but in the end I got them from dustmen who used to clear the rubbish from pubs and clubs. The empties had to be in very good condition. I also managed to pick up some empty Scotch crates.

I then had to buy some tea that I brewed in vast quantities and let get cold. It was important to get the colour of the tea right and make sure that all the leaves were properly strained before I poured it into the empty whisky bottles. I then resealed them. At the end of it, I had one case of genuine Scotch and forty-nine cases of genuine Scotch bottles filled with cold tea that looked exactly like Scotch.

I would then have to find a buyer for the Scotch. I would go into, say, a barber's shop to have a haircut. I would ask if anyone want to buy some Scotch at a third of the shop price. I explained that I knew a pal of mine who had some cases.

He did not want to sell it in twos and threes because that was a pain. He wanted to get rid of the whole fifty cases quickly and on the cheap. Although I did not say so, everyone who heard me assumed that the Scotch was stolen or in the language of London, "it had fallen off the back of a lorry".

Once I found a buyer, I took him to meet my partner who was of course Benny. I would break open a bottle and give the punter a taste to sample it. It would be genuine.

"Cop that, it's pretty good, isn't it?" Sometimes Benny would accidentally drop a genuine bottle on the ground so that when it broke the punter could smell the whisky. He would know from the smell that the whisky was sweet. "You clumsy bastard Benny! Sorry, I'll knock it off the price."

We would then load the cases from our van to his van and do so really rushing. No one wants to be caught in the act of buying stolen Scotch. We then got paid and drove off quickly, as would the punter.

I did the same scam with cigarettes. Getting the cartons was the main problem and sealing them up was trickier than with the Scotch, but in the end I figured how to do it. If the punter buying the stuff was an idiot, we would arrange to meet and move the goods from our van to his van. If the buyer was a bit shrewd or a gangster, I would have to give him no chance to inspect all the cases. I would arrange to meet them but ring up on the delivery day and say that I've had a breakdown.

"We put all the stuff in the back of the van and there was not enough room so we had to put some stuff in the front of it and I am so sorry but would you bloody believe it, the stinking motor's broken down right in the main road right in the middle of traffic. Can you do me a favour? I will knock off a hundred pounds — can you come and get it?"

For a hundred pounds they always came out. When the punter came in his van I created a panic situation (gosh, are the cops around?) and transferred the goods all at speed so that the buyer did not have the time or the inclination to check all the cartons.

He thought that he was buying stolen goods. When he found out that he had bought cold tea or empty cigarette cartons he was hardly in a position to complain or to know where to complain. It worked every time. They were good little scams, for a learner.

THE SCOTCH AND CIGARETTE SWINDLES were the first coups that I devised. I got a great kick doing them and there were no comebacks. I made tea look like Scotch in my first little coup. In fact tea stopped me from ordinary robbing and turned me into a confidence trickster. This is how.

Benny and I found a crooked lorry driver who was driving loads of Brooke Bond Tea around the country. I arranged that he would leave his lorry while he had his mid morning break and Benny and I would steal the lorry. I found a buyer for the tea before I stole it but I needed somewhere to park the lorry and offload the tea. I managed to do a deal with a crooked scrap metal man who had a yard. A big

wall surrounded the yard and there were heavy gates. I agreed with the scrap metal man that he would let us use his yard to offload the tea. His end of the deal would be the scrap he could get from the lorry. Benny and I would get the money for the tea. Neither Benny nor I could drive a lorry so I cut Blind Tom into the deal.

At first everything went according to plan. In I go. Tom stole the lorry, while I gave the driver some cash for his cooperation. I arranged to meet Tom later that day so that we could go to the yard together and sell the tea to the buyer that we had lined up. Blind Tom waited for me to arrive at the arranged meeting place, but while he was waiting, someone hit him on the head and stole the stolen lorry.

It had to be the guy who was supposed to be buying the stolen tea. I was down some cash and had been outwitted.

Around this time I got married to Carol, my first wife. I met her when I came out of a pub one Sunday, saw her at the bus stop, talked to her, got her back to her parents' house.

Carol was petite, slim with long brown hair. She had a fine figure and could have been a movie star — no, a silent movie star because she had a horrible voice. She was only eighteen years old and would never look as good again as she did when she was eighteen. We had a hard chemical attraction for each other and could not be kept apart.

I married her when I got her pregnant. That was the done thing in those days, it was the way that everyone I knew got married. It did not seem to matter whether you took "precautions" because sooner or later you got someone pregnant and had to marry her.

When you get married things change. The attraction gets less intense. We had a baby, a fine son whom we called Mark, and a few years later we had another boy, whom we called David.

Carole knew what she was getting into, marrying me. She knew that I was crooked and that it was likely I would be spending some time in jail. I knew that I would probably have to go back to jail but was determined to avoid that if I could.

I had the most appalling parents-in-law. Her mother was a prude and her father was a drunk. Carol's sister married a policeman. Her mother used to say, "Look at Bob, what a fine man he is! Why can't you be like him?" Bob eventually turned out to be a wife beater, a child beater and turned gay (or so it seemed then) and finally, to round off a really nice life, committed suicide. I used to say to the mother-in-law, "Is that what you want for me? Is that how you want me to turn out?"

Although it doesn't seem fair, Carol lost her fine figure and her beautiful features almost as soon as she got pregnant the first time. That was also normal in those days among my friends. As soon as you got married, you and your wife jumped to middle age. There was nothing that I could do about it. She was my wife and she looked after my kids. I had to look after her as best I could.

CASINO

SYD WAS BEGINNING TO BECOME A CON MAN. Look at the rabbit — now you see it, now you don't. Look at the Scotch. It's not Scotch that you're buying, it's tea, but it's wrapped as Scotch and look, it smells like Scotch, tastes like Scotch, only it isn't and your money ends up in Syd's pocket. Syd had worked out that conning people works best if they too are doing something wrong. There can be no come-backs from the law because a bent publican is not going to go to the police to complain about the tea he bought thinking it was stolen whisky. Of course, it is a dangerous game because if the guy who has been conned manages to get hold of the con man the con man would end up with his face rearranged, his arms broken, or dead. Syd was not conning people who seek redress through the courts.

Syd reasoned that even if one of his victims did catch up with him, he would figure out some excuse. He could say that he had bought the whisky from some-one else and he too was a victim. At the end of it, however, Syd knew that if things got rough he could look after himself with an explosion of violence.

All around him in London, on the other hand, there was an explosion of peace and love. Yet Carnaby Street and swinging London do not move Syd; he was bit old for that. The hippies were pedalling flower power and drug use was becoming more widespread but Syd wasn't paying much attention to this or to the nuclear threat, the red menace or hey, how many kids LBJ killed that day?

Syd wore his lapels wider, his ties kipper-style and his trousers slightly flared. He wore his hair longer, down to his shoulders. Apart from these superficial con-cessions to the times he was the same Syd, hard on top and harder underneath. The gentle message of the hippies was not for him.

His life was rapidly moving to a crossroads. He realised that if he kept on with this sort of life he would end up in prison again. The police knew him and, more importantly, stealing and robbery now struck him as stupid. It was easy to hit someone over the head and steal from him, but that was no good at all. In nine cases out of ten the man you hit on the head was only doing his job. He had to find another way of making his living. He had just begun to taste the good things in life and he liked what he had tasted.

He was finding his friend Benny becoming more of a liability and less of an asset. Benny wanted to fight his way out of everything. Syd was reaching the conclusion that he had to do something that would keep him out of prison. He did

not like it in prison and prison, to that extent, worked. But Syd never thought of going straight any more than the USA thought of abandoning Vietnam to the communists. Syd's considerable brainpower was beginning to be used for the first time. It couldn't be used properly, it could only be used improperly, as a tool for crooked schemes because for Syd there was simply no alternative.

I SAW AN ADVERT IN THE NEWSPAPER FOR CROUPIERS. The advert said that training would be given and suitable people should apply to Mecca, a large leisure company that owned a famous dance hall in Leicester Square. I didn't know exactly what a croupier did but I fancied being one. I liked the idea of working in a casino dressing up in good clothes and working in luxurious surroundings.

In all my life of crime I had always been charged and found guilty under the name of Godfried and not Gottfried. My mother gave that as her name when we came over from Ireland because she did not want people to think that we were Jewish.

The advert said impeccable references were required. In order to work in a casino I had to be clean. No one with a criminal record was allowed to work there. My criminal record was under the name Godfried so I applied in my real name, David James Sydney Gottfried. Everything was exactly the same except for the spelling. The casino checked it out with the police who reported that I was clean. Out of about 200 people who applied, Mecca picked out twenty and I was one of the lucky ones.

I went to Mecca's training school and I took to it right away. I learned every game and after training I was the best. I was the best craps dealer, the best blackjack dealer, the best roulette dealer and the best French roulette dealer. I was one of the few people who could understand the rules of craps, which is a very complicated game. Mecca opened a casino in Kingston and gave me a job there as a craps dealer. After a couple of months I was promoted to pit boss and then I became head croupier. That is a sweet little job because when you are on the till it is easy to nick some chips. I also got quite a lot of tips from the successful gamblers.

The Kingston casino wasn't really for me. It was not high class. It catered for the poorer, less posh market. It didn't bring out the best in me so I applied to work at Curzon House, which is one of the best casinos in London. They gave me a job in the Palm Beach casino instead.

Palm Beach wasn't what I wanted. I wanted to be with the big spenders. The croupiers there were scruffy and their shirts were frayed at the cuffs and at the collars. The whole attitude in the place was low class. I was always immaculate. I used to go to work dressed beautifully in stiff collars. I had four or five different dinner suits so that I could always change. I looked the business. I spent a good deal of what I stole on my clothes.

I discovered that all the other croupiers were crazy gamblers. They would spend most of their wages either in a poker game or in another casino. And so it was that I learnt about all aspects of gambling, not only as part of my training but

also as part of my leisure activities with the other croupiers.

That was the one big difference between me and the other croupiers. They loved gambling. They enjoyed playing cards. I hated gambling. I hated the time that was wasted playing cards. But I enjoyed getting the money and it made no difference to me if I got it legitimately or not. I don't think that honesty comes into it. I believe that almost every gambler would cheat if he thought that he could get away with it. I have seen thousands of gamblers in action. There is not one that I would trust not to cheat.

There is a story about a travelling salesman in a one-horse town for the first time; the salesman asks the bellhop at the hotel if there is a poker game in town. The bellhop warns that there is only one poker game in town and that is at the saloon, but not to play poker there because the poker game in the saloon is a crooked game and the salesman will get cheated.

"Don't play there under any circumstances. It's a crooked game," the bellhop warns the salesman.

Next morning the salesman sees the bellhop on his way down to breakfast and complains:

"I lost all my dough in the game last night."

The bellhop says, "I told you it was a crooked game. Why did you go?"

The salesman sighs, "Because it was the only game in town."

Living in our south London flat with Carol, Mark and David, I soon fell into a pattern. I would work the unsocial casino hours, get home very early in the morning when everyone was sleeping, and wake up after the boys went to nursery or school. Mostly, Carol brought them up by herself. I suppose that because I was not at home much when the boys were awake they looked on being with me as a real treat.

I suppose that I had the best times with them, leaving Carol to the rest. I never changed nappies or had my sleep interrupted.

We had plenty of money in the house and what I could not do with time, I did with money. They never went short. But Carol seemed to me to get lazy. She stopped looking after herself, put on weight, got fat and to me, anyway, appeared coarse. Her voice seemed to change. Or it could have been me. I was spending most of my time in the casino, where people mostly spoke properly. Carol's voice began to jar — it almost hurt my ears.

I constantly pestered the manager of the Palm Beach until he got me a job in the Curzon House, where I worked for over two years. I started off as a dealer; from dealer I was promoted to box man, and from box man to pit boss. Now I was stealing £200 to £500 a week in my pocket plus I was working in an easy job. The casino catered for gentlemen gamblers, not degenerates. I used to work by walking around the casino chatting up good-looking girls keeping an eye on the games and stealing.

One of the croupiers introduced me to golf. I soon became hooked on it. So, from being a prison convict throwing shit at the wardens I had become a respectable croupier wearing fine clothes, earning good money and playing golf, a fine

gentleman's game. I improved my speech and manners and learnt, from the posh people in the casino, how to dress, how to speak and how to behave in good society. I became more ambitious. Things that I thought were never going to be for the likes of me became nearer.

I HEARD ABOUT A CASINO IN BONAIR, in the Netherlands Antilles, from a friend who worked in the Knightsbridge casino. He said that the Mafia ran it. The operator got slung off the island for stealing from the casino and now it was up for grabs.

I had never heard of Bonair or the Netherlands Antilles. But I found that there were a group of three main islands off the coast of Venezuela, known as the ABC Islands, made up of Aruba, Bonair and Curaçao; these were colonies of Holland. They lie almost on the equator. At the time I had vaguely heard of Venezuela.

I didn't have the money. How much did they want for it? I was told that it was half a million dollars. I thought that I should try to buy it — I had been working in a casino for over two years and seen the kind of money that goes down the box. I knew that it would be worth it. I wanted it. I rang up the owner in Bonair to introduce myself as a potential buyer and he told me that they wanted someone English in Bonair to run it. I sensed that they wanted someone gentle and honest, as he complained about the dishonesty of Americans. He asked me to meet him in New York and I agreed immediately, as though I had spent all my life flying on jets around the world to business meetings.

I had to steal the money from the tables to get the airfares and money for the hotel bills. I stole about £1,600 that week. It was a big week. My pal in Knightsbridge wanted to be my partner in the casino — I agreed but he did not have any money. I told him to steal it but he couldn't steal a chip. He hadn't got the bottle so I had to steal for both of us.

We checked into the Hilton in New York and met the casino owners. They asked us about our experience. I told him a pack of lies about my experience. I claimed I had owned several small casinos in England, managed some of the largest ones there, and was now looking for a new challenge. I said that I had a British Gaming Board licence to own and operate a casino in London. I pointed out how strict the British authorities were about giving licences.

There were many people who were interested in the casino functioning properly. There were the present casino owners — they included McDonnell Douglas, the aeroplane manufacturers, and a host of other New York investors. Since the casino had closed down they were not getting any rent from their investment. Then there were the Dutch officials from Bonair — they thought that the casino would encourage tourism in the island. A Governor of the island, Governor Hugo, represented them. The Dutch Government also owned a share in the casino, along with the other investors. The casino was supposed to produce a profit for the investors and pay gaming tax to the island government.

I told the casino owners that I preferred not to buy the casino outright. I wanted to take a five year lease and share the profits with the owners. Eventually we thrashed out a deal under which my friend and I would run the casino for five

years getting the lion's share of profits for ourselves.

The owners asked me how much bankroll we could put up as security. Obviously they were leasing us a valuable property — it was located on the first floor of the best hotel in the island — and they wanted to be sure that we would look after it and have enough money to pay the punters should we hit a losing streak. I suggested $100,000. They suggested $250,000. I haggled and finally agreed that I would bring over $150,000 as bankroll security in cash. The $150,000 would be used to pay out punters if we hit a losing streak and as a guarantee that we wouldn't run away with the takings.

The owners took us to McDonnell Douglas. I fannied my way through all the people in McDonnell Douglas, their lawyers, accountants, the lot. In New York I signed and sealed a contract giving my friend and me the right to manage and operate the casino for five years.

I got back to England knackered, thinking I had just done the hard bit. All I had left was to find the backing. $150,000 was not a lot of money to put up as security for a five year right to operate the only casino in Bonair. I was very confident that I would find someone who would be prepared to take a share of the profits in return for putting up the security deposit.

As hard as I tried I could not find anyone prepared to put the money up. No one had heard of Bonair in the middle of the Caribbean. I was still working the club. The casino was supposed to be opening in six weeks' time and that was the time it was going to take to get the new equipment that I had ordered.

I met Bubby, the previous owner, who had been flung out of Bonair and who did not want to lose it. He loved me. He promised that he would help me operate the casino by giving me all the advice that I wanted. He had made a lot of money out of it but was thrown off the island for cheating. He was based in Florida and promised he would send me gamblers who were high rollers.

I told Carol that I had to go for a new job in the Caribbean. She did not seem to mind, apart from complaining that I wouldn't be taking the boys to the zoo on Sunday. She never seemed to worry too much about me leaving her for long periods. For my part, I was glad to get a break from her although I was sad to be leaving the boys. That part of it was hard. I promised them that I would be back as soon as I could and told them to be good and listen to their mother.

When the time came to go to Bonair with the money I took £7,000 out of Curzon House. My pal from the Knightsbridge got nothing. Not a chip. I told him that if he wouldn't steal anything he wouldn't come. He told me he was not going to steal, he didn't want to get caught. I telephoned the New York people and said that my friend had suffered a serious heart attack and he was not going to be part of the deal. Could he sign himself off the contract? They agreed to the amendment of the contract and assured me that an amendment in London would stand. They wanted the casino opened.

I had about £7,000 and managed to get another £3,000. I went over together with £10,000 towards the agreed $150,000 security.

Governor Hugo greeted me at the airport like royalty. All the croupiers from

the casino were lined up at the casino to shake my hand, glad to be going back to work. I was their saviour.

They took me to the bank to deposit my $150,000, which, of course, I did not have. I met the Bank manager, who was an immensely fat man who had been briefed to look after me and my $150,000. He showed me around his bank, proudly pointing out all the security features, while I clutched a paper parcel to my chest. After the tour he showed me into his personal office and gave me coffee.

I told the bank manager that I had $150,000 in cash in banknotes in my paper parcel which I lay on his desk unopened. I could give that as a deposit but if he banked it they would, of course, send the money back to England because the parcel did not contain dollars but the equivalent in pounds sterling. The Bank of England would trace the banknotes and check where they came from. At this time there were very severe penalties for exporting currency from Britain in breach of the exchange control regulations. The maximum amount of cash that you were allowed to export was £30. I did not want the Bank of England to be able to trace the notes to me.

I told the bank that I had brought sterling and wanted to keep my money in sterling, in case I lost on the exchange, should dollars go down in value.

The bank manager quickly agreed that I was right. We were in the Netherlands Antilles, which was then, as now, a tax haven. They were used to dealing with "black money" and conspiring to defeat the tax and central banking authorities in countries all over the world. They were expert at this game and the local economy largely depended upon washing dirty money. Of course, the Bank of England could not and would not try to trace banknotes. It would be impossible, but the bank manager did not know that. His natural caution had trained him to advise people against taking chances. It was also in his interests that his bank would not be implicated in money smuggling. My wish to keep the money in sterling rather than to change it into dollars was perfectly understandable. I would be there for five years. A lot of currency fluctuations could take place in that time.

I gave him the large sealed packet containing paper and said that here was $150,000 in sterling. I wanted him to keep the money in this sealed package safely in the bank. He agreed and never opened the parcel. He had it taken down to the vaults that he had proudly shown to me earlier and started to issue me with a receipt when I stopped him. "I don't need a receipt from you! The bank is not going to abscond with my money." And everyone laughed.

I had the packet ready with me before I went to Bonair. I carried it as hand luggage on the plane. It never entered my head that they would inspect the parcel. I had made a point of signing the packet before I sealed it with tape. Somehow, if the thing was signed people would assume that it was correct. The manager took us into his office. He told us of his bank's impressive credentials — they had some sort of association with Barclays Bank in London — he never made it clear just what the connection was but it sounded good.

Not having any real capital as security had one real potential problem. If someone had done well in the casino in the first few weeks the casino would have

been broke, without a doubt. It would not have taken a very big win to do that. I just had to do my best to make sure that this did not happen and keep my fingers crossed.

They gave me a five year contract to run the casino because, supposedly, I was an honest Englishman. Yet none of them considered the fact that I had exported £150,000 in cash out of England in breach of the criminal law to be a sign of dishonesty in me. They all thought that I could make the casino run at a profit, and I would be honest in doing that. Breaking the exchange control laws and not declaring cash to the Inland Revenue was normal behaviour. Nothing dishonest in that.

THE CASINO WAS MAKING two or three thousand dollars a week and running along really well. Bonair was a beautiful place, it was exactly how you imagine a tropical paradise to be. There were palm trees, soft hot sandy beaches and a warm sea. All the didi-didi trees bent in the same direction, as a result of the near continuous breeze that always blew from the same quarter. It was a flat place and there were salt flats where they still had the tiny huts in which the slaves used to live. It was a paradise to me.

I sent Carol money every so often. I spent the rest of what I made as I made it. I rented a luxurious house right on the ocean, filled it with servants and bought the best clothes and jewellery I could find. I had the lifestyle of a millionaire, which, for a boy who had been in Wandsworth only a few years earlier, was quite a change.

The town had jewellers, a few shops and some restaurants. It was a stopping place for cruise ships that used to announce their arrival by radio. Then the town sounded a siren to indicate that a cruise ship was on its way. Whenever this happened every shop and business on the island opened up. They knew that within a few hours of the siren blowing hundreds of wealthy tourists would be landing on Bonair. Whatever time of day or night the siren blew, the whole place came alive.

Governor Hugo was a character. He had a wife who slept with as many different men as possible. Hugo found out about his wife's unfaithfulness and printed up some posters which he distributed around the Island. The poster named his wife and all the lovers that she had taken, or at least all the lovers that Hugo had found out about. I asked him why he did that. He said it was to shame her so that she would not be unfaithful any more. He said that he wanted to teach her a lesson. I told him that he was stupid; he made himself look more of a fool than his wife, but he didn't see it that way.

Hugo appointed an official called George to supervise the casino and make sure that the casino profits were being correctly recorded. George was a very nice man; he was very black and his face was round and shiny with long curly hair. He laughed a lot but he was not the world's brightest spark. He would come in with a notepad. He had ruled it into columns with the date and each game, and he had left the final column blank to complete the amount of money taken that day on that game. George was supposed to witness me opening each game's

moneybox at the end of the night, see me count the money and check the count.

George liked the good life. After a few weeks I suggested that we go out drinking at the end of the evening. He asked if we should count up first. I said, no, let the cleaners finish up. We could leave the boxes locked and come back later. I took George out drinking every night. Some nights I took him out whoring. I always got back to the casino before he did and took some money out of the boxes before George witnessed the official opening up of the boxes and the solemn counting.

I met Rigna in Bonair when she came for an interview for a waitressing position in the casino. She was stunning; petite, long straight black hair, very slim and very beautiful. She moved like an angel. She had dark mulatto skin, and spoke English, Dutch, Spanish and Peppermento.

As she walked into my office to be interviewed I fell in love with her, love and lust at first sight. She was shy and had honey eyes that followed me around. Sometimes when you see someone, you know that you can really love him or her, if you get the chance. I felt like this when I saw her. I had to make the chance.

"You've got the job."

"Thank you."

"And you start tomorrow."

"Yes, sir."

"And you are mine."

"What do you mean, sir?"

"You are now my woman and I am your man. We are now together. From now on you are going to be my lovely lady. I will be your man."

"Yes." Rigna looked down at first and then her eyes moved up and stared into mine.

"And you are beautiful. Very, very beautiful"

Her father came to see me after she moved in. He was six feet six inches tall, very broad and had monstrous strength. He asked me what I was doing with his daughter. He looked as though he was going to give me a smack. I told him straight that she had come to me and we were together now. I loved her. He liked me immediately and we became good friends.

I ran the casino for nearly a year. I lived with Rigna in this tropical paradise. The more time we spent together the happier we became, we never argued or had any differences. Rigna was totally obedient and wanted nothing more than to make me happy in every way. I bought her some presents but she refused to take them. She looked after my house, my food and my clothes. She did everything out of her love for me. I was very lucky to have met Rigna, looking after her made me happy.

Everything was perfect. Everybody loved me there and it could have gone on forever, I think, except that I had a problem with the government. I don't know how the Governor found out about the fiddling. It was probably likely that a dealer had said to George something casual; perhaps commenting on how much money he had taken on roulette the night before. George may have heard a sum men-

tioned that far exceeded anything he wrote down in his notebooks.

So in the end the government tumbled. I was called up to see Governor Hugo. He told me how pleased they were with the way I was running the casino, but they had their doubts about the daily count being accurate. When he told me this I said, in horrified tones:

"What! The count is not right! I'll fire the whole crew!"

The Governor said, "Well, we think it's not the crew, we think it's the owner!"

"Ridiculous, you don't believe that for a moment do you?" I asked him using my best upper class English accent.

"Well, I have to investigate these matters and I'm directing two sergeants from Curaçao fraud squad to investigate."

These policemen came and started talking to the croupiers about takings. They built up a pretty solid case against me — it was time to leave. I had a lot of the casino profits in cash and I took them with me. I left the island in Bubby's light aircraft courtesy of Bubby's one-legged pilot and landed in Miami. I left behind my "security deposit" at the bank. My life as a casino owner had ended.

Before I left I had to tell Rigna that I was returning to London. She was tearful, but I told her that if I stayed here they would send me to prison. Leaving Rigna was the hardest thing but it had to be done. I did not leave a forwarding address but I gave her a lump of money and told her to find herself a nice man, not someone crooked like me who would always be on the run. She promised me that she would never stop loving me. I knew that. But love can't thrive if you always have to be one step ahead of the law and as much as I loved her I knew that.

I had been a fool. I had a beautiful house on the ocean. I used to wake up and dive into the hot sea for a swim each morning. My maid would catch fish in the sea while I was swimming and cook it for my breakfast. I had a beautiful girlfriend who was head over heels in love with me. I loved her family and they loved me. I was even a respected confidant of the Governor and a pillar of the local society. There was no violence, no hassles. Life was truly idyllic.

I came back to England with about £14,000. I was making $3,000 a week in Bonair, which then was the equivalent of the average man's yearly wages. I could buy whatever I wanted. I had to give it all up to save tax of twenty-two percent on my profits and at the end I had virtually nothing to show for it. I was an idiot.

WHEN I GOT BACK FROM BONAIR, I went home to my wife Carol and the boys. She had a newly born daughter we called Lisa.

Three weeks after I got back, I was home when the telephone rang. It was Rigna who had arrived at Heathrow. She had unexpectedly arrived and wanted me to come and get her. Carol answered the telephone. She wasn't impressed — I was.

I was astounded to get Rigna's telephone call, and even more astonished to hear that she was in London. When I left Bonair I thought I had closed that chapter of my life. I never gave Rigna my address or telephone number — I never even told her I was leaving. She had never been off Bonair before in her life and

yet she flew halfway across the world to a strange country to find me. I was elated and excited.

I was pleased that Carol found out about Rigna because things had become so difficult with Carol. Rigna's arrival forced me to make the right decision. I left Carol, who eventually divorced me. I moved in with Rigna. I was sorry to leave the kids because I really loved them, but I thought that I couldn't stay with Carol and I don't think that Carol even wanted me to stay with her. I think she got fed up with me. I had moved on in my life, Carol had stayed still.

I liked the life that I was leading. Violence and robbery seemed stupid to me now. I resolved never to get involved with them again. I got a big kick out of going to Bonair and running my own casino; I had managed to fool so many high-powered people. I thought that this would be the way I would do things in future — I would rely on my brain, not my muscle.

I saw an advert in the paper that inspectors were required in Charlie Chester's casino. I always thought that Charlie Chester's was a Mickey Mouse operation. It is in the middle of London, near Piccadilly Circus, but is not in the same league as Curzon House. I applied for the job and was interviewed by the manager — whom I would not have employed as a croupier. I agreed to take the job. They told me they were having problems with dealers, who were no good, so I offered to come in early and teach the dealers. I told them they were losing money because the dealers were too slow.

After a month they promoted me to pit boss. They then offered me the manager's job, which I declined. I didn't want to manage that dump but I did want to get all the money I could out of them.

There was a dealer there who I will call Dave. Of all the bad dealers he was probably the worst of the worse. He was hopeless. He looked like a little school-boy with large spectacles — the kind that always comes top of the class. He was never going to make it as a dealer, he was awkward and clumsy. I thought he was corruptible.

I took him out to dinner one night and told him he wasn't going to make it as a croupier. He was upset because he wanted to be a croupier very much, but I had to tell him that he didn't have what it takes. By rights, I said, I should be sacking him.

Tears welled up behind those big glasses. He had his heart set on being a croupier. His ambition was to work in a posh casino. He would never be good enough.

I then made him a proposition to give him a new start in life. I said I would show him a trick, and if he repeated it a few times in the club he would make money, but whatever money he made he should save, because after I had gone he would not get by as a croupier. He wasn't good enough. He agreed. If he couldn't be a croupier he would be a thief.

Now I had brought in a new rule in Charlie Chester's. Instead of the dealers standing around with the cards spread out waiting for the people to come in and open each table, the dealers would be practising until the punters came in. The faster the dealers could deal the more money the casino would make. The deal-

ers needed to practise if they were to improve their speed.

The trick I taught Dave was for cheating at blackjack. This game is played by the casino against the gamblers. It is also played by kids against other kids under the less sophisticated name of Pontoon. Everyone receives two cards. The dealer plays for the casino. To beat the casino you have to get either a twenty-one (pictures count as ten and aces as one or eleven at the player's option) or more than the casino gets with its two cards without getting more than twenty-one. If anyone gets more than twenty-one he is "bust" and loses. If you are not bust you can keep drawing cards as long as you want until you become bust. The casino must draw a card if it has fifteen or under and must not draw a card if it has sixteen or more.

Blackjack in a casino in England is dealt from a "shoe" — the long box into which the shuffled cards are placed (usually three of four packs of them) and on top of the cards a wooden weight goes. When the cards are in the shoe all you can see is a small semicircle of the back of the next card before the dealer pulls it out of the shoe and puts it on the table face up. Only the dealer is allowed to touch the cards.

What Dave had to do, while he was practising, was to pick up the cards in a certain order so he would create a set shoe so that the cards would come out of the shoe in a set order. While Dave was "practising" he would have to deal a few hands to imaginary blackjack gamblers. After each hand the dealer would pick up the used cards and put them in a plastic tray on one side.

I taught Dave to pick up the cards and put them on the plastic tray in a set order while he was practising so that the punter would win. Having ordered the cards on the tray, Dave was then to introduce the cards into the shoe when no one was looking.

So if Dave arranged his cards in the order of ten, five, queen, eight and nine then assuming the house was playing against one lone gambler, the gambler would get the ten and then the queen (making twenty), and the casino would get eight, five (making thirteen) and then have to draw the nine which would "bust" the casino with twenty-two. The gambler would win.

Dave's job was to load a shoe like this so that a dealer would lose five or six games in a row. We didn't worry about other gamblers joining in (that would have spoilt the set shoe) because the gambler that we would use to collect the winnings would ask for the maximum limit at the table. That usually scared off any other gambler to tables where the stakes were lower.

After three weeks Dave got the hang of what I taught him and he was ready to be set loose. I introduced him to a gambling friend who looked like a film star. I told him that on a certain day the "film star" would come in just before Dave was due to go off on his twenty minute break. As soon as he came in Dave was to drop the set cards that he had built up on the tray into the blackjack shoe, and then go for his break. Every twenty minutes they had a break. The set shoe was, of course, loaded so that our people would win when they played blackjack. An innocent croupier would deal the cards. I would watch the gambling as an inspector, mak-

ing sure that no one cheated the casino. That was my job and I took it seriously.

Dave followed his instructions perfectly and we ended up with a new dealer dealing the crooked shoe just as the film star sat down at the table. I had told the film star to come in with a couple of hundred pounds. In the event he had only £6. I had a count up to see how much I could lay our hands on. When he came I gave him all my money and all I could borrow without raising suspicion. All in all I only raised £90, which I discreetly slipped to the film star.

He played the crooked shoe and won about £5,000. After that I had given him instructions to play one more shoe, a straight shoe, bet a little on roulette and then leave with the winnings.

The casino required us to write down the particulars of every punter. I wrote down "Film Star X, buy in — £250, out — £5,000". I then had to hope that the table took enough that night after he had gone to show the figures making sense. It worked, and after losing a few pounds on the straight shoe and a few more on the roulette the film star left.

It was essential to lose a few hands at the end so that it would be assumed the punter felt he was starting to get unlucky and leave. That would present itself as normal behaviour to the casino.

We divided up the money that night and arranged that our film star would come in again.

This time we decided the film star should appear to be more of a big shot. I told him to go to the betting shop, take an empty slip, and fill it up as though it was a winning £100 Yankee bet on that day's races. He was then to say to the management, "Excuse me old chap, how did these do?"

The management would check the winners on the betting slip and find out that he had "won" about £20,000. They would be desperate to find out who he was; rich gamblers are their source of income. The rest of the plan worked again exactly as before. We must have hit them eight times like this, not for a lot, not more than four or five thousand a time. I felt we could try for a big one. I thought I could set up such a good shoe we could try for a real coup.

Dave left the casino and got a job working for a firm of accountants. He put a deposit on a house with his share of the winnings. I just blew mine on fancy restaurants, clothes and jewellery for Rigna and good living.

Without Dave, now studying chartered accountancy, I had to try something else. I managed to steal a shoe and some cards from the casino, took them home and set it myself for a big pay off and smuggled it back in the casino.

I carried the set shoe to the table, perfectly openly, and swapped it over. No one questioned what I did. The film star was of course nearby and then decided that he wanted to play. I suggested to the manager that he himself deal the shoe, and I complained about the film star being too lucky no matter who deals to him. The manager agreed. He approached the film star, shaking his hand saying "How are you sir, I'm the manager, do you mind if I deal myself? I haven't had a practice for some time."

The film star said, "Not at all. My pleasure, but can we have the limit raised?"

"Sorry sir, we can't."

"No? In that case I do not want to play," he bluffed exactly as I had previously instructed him.

"Wait a minute, sir," and the manager telephoned the owner to ask for permission to raise the limit. Permission was given. It may be a game of chance but the odds are technically in favour of the casino.

I was wary of using the same techniques too often. I thought that using a set shoe too often would be detected so I decided to use a different technique in a different casino. That technique involved marking a set of cards. For blackjack, all you need to know is the card in the shoe, in case you want to draw it. To win consistently you only need to know whether the shoe card is a picture card, a nine, an eight or an ace. Those cards had to be marked somewhere on the small semicircle that is exposed when the card is in the shoe. Because the card has no right way up — it is the same if you turn it upside down — I had to mark each card twice. I marked several decks of cards so that I could read them while they were in the shoe. The marks had to be tiny and I spent weeks training myself to read them accurately.

This was my first time marking cards. I simply rubbed away a small section of the back of the card in one position to show it was worth ten, and a different position if it was an ace and so on. Cards without marks were worth between two and nine. That was enough information to enable me to win.

I decided that I would try to get a set of our marked cards into a casino. I chose a casino near Park Lane, where you meet a better class of people.

I recruited my girlfriend Rigna into the coup — Rigna would have walked on fire if I asked her to. She was desperately in love with me and although she had never done anything crooked before she agreed to help without hesitating. Rigna is the only girl that I ever brought into a coup, before or after. I cannot really understand why I brought Rigna into the coup. I never brought any other girl in because I knew it was one thing for me to serve time if I got caught but quite another for a girl to do it. Also, I think, at the back of my mind was the thought that if things went wrong I would fight my way out of it, if necessary. Girls can't do that.

I gave Rigna a big carrier style handbag containing a blackjack shoe with a deck of marked cards. My job was to distract the dealer while Rigna switched the shoe and a confederate of mine called Ralph waited to play. I used Ralph from time to time to work against the casinos because they knew him as a lunatic unlucky gambler. He had spent years in the casinos and always lost. I believed that if he started to win now it would be a lot less suspicious than if a stranger suddenly came in and started winning. The casinos would think that it was Ralph's turn to win. They had seen it all before and knew that they would win the money back from Ralph in the long run. Ralph who had lost a small fortune over the years needed no encouragement to be given a certain chance of getting some of it back.

So Ralph, the unluckiest gambler in the world, came in, sat down and asked the dealer to shuffle the cards. After the dealer shuffled them he put them into the shoe.

"Oh, wait a minute," says Ralph "I didn't bring my money with me! I'm going to go and get some."

Now the dealer had got the shoe ready to deal but the gambler forgot his money.

At the same time I would be talking to the pit boss "This dealer here is a cheeky little rascal; he's lippy. He's given me a lot of trouble," I said. "What is his name?"

The pit boss called him over.

"I was in here the other night remember, when I had that double and you flipped my chip off the pile?" I accused the dealer.

Every dealer would deny stealing a chip from a customer.

"No sir, that wasn't me, sir. I am afraid you are mistaken, sir."

"You don't remember, you low life! Let me tell you something, you don't know who I am but you'll find out. The only thing that's saving you now is the manager here; he's my pal. Now just you look at my face and whenever I come in here again you treat me right."

"I'm sorry sir, but I don't remember you sir, it wasn't me sir."

I was acting in the slightly aggressive and illogical way that some punters act after drinking too much and being a little disappointed with the evening's play, but going just that much further than they normally do in accusing the croupier of stealing.

"Now clear off. Scram."

By the time this distraction had finished, Rigna switched the shoe on the table with the shoe in her bag. She wandered away and, as I instructed her, she paused for a few minutes at the roulette table, and then slowly left the casino.

I said "Bah! I'm not going to stay here". I pretended that I had got the needle and left just before they would have thrown me out. Ralph sat back down; he brought some money out of his pocket. "I had it in my other pocket" he said sheepishly.

Ralph asked if the game was going to start? Could he play £200 a box?

Any other punter watching this scene at the table would say "Hell, that's too much for me, £200 a box! I'll go to the next table."

Ralph sat down. I had told Ralph that after he had won, he was to play about four or five losing hands on the next shoe and then, because he was losing, to walk out. As he walked out he should bet a few quid on roulette, one number only, a thirty-five to one shot and leave after it lost. He started to win; he kept on winning. He won and won. The manager was called in and then assistant manager. They all looked on in utter disbelief.

I was in a nearby coffee bar waiting for Ralph to come out with the winnings from the crooked shoe. I had worked out that he should be out of there in about ten minutes at the most. Half an hour passed and he still wasn't out. I thought to myself, no, he's blowing all the money, gambling it all away, the bastard! I asked someone if they had seen Ralph. The man said, "Yes, I saw him. He was winning like a champion." I became very despondent at this because I knew that the leopard couldn't change his spots; Ralph was a lunatic gambler and after getting

£27,000 from the coup he was now in the process of losing it back.

Three quarters of an hour later in Ralph beamed.

"What happened?" I was dying to find out.

"You won't believe what happened."

"Tell me."

"The first shoe I won about twenty-seven grand. Now, like you told me, I played two more shoes the same way waiting to lose half a dozen hands but I had three winning shoes. I just couldn't lose."

He had three more winning shoes. All in all he had won, both legitimately and illegitimately £52,000. Ralph's luck really did turn, for that night at least.

I have always split the spoils of my scams equally. It means that there can be no arguments between my helpers. They all would have let me take the greatest share because I thought up, planned and supervised the coup and I was the leader. But I was happy with equal shares and everyone got equal shares. I think that Ralph's share of the £52,000 lasted him for about a week. In no time at all he was the same poor old lunatic unlucky gambler. He gave it back to the same casino we had stolen it from. My share lasted longer, but months rather than weeks. When I had a lot of money in my pocket I spent a lot of money. That was easy and there would, I was sure, be more easy money to be made. Rigna's share was my share.

I HAD NO QUALMS ABOUT CHEATING CASINOS. When I was a pit boss it was my duty to get and write down information about all the punters. I was supposed to chat them up and find out all I could about them. I would ask receptionists, doormen, cabbies, in fact anyone who could give me information about the gamblers. I would find out what cars they drove and ask about people they might know. I'd casually mention a stockbroker giving me a tip or a racehorse owner giving me a certainty, or I'd know someone in the same line of business. I would have to write reports about all the winners and I believe all casinos do it to this day.

Casinos would always know if someone like a trustee or a lawyer was gambling with other people's money, but they don't care. If anyone won, there would be a stewards' enquiry. If some one lost £50,000 no one would blink an eyelid.

If someone won £10,000 the casino would find out who he was, what he did and where he worked. From this information they'd have a good idea of his salary. They'd find out where he lived. They might find out for example that he came in to gamble with £20, won heavily and he was a small branch manager of a building society, earning about £19,000 a year plus car, and had a house worth, say, £60,000. He would go back again and inevitably blow his £10,000 worth of winnings.

When he went back again he would get free membership, complimentary meals, free drinks and a free taxi to and from the casino to encourage him to come and make it easy for him. He would be treated like royalty. He could lose another £30,000 and the casino would have to know that it was not his money he was playing with but they wouldn't care. They would encourage him to come

again with more free meals and free drinks and luxurious, chauffeur-driven cars. It didn't matter who owned the money as long as they got it.

Gamblers in casinos are like drug addicts. I remember one gambler in Curzon House (where they are all nice people), he was an American who worked for a big company. He was very wealthy and was losing £10,000 a night. When I saw him he was crying. I tried to comfort him. He said, "If I don't fucking cry I don't enjoy it" and he meant it. He liked to lose so he could ruck. Another guy used to walk around with a plastic bucket full of chips. He always lost and did not care. I have no sympathy for the gamblers, and even less for the casinos. The gamblers are going to lose anyway. In the long run they always lose. The casino owners are even bigger crooks than me. Of course, there are croupiers who have worked for twenty years and never stolen a penny. But I don't think that in those days there were many of them and virtually all croupiers gamble.

With my share of the coup I bought a gambling club called the Edgware Sporting Club. I bought it from someone who didn't know how to run it. It is amazing how many people have gambling clubs that do not know the first thing about them. I also bought one in Watford. I was ready to give up my life of crime and retire permanently — I owned two casinos making very healthy profits; what more did I need?

I copied what I saw in the big London casinos — I got my staff to hand out free drinks and so on. I used to say to the girls who handed out free drinks to the punters, "If I see anyone with an empty glass you're fired. And don't give them a single measure, give them doubles or trebles".

A drunken gambler is going to lose money and will lose much more of it than he planned when he came in through the door. The more they drink the more they lose. I liked winners because they boast to everyone about how much they have won; it is the best form of publicity for a casino owner. When the same person loses a lot of money they tell everyone that they have broken even. So even that is not bad publicity.

Everyone knows that the odds favour the casino. And yet people come into them every day thinking or hoping that this will be lucky for them. In the long run it never is. What is the worse kind of gambler to have in a casino? One who keeps his money at home.

I never did retire because a new Gaming Act was passed and it designated special areas for casinos. Watford was not a special area, neither was Edgware. They sent me a big form to apply for a gaming licence. As soon as I read the form I could see that no way in a hundred years would the authorities give me a gaming licence. I closed them down.

JUICED

THE BEATLES SPLIT UP, but Syd was never interested in them. And with the Beatles went the sixties. The seventies was a time when amateurs became more professional — rock'n'roll impresarios turned into tycoons and politicians figured out that wearing stage make-up on TV was better than showing five o'clock shadow. Sir Alec Douglas-Home's surprised comment to the make-up artist who told him he had a face like a skull — "hasn't everybody? — was the essence of naivety. People became more concerned with the by-product of activity — money— and less concerned with the activity itself. Freshness and originality were, to an extent, replaced with choreographed and systematic performance.

Amongst all the glitter there was hidden gold. We would not realise until much later that some of the seventies were really good. Like men with hangovers we held on to some of the styles of the sixties in the hope that perhaps they hadn't really ended. We kept our hair long, and Syd had his hair almost to his shoulders, the blond locks curling slightly upwards at the edges.

If you had asked him then why he was a criminal he would have been able to answer very easily. It was all a question of getting things. Other people had possessions and money, he wanted possessions and money, so he would get them from the people who had them. Why shouldn't he? He was the important thing, him and his mates, not other people.

Syd became a professional in his criminal activities and focused on his objective of making money even more clearly than ever. He realised the virtues of systematic planning and while he appreciated that to get away with it he had to plan every possible detail, he also had to do the unexpected, every scam had to have its own angle. Syd did not want to go to prison, therefore careful organisation was essential. But he still wanted it to be a lot of fun.

He was in his thirties and had learnt from his mistakes. He had his friends and his circle and in the normal course of events a criminal like Syd would have stuck to his friends and stuck to his manor, south London. Had his career followed a standard route he would have probably gone to prison at this stage for five or six years, come out as he approached his forties and then lived on the edge of the law, doing a bit now and then, for the rest of his life. But he was different.

Syd did not fit into a normal pattern. He had already been a criminal too long to think of doing anything else. He had no real roots, nothing that kept him to a

particular lifestyle or place, although he loved his family and enjoyed the company of his south London friends. He had improved his speech (vital among the snobbish English) and his dress. He had become a croupier, seen worlds very different from his own and enjoyed life as though he was a millionaire. To keep things this way he had to constantly improve, strive for perfection both in the artistry of his planning and in the science of the execution of his crimes. He had to learn scraps of behaviour and the customs of the rich world, the people who never seemed to go to prison no matter what they did. He wanted to join that world.

His next logical step was to realise that neither planning nor the most brilliant execution were sufficient. He needed to build up a team, rather in the way that a successful entrepreneur builds up his own team of managers and advisors. In Syd's case he needed specific skills and he knew that with all the teaching and training he would never be able to get Ralph and Rigna to perform flawlessly and regularly. He was on the look out for suitable partners, but he needed more than partners; he needed an audience, a fan club.

TINY WAS AN AIRLINE PILOT WITH AIR CANADA. He used to fly the Queen to Canada, or so he told me. He was also a big gambler and drinker. He was called Tiny because he was huge. He could help me get work and with my casino closed I had to go back to work. Going back to the scamming business meant that I needed people to help me and I had run out of people to help me. Dave was gone and Ralph was too unreliable. I didn't want to push my luck. I didn't want to get caught.

As usual, I had run out of money so I was working cards with a pal called Colin "Wank-Dog" Walters. Colin was very tall and very thin. He was called "Wank-Dog" because he had a very long penis.

I used to play with my crudely marked cards which had tiny sections scratched out on the back to identify them. When I played, Wank-Dog came with me to mind me. We were invited to a game by Tiny who I had met at the golf club. Tiny told me that there was a poker school I could join — three players on the look out for some action. It was a chance to earn some money and I took my crudely marked cards with me. One of the players was introduced as an estate agent, the other as a travel agent and the third was a Canadian kid called Roman.

Roman was only eighteen. He was short, stocky with curly black hair and spoke with an American accent. He had exaggerated gestures and all the card slang of a Las Vegas gambler. He looked a bit like an Egyptian with his swarthy face and curly hair; I found out later that he was actually born in Oldham, Lancashire and that his parents came from the Ukraine but he was brought up in Canada.

We were not playing long when I realised that something was wrong. While I was cheating with the marked cards someone else was cheating in some other way. I didn't know at first that one of them was cheating so I had to wait. I noticed that every time Roman dealt I got good cards but the estate agent got better cards. It was impossible for that to be a coincidence. Everyone was cheating. We

were playing with my marked cards and Roman was dealing with a fake shuffle or handing out cards from the bottom.

They were using the estate agent as the take-out guy — so that the person actually winning is not the person "doing the work" with the cards. I studied Roman to see if I could spot his handwork. I couldn't see anything wrong. The Canadian kid was good.

After a while I told the others that I was feeling sick and could we postpone the game to another day? They agreed and left. Wank-Dog asked me why I stopped and I explained that we were going to get done. I had the marks but Roman was doing the work! Either he was going to win a little bit or we were going to win a little bit. But one thing was sure; we were going to sit there all night for pennies. But I could see that the kid was good. I wanted him on my team. I had only used people who were take-out men, such as Ralph, or minders like Wank-Dog. This Roman, I realised, was as good in his own way as I was in mine.

I set up a meeting with Tiny the next week and asked him if they wanted to play again. Tiny said they did. I suggested that we play at my room in the Chelsea Hotel and that Tiny should come early. I targeted Tiny because he was the person who set the game up but did not play.

When Tiny turned up in my room I said that I wanted to talk to him and asked him to sit down. I was very pleasant to him, and smiled as I spoke. He sat in a big armchair perfectly relaxed.

"How are you feeling, Tiny?" I asked as I walked round to the back of his armchair.

"I'm fine. I hope that you're feeling lucky today, Syd," he said as I moved behind him.

He was a little lazy, like most fat people and didn't turn to face me. I pulled a wire cheese cutter out of my pocket. It was a catering quality model with wooden handles and fine wire.

"Oh, I'm going to be very lucky today, Tiny," I said in a threatening voice as I put the cheese cutting wire round Tiny's throat and started to pull;

"You fat piece of shit. Working a scam on me are you?"

Tiny was frightened. The cheese wire made a thin red mark as it cut into his neck.

"It's not me, it's not me, it's them," he said crying. "I'm only steering for them. I'm only working for them — they are the crooks."

He admitted it without a moment's hesitation. Tiny was steering marks to Roman and his team. Tiny was ideal for the job. He was a regular honest chap with a good job. He looked trustworthy, he was amenable and not a hard man.

Tiny told me the whole story. Roman was from Canada and was trying to work the punters using his skill with the cards: moody shuffles, dealing off the bottom and similar tricks. The other two were on the team in order to make up the numbers and take-out the money. Tiny was steering the punters to the team.

I told him not to say a word when the others arrived; he was to act normally. He agreed, perspiring tremendously. He adjusted his collar to try to cover the red

mark made by the cheese wire. The red mark looked obvious to me but I wasn't worried. Tiny was no oil painting and you wouldn't have studied his neck anyway. Eventually, he calmed right down and in the end played his part well.

Before they came, I got Wank-Dog and another helper to come. I didn't like to be outnumbered. We took the cards out and sat down to play. Soon it was Roman's turn to deal. I let Roman deal the first five cards to each player. As soon as he did that I raised my right hand with its palm facing the table. I said in a loud but matter of fact voice:

"Stop — you just dealt a crooked hand."

Roman said, "What the hell's the matter?"

"I have got," I said, "two kings, and you have ace king. By the time he drops out [the travel agent] and you drop out," I said pointing to Roman, "he [the estate agent] will have a pair of aces and I will have a pair of kings. Deal the cards."

"What do you mean?"

"Deal the fucking cards, boy. You must think that I am fucking stupid."

There was a long pause. I waited to let them get more nervous.

Suddenly I bellowed, "See your fat friend here? Ask what happened to him earlier."

Tiny started to whine. "He said he'd kill me, boys, he had a wire round my neck."

I held up my hand again.

"The coup is over boys. It is finished. I have captured you and the only reason that I have captured you is that I am cheating too. You," I said, pointing to the supposed travel agent, "are out and you" pointing to the supposed estate agent, "are also out. You, Tiny, are good as a steering man and you have got a job. You, Roman can come and work with me."

Roman paused and then slowly smiled.

"I sure ain't made no money with these guys yet!" he said. "I have been here for five months and I ain't made a fucking penny. I'll come and work with you."

FROM THAT DAY ON WE MADE MONEY and formed an unbeatable partnership. We kept Tiny on because he was a brilliant steerer and he could find good people who loved to gamble and had a lot of money. He lived in a little village with his wife. He had been married to her for thirty years and she never knew her husband was crooked. As far as she was concerned he was an airline pilot and that was all he was. He used to go to work on the airlines, go home at weekends, and be nice to his four children. He brought us down to dinner once and swore us to secrecy. No one would ever associate Tiny with cheating. He would find someone at his club or wherever who liked to play poker. He would introduce them to us and we would play, knock the mark out in a game and give Tiny his corner.

Tiny never played in these games; he only steered. His corner was usually a percentage, generally four or five percent of our winnings. And Tiny lived well on that until he died of a heart attack.

When I played poker as a team with Roman, I developed more and more

complicated strategies. We used marked cards at first then as Roman and I became more proficient with the cards, we preferred to work the cards because the marks could have been spotted. I would win from the mark and two or three hands later I would lose my winnings to one of my take-out men who I specially employed just to win. I would always be a loser. When the take-out man who won went home at the end of the game, I would stay with the other players and talk about the game. That way I would learn what the punters thought about the game they had just lost and figure out any improvements and refinements of the scam for the next time.

The winner will always bring suspicion on himself by being the winner. As one of the losers in the game I would say all the right things to the other losers. The losers would be thinking that they could have had the money but unluckily the other player beat them to it. That way the losers would come back.

I always played the mug and a very poor gambler. The take-out man has to know how to play poker well. That way the loser thinks that he has lost his money to a good poker player and that the loss was bad luck.

A Californian called Andras Chevez had taught Roman these card tricks as a kid and Roman had practised endlessly. He taught me his tricks and I taught him mine. We would spend hours practising everything. Roman did a very good fake shuffle, where it looked as if you were shuffling a pack of cards but in fact only shuffled the bottom half of the cards. I would watch him as he practised and try to spot what he was doing. If I couldn't see it, neither could any other gambler. This method of only shuffling the top half of the pack is called "the pull through". Even if you know about it, it is impossible for the eye to see it being done.

There were also other techniques that we practised. Roman taught me how to "crimp" the cards. This involved bending the top half of the deck very slightly, but enough so that when the cards were cut, the person cutting them almost inevitably picks them up in the place that they are crimped. In that way a mark who insists on cutting a set deck will cut the deck in the exactly the place which brings the set cards into play.

The hardest thing was to try to be clumsy with the cards. Good gamblers can shuffle and deal very smoothly and quickly. Roman and I had to give the impression of being incompetent gamblers, so we would practise spilling the cards while we shuffled and being unsure about what we were doing. The clumsier you were with the cards the better. Obviously if you were very slick with them people get suspicious. Also, your clumsiness masks the tricks. That's the hardest part. Other players have to think that you are stupid. It really takes years of practice to be so clumsy and stupid with the cards.

There were only three of us then and that was not enough. I needed another helper; Wank-Dog said that he knew a suitable candidate who was Irish, but that should not put us off. He lived in Thames Ditton with his wife and five children and was called Tim. Wank-Dog knew Tim all right, but he knew Tim's wife much better and used to fuck her while Tim was at work.

Tim had a meat round. He used to buy meat from wholesalers and sell it door

to door from his van. He made about £500 a week, which in those days was a lot of money. But there is no link between intelligence and the ability to make a lot of money. Tim was unbelievably stupid. When I met him I thought that because he was stupid he would go very well with the team. No one would believe a man as stupid as Tim could be up to any skulduggery. But he was also a very pleasant looking man and as soon as you saw him, before he even opened his mouth, you knew that he was Irish.

Tim was bored with his meat round, even though it was making more money for him than someone of his stupidity deserved to earn. He wanted to get into a life of crime and adventure. I tried to educate him on how the card games worked but he was so thick he couldn't understand. He didn't know what to do or what to look for, but he was good enough to watch other players in the game.

I told him to look out for anything unusual. When you are playing with marked cards all your concentration is focused upon seeing what the next card is. I have got to know four or five cards and that takes a lot of concentration. Sometimes I have to look twice because it is possible to make mistakes. I did not want to make mistakes so all my energy was concentrated on the cards. Roman's concentration was to check that I was not making a mistake and that the people dealing the cards were not cheating.

Neither Roman nor I could see if anything else was going on. For example, other players could be making signals to their friends. Tim's official job was to get drinks, cigarettes and look after us generally. He was introduced as our driver.

If Tim saw something crooked he was supposed to use the word "Tom" in a sentence. "Don't forget Syd, you had to call Tom." This would be an excuse to leave the room with Tim and find out what he had seen. He would tell me what he thought was happening. I would return, play some hands and check for myself. If everything was right I would introduce the word "George" into the conversation.

Although Tim used "Tom" a number of times, he never did spot anything wrong. I think he just said the word in order to prove that he was looking out for us. He had to be seen to do something to be earning his money. I suspect that even if the other players were making signals, Tim would not have seen them.

Nevertheless, Tim was supposed to watch the table and was on the look out for any cheating that might be done against Roman or me. Tim would get a one third cut for this job, but he used to get tired and fall asleep. Once we played in South-ampton for two days and two nights against two casino owners. Every time Roman and I knocked them out they went away and came back with more money. I was really tired at the end of it but at the end Tim was as fresh as a daisy. He hadn't been watching, he had been sleeping

In the course of this two day marathon one of the casino owners came back wearing a pair of glasses. Whenever we played in a strange place we didn't always get to use our own cards. We often relied on Roman's sleight of hand rather than marked cards. So when I saw one of the poker players come back wearing glasses that he had not worn before I wondered whether he had put "readers" in, that is a deck of cards that had been marked in a way that the marks

could only be read with special glasses. So I spilt my coffee over the cards, making them useless. He brought another pack of cards in, won a bit more, and I spilled my coffee again.

Tim was asleep.

Eventually when we finished playing I counted up the money at home to divide it between Tim, Roman and me. I gave Tim £3,000. He said, "How much did we win then?" I said, "£31,000." He asked how come he only got £3,000 when he should have got some more? (He wasn't sure of exactly how much it should be.) I told him that was his sleeping money. He said that he was supposed to get a third of the winnings. I agreed that he was supposed to get a third of the winnings but pointed out that he was supposed to be watching the game. Getting paid £3,000 for sleeping was a good deal for him.

One time Tim really hurt me was in Italy. I was living with Enzo in Milan and was working with Johnny Gatto, Enzo, and Tim. I will tell you about Gatto and Enzo later. We went to a nightclub. We were watching the people dancing but Tim was staring at a girl on the table opposite. I saw that she was with a man. I asked Tim what he was doing. He said the girl was "fucking beautiful" in his thick, drunken, Irish brogue. I pointed out that the girl was with a guy, that there were plenty of other women around and if he kept looking he would cause a ruckus. Tim kept looking and the girl's Italian boyfriend was getting more and more upset.

Finally the Italian came over and started to speak to Tim in Italian. Tim said that he did not speak Italian. The Italian said slowly for Tim not to look at his woman. Gatto then said, "Excuse me, but would you please go to your table?"

"Who the fuck are you?" said the Italian and went for his pocket. I smashed him on the wrist before he could pull out whatever it was he was going to use against Tim and a fight started. Almost immediately two carabinieri came over, identified themselves and arrested us. It became clear that the man who objected to Tim looking at his girlfriend was a cop in that club on undercover work. That was typical. Here we were, a bunch of criminals in a night club and Tim makes eyes at a copper's girlfriend!

At the police station they eventually let us go because they said that there was fault on both sides. As soon as we got out of the police station I wanted to beat the shit out of Tim, so did Enzo and so did Johnny Gatto. We looked at Tim's stupid happy face; he didn't know what he had done wrong.

"Tim," I said, when we were alone, "You've been a naughty boy, a real cunt. You could have got us all arrested. I told you to stop, but you didn't. Now you have to be punished."

It dawned on Tim that we were going to beat the shit out of him. Enzo held him and Johnny Gatto and I took turns to smack him. It wasn't terribly satisfying but it was important that discipline be maintained. I hit him as hard as I could, although I got the feeling that the Italians were holding their punches back. I think I got carried away, as I often did when things became violent. When I hit him in the face I hit him as hard as I could. When I held him for one of the Italians to hit him, I pushed his face forward into the punches with exquisite timing.

When his punishment was over I picked him off the floor, helped clean up his face and brush down his clothes and took him home to bed. The beating was over and he was still part of the team.

Another time, much later, I was plotting a con against a diamond merchant. As part of the con I took the diamond merchant and his wife out to dinner with Tim. Tim started making eyes at the merchant's wife; he wanted to fuck her and it was clear that she wanted to fuck him. They were on the dance floor together having a grope while I was trying to set up a deal with the merchant. The merchant saw what was going on and as he didn't want his wife to fuck Tim, took her home in a huff. When I got out of the restaurant I reminded Tim that we were there to take the man's money, not fuck his wife.

Tim spoiled the coup because of his behaviour. Once again I had to give my friend Tim a smack in order to punish him. He could mix work and pleasure, we all do, but not to let the pleasure spoil the work. This time I enjoyed hitting him. I had put a lot of energy into the coup that Tim's behaviour ruined.

Tim was an idiot. But he followed me because he liked me and enjoyed being with me. He always made money with me. Whenever he joined in a coup, he didn't really understand what was going on. He rarely did his job well but he always got his cut — except that time when he was sleeping on the job.

I HAVE BEEN A CARD READER. I marked cards in ordinary ways. Most cards are not made to a high specification and you can scratch them or shave them. But casinos and good gamblers use the highest specified and best quality cards in the world — Kemcards. I had a method for marking Kemcards. An American company that manufactures plastic playing cards makes Kemcards and they claim that their cards are unmarkable. That is the reason why most poker players want to use Kemcards. I got hold of a way of marking their cards. Now I didn't actually find this formula. It was given to me by Roman's teacher, Andras Chevez; he was then around sixty. He came over here with his wife to see Roman; he's dead now.

Andras was responsible for teaching Roman how to work the cards. He taught him from a very young age so that when most kids were playing football or riding bikes Roman was practising the pull through and dealing off the bottom. Andras was very pleasant — a typical North American and lived in San Jose, California.

When Andras and I got talking, he asked me what kind of cards we used in England. I said that all the casinos use Kemcards. He said, "I can mark them."

I said that it was supposed to be impossible and that people who could mark them are on to a fortune. So he said, "I've got a marked pack. I looked at them. I said they looked alright to me. He shuffled and I drew cards. In every case he called them right, "OK. ace, six, queen, two, ten, nine, ace, king, jack, four, nine."

I took the cards home to see if I could find out how they were marked. At that time I considered myself pretty shrewd with cards. I spent hours looking at the cards and I couldn't find any marks. I tried everything I knew, looking for marks as I would do working in the casinos as pit boss. I couldn't find a thing.

Casinos give you training on how to look for marks. The usual ways of marking

the cards are a scratch, a line, an erasure, a break in the pattern of some description. Sometimes, cards are shaved very slightly so that the aces are slightly narrower than the rest of the pack and the kings and queens are slightly shorter than the other cards. I looked at the cards that Andras had marked for hours and hours and hours. Then I thought that maybe they were not marked and that Andras had the cards in a set pattern, which he had memorized. He could have done a "moody" shuffle and I wouldn't have spotted it.

I went back to him, shuffled the cards myself and said "OK, Andras, do it now." He did it. Then I guessed again. He was wearing glasses. So I said, "Take your glasses off." Now he could not read the cards. I thought that he wore "readers". Andras said that it was not the glasses."I should be able to read them for you without the glasses but I've got bad eyes — I've got diabetes — and I can't see too good these days," he explained.

So I said, "Well, I'll tell you what I'll do. Take your glasses off and just read a few as close as you like to your eyes." He did this and he could still read the cards.

Now I knew it was not the glasses. I couldn't see the marks but the cards were marked. Andras refused to tell me where the marks were. He said take the cards away again and come back tomorrow. I took the cards back again. I went through them under all kinds of light and I still could not see the marks. Andras said that he wouldn't tell me how to mark Kemcards unless I found the marks. He didn't want his secret to fall into the hands of anyone who was not going to be worthy of it.

A few days later when I was driving in the car a thought occurred to me. I looked at the cards and I could see the marks. I could not believe it. I saw every card. A tiny portion of the pattern on the back of each card was shaded very slightly. A different part of the pattern was shaded according to what the card was. The shading was so subtle, so good, that it looked like a normal manufacturing production. There was no break in the plastic skin of the card; it was as though Kemcards had shaded the cards in the factory before coating them with plastic. There was absolutely no sign that the cards had been tampered with in any way.

I could see that the shading could be hard to read; to me at first sight it looked impossible to read the shades during a poker game. Normally a player would have probably less than two seconds in imperfect light in which to read the back of the card at a distance of five or six feet before the card is picked up and obscured by the player. And yet I remembered that Andras read the cards quickly and from a good distance.

I told him that I had found the marks and I pretended that they were easy to read. He was very offended.

"You're cheating," he said.

"I'm not cheating; I'm looking at the back."

"Yes, but I marked them for artificial light. If I give you a pack of cards I marked for outside then you couldn't see them."

I believed that.

He told me the story. He had met a chemist who worked for Kemcards. They were made with a plastic coating so that if you make any kind of mark or scratch

on the card it immediately shows up. You can't put ink on them because it wipes off. So the chemist had devised a system to penetrate the plastic; to go under to the surface of the card, mark it and reseal itself. It was not actually a mark, it was a shade, so if the pack of cards had a red pattern on the back the chemist would create a red shade, so that the red shade would be a little lighter or darker at a particular part of the pattern, but only very slightly.

Now the chemical that Andras used to shade the card was aniline — it's a fabric dye that has got to be in powder form. It's no good in liquid form.

I couldn't get it in England or the United States — both countries had stopped making it. I tried everywhere. In the end I telephoned a company in Holland and found that they had some aniline dye powder left. I asked, "What colours have you got?" The man on the other end of the telephone said, "I don't know, and I've only got half a dozen of jars. Whatever I've got it's here and you'll have to come and get it."

I offered to send the money but as he refused to mail the chemical to me; I had to collect it. So I went over to Holland to see the guy with the dye. He said, "What do you want to do with it? What do you want it for?"

I said, "Well, actually, it's for a friend of mine from California who is an artist and he asked me to pick up some aniline. I've tried all over the world and can't get it. Apparently they don't make it anymore."

He said, "There is a restriction on selling this in Holland because if you were to take this little bottle and throw it into the reservoir, all the tap water in Holland would be red, blue, green or yellow or whatever colour was in the bottle, and it's almost impossible to get rid of the stuff."

I found out later that when you work with it you put a little drop in the sink, a tiny, weenie bit, and the water in the whole sink turns red — it's unreal.

He had red, green, blue and amber colours. I bought the whole lot from him. Out of all that lot and the years I've been away I've managed to hang on to two jars. So I can still go to work with it, but of course I am retired now.

The secret is in the mixing. Before you can make the powder dissolve you need to mix it in methylated spirits. It won't dissolve in anything else but methylated spirits; amazing isn't it? Then you have to add pure alcohol to it and then there's a little tube; I don't know what it is, but I haven't got much of that left. You just use one drop from that little tube and you mix it up and get a very fine, fine brush with which you do your work. When you paint it on the surface of the card very thinly, it penetrates the card, shades the area underneath the plastic and somehow reseals the plastic surface of the card. When you look at the card it's completely clean; there's no mark, no scratch — nothing. It's fantastic. No one can see them and even when I've shown them to people saying, "Look, there's the mark!" they still can't see it.

I used to be able to read from yards away but now my eyes have gone. Like Andras all those years ago, I too have got bad eyesight and diabetes now. Diabetes must be the curse of card readers.

It took me ages to mark a set of cards. Cards come in sealed packets. The first

problem was to open a pack so carefully that you could reseal it after you had marked it. This involved opening the cellophane at the bottom of the pack where it was stuck together.

The card manufacturer puts a seal over the flap on the box of cards, top and bottom. If you take a razor blade you can cut along the place where the box is stuck together on the side, and, carefully pulling the cards out you can avoid breaking the seal. When you put the cards back you have to stick down the join on the side of the box with glue.

You then have your cards. Taking a very small brush you have to paint the solution onto the correct part of the card. The cards have a pattern on the back. That pattern usually can be marked in such a way that by shading one segment you can indicate the card is an ace, another segment shows it is a king, and so on. Each segment must be tiny, not more than a millimetre square. Each card takes about five minutes to mark, and the whole process, after practice, can take three hours to "juice" just one deck of cards.

One small mistake and you have to start on another unopened pack.

Next you have to reseal the pack so that it will not be detected. If you made a mistake here you would have to carefully open another pack. And then, if you were introducing marked cards into a casino you had to introduce sufficient of them, and this meant marking a number of packs.

At the end of the work I had dozens of packs of sealed normal looking cards but every pack was juiced.

It is only necessary to show just the value of some of the cards. In any game of poker or blackjack, knowing aces and kings is enough to win consistently.

HAVING MADE THE JUICE I decided that I should juice the London casinos.

This was how. I put an ad in the newspaper for a salesman who would have a great new opportunity. Dozens of people applied and I interviewed them all. I chose out of all the applicants a Sikh who wore a huge white turban. I told him that we were trying to get into the market of supplying casino requisites. He had to go around from casino to casino selling our special offer, which was for a dozen packs of Kemcards at half the normal price that casinos paid. Casinos usually buy their cards from the same highly reputable supplier who has been in business for dozens of years. We were, I told the Sikh, trying to break into that market.

I had to buy the Kemcards at normal prices and that meant that I made a loss on every sale. But I did not worry about that. I had business cards printed for my Sikh employee and organised some nice printed stationery and order forms and set the salesman to work.

The Sikh was a very good salesman and the casinos were greedy bastards. In order to save a few pounds they bought juiced cards from a person who simply knocked on their door with a special offer. The Sikh never knew what his real purpose was. After he sold all the juiced cards I paid him off and told him that the business was unsuccessful.

I taught Tim how to spot the juice. It took weeks for him to learn. Eventually he

got the hang of spotting the juice but he couldn't read the juice. He was too stupid for that. He then had the job of walking around the casinos each night and looking at the cards that they were using that night. As soon as he saw our juice, he telephoned us and then Roman, me or Wank-Dog turned up to play the casino with our juiced cards. Tim's normal expression was one of a stupid stare, so him staring at the cards in the blackjack shoe wouldn't raise any suspicions.

It was better that Roman and I were not spotted winning. Casinos really don't like the same people to win too much. They make enquiries about you and if necessary bar you from the casino if you're a regular winner. I had to hire people for a ten percent cut to go to take the money out when Tim found juice.

One of our take-out men took his winnings in the form of a cheque from the casino. When I banked it they stopped it — "orders not to pay". I sent him back to change the cheque for cash but they refused to do that. In the end I hired a lawyer who threatened the casino with a writ and eventually they paid up. But it was an interesting exercise to me.

By law, if a punter stops a cheque that he has given to the casino the police will prosecute him for fraud. If the casino stops a cheque they have given to a punter they are never prosecuted, no matter how lame their excuse about being suspicious is.

In those days the casinos used to keep the cards for a year at a time. When the cards got dirty the trainee croupiers used to have to wash them and let them dry and put them back They were so stupid. It sounds incredible doesn't it. They were losing so much money in Charlie Chester's that they decided the cards were crooked and they called in Scotland Yard, who took the cards away to the forensic laboratory which photographed the cards and blew the photos up on a projector in order to check them. They sent back a report to Charlie Chester's saying the cards were completely clean. You know what Charlie Chester's did then? They put the cards back in the casino and played with them.

One day at Curzon House, the really exclusive casino in the West End where I begged to work years earlier, two of my take-out men were taken upstairs by the casino "security" staff who were suspicious as to why they kept winning. They threatened my men, saying that unless they told them how they kept winning they would have their arms and legs cut off. Now Curzon House was probably the most expensive and exclusive casino in London. They had been checked by the Gaming Board and been given a licence to run a casino in the heart of London's West End. This was a licence to make huge amounts of money at no risk but when they discovered that people were winning consistently they threatened the winners with violence. My people took the threats seriously enough to spill the beans. As a result the juiced cards were taken out of circulation in the casinos and the coup was at an end.

Afterwards, Roman and I discussed whether such an expensive and exclusive casino would have actually hurt the men. I said that they would not have gone through with it — it was all a bluff. If the men had gone to the police, nothing would have happened. But Roman said that he was not so sure. He said that these

casinos are all crooked and would do anything to protect themselves, even going as far as violence. The law treats the threat of violence as punishable, as if violence was actually used; if the casino were ruthless enough to do that who knows where it would have ended. I now think that Roman was right.

AS USUAL, THE COUP PUT A LOT OF MONEY IN MY POCKET all of which flowed out again very rapidly. Rigna got very upset at the way that I spent money. She urged me to save some, or put some by. That wasn't my way. I couldn't see myself buying a life insurance policy or opening a deposit account. I was nicking cash and I kept it in cash. When you keep cash it vanishes easily.

After the Curzon House incident, I decided that I should stop juice in the casinos. Never overdo a coup. If you do you'll get caught. Time, I thought, to leave London.

A New Zealander I'll call Johnson started a casino in Southampton called the Silhouette. Johnson used to sleep there because everyone who worked for him kept cheating him. The Silhouette was making a lot of money but because everyone was cheating him he never saw any profits. Johnson didn't know how to run it.

He advertised for people to work in the casino as croupiers. I spotted the ad, made some enquiries, thought that I could make some money and Southampton was far enough from London so I applied. At the end of my interview Johnson said, "Look, everyone is cheating me here. I'll pretend to employ you as a croupier but you will really be the boss. You will be my eyes and ears here and will tell me who is cheating me." I agreed.

Roman also applied for a job and was employed, but as manager of the casino. We both started on the same day and when Johnson introduced us we pretended not to know each other. I got digs with Roman in Newmarket.

Getting digs with Roman had its advantages — he was a good laugh — but also had disadvantages — he was in love with whores. Not with any specific whore, but with all whores. After work, when I wanted to get a good night's sleep, Roman would be looking for new prostitutes. He knew how to get them and often brought back two or three to our digs. This was fun for me at first but after a week or so I tired of it. Roman didn't — he was addicted to prostitutes and had them in all sizes, flavours and colours.

While we worked in the casino, we met a chap called Ron who was employed as a troubleshooter for a big chain of betting shops. Ron was a degenerate gambler. He was a loser. He would never have any money. As soon as he got his wages, he would be down the casino losing them.

Ron propositioned me. He said that he was always losing his money in the casino, he hated Johnson and could we do some skulduggery together? I asked him why he came to me. Ron said that he could see that I was slippery and sharp and because I was the best dealer that they had seen in Southampton. He asked if he and I could do some business.

I said that we could but laid down some strict conditions. I said I would pass him some chips. Whatever I handed off to him I wanted fifty percent of it. I told him

that he had to be sure what we were agreeing. If I gave him £2,000 during the night, when I came round to his house I wanted £1,000. I did not care what he did with the money. If he played it up to £10,000 I would still only want £1,000. If he lost it all, he would still have to find my £1,000.

I told Roman that we had found one scam already. I told him that we would pass off a couple of thousand pounds a night to Ron, and that I would do all the skill and share the money with Roman who would mind me.

I would pass off to Ron a couple of thousand pounds a night. Ron would invariably lose the whole lot in the casino so Johnson lost nothing as a result of this scam. Only Ron. I did try to suggest to Ron that he should not gamble with some of the money that I slipped him. That way he could make a profit. He told me that he had thought about that but he hated Johnson so much that he had to gamble in order to stand a chance of winning.

Johnson continued to complain about the casino losing money. I used to bring in gamblers from London and made sure that they won. I explained to Johnson that these were games of chance and he could lose. I said that if he wanted to, I knew someone who could give us some crooked dice and that would knock the punters out. Johnson was horrified; he told me that he did not want to do anything crooked. I suggested that Johnson should stand at the tables to watch.

Roman and I used to set up a dealer from time to time, get him to do a bit of skulduggery for a fee and then make sure we caught him and fired him. That kept Johnson happy. But we overdid it and after a while the only people left were Roman and me.

Johnson told me that he had been thinking carefully and it had to be Roman who was stealing from him. I assured Johnson that Roman was one hundred percent straight but Johnson was not convinced. He told me to fire him but I pointed out that I was only a croupier and I could not fire the manager. In the end, Johnson fired Roman. I was the only one left. It was no fun without Roman so I left. Johnson never knew it was me.

The place was taken over by a Greek guy called Andy. He played it straight and refused to steal a penny. In the end, Johnson made his profits.

When I was working at the Silhouette, Roman and I had the opportunity to meet lots of gamblers. Ron, who was a trouble-shooter for the gambling chain, also knew all the gamblers and could steer them in to us. We used to play these gamblers in hotels, their own houses and even in their own casino in Bournemouth.

One day, I sat down with the poker players, played with them, switched their cards for my marked cards, played for about three hours and won their money. They went to get more money and came back for more. Roman helped me.

We had another man on the team whose job it was to put the straight cards back again at the end of the game. We didn't want to leave our marked cards behind in case anyone found the marks. Now, when cards have been played with for hours they feel warm, so we could not swap the warm marked cards that we had played with for cold cards. It then became necessary for there to be another

game going while the main game was going, in order to keep the cards warm. I always made a point of mixing up the cards on the table after I had won. Then those cards could be scooped up and switched. Gamblers always like to take their own cards back with them and I always made sure that they took clean cards with them. When they lose, they have to look for an excuse and they will spend time looking over the cards for marks.

Roman and I once took a lot of money off a car dealer at playing cards with juice. He was a horrible man, the most obnoxious man that I have ever played with. In the end I popped him. He asked for credit to carry on playing. I gave him £15,000 credit. I didn't mind. I was playing with juice and he could have all the credit that he wanted.

After he lost again he vanished. I spent some time trying to chase him up. He didn't take my phone calls and when I turned up at his east London second-hand car dealership unexpectedly, he ran out of the back door as I came in the front. It was as well that he did because I would have given him a smack.

Whatever I tried, he avoided me and he never did pay up until I asked Tim to go and sell a car to him. I lent Tim my Rolls Royce for this purpose, then worth about £18,000. I told him it was worth about £6,000 but to get as much as he could; I would take £5,000. I decided against telling Tim what I was up to; I felt he would be more believable if he didn't know. I hid across the street and watched Tim, wearing his most stupid face, go and try to negotiate the sale; there was a lot of agitated talking. I could see the car dealer getting his money out ready to pay Tim. I burst into his office and grabbed the car dealer's cash. It amounted to £12,000 and he had no choice but to give it to me, especially when he realised that Tim was my man. I am sure that he expected to get hit after he handed the money over. As much as I wanted to, I never laid a finger on him. It could have given him an opportunity to go to the police and claim that I had robbed him. Better not risk it. Shame.

As Tim and I drove away in the Rolls Royce with the £12,000 safely tucked away, I asked him how much he was going to sell my car for.

"I was in the middle of doing a good deal for you, a very a good deal, Syd," he said smiling with that stupid grin of his. "I got him up to £3,000."

I do not think that many other people to whom he owed money actually got what he owed them. I read in the papers that several years later he got shot. Someone just drove up to him and shot him. I have no idea what he was shot for. He must have popped somebody, I don't know who, but whoever it was collected his life for the debt and made sure that he would not do it again.

ROMAN AND I WERE GETTING TO BE KNOWN AS GAMBLERS. We were running out of marks. We needed to go to a place where we were not known so Roman and I went to Canada.

I told Rigna that I would have to leave her for a few months. She was unhappy because although we were living together she hardly saw me. She looked after me, kept the flat immaculate, cooked for me every night, whether or not I would

be there to eat, and more often than not threw away the food she made. Rigna was tearful but that raised no serious objection to me. I got on the plane to Toronto and waved goodbye to Rigna at the airport.

It was in Canada that I devised a method of cheating at backgammon. This is how it happened. I read in the paper that a man had won the "pick six horses" three times in a row. He had won a huge amount and that was good. It was good that he was a gambler and it was good that he had a lot of money. He had altogether five or six million dollars and he was a hairdresser by trade. I sent Roman in to get to know him. Roman told the hairdresser that he knew an English-man called Syd who played backgammon for big stakes. Syd had untold money, even more than the hairdresser. I was the world's worse backgammon player and it would be easy to take all my money.

Roman taught the hairdresser how to play good backgammon. I played the hairdresser and took his money. He accused me of cheating saying that I had used crooked dice. I told him that he could use my dice and I would use his dice. He went to get some more money, played with me some more and lost again. I asked him if he was happy or if he thought the dice were crooked. He apologised to me and we arranged to meet again.

At the next game he brought five friends with him. I have always used three key signals with my team. "Tom" meant danger, "George" meant that everything was OK. If I were to rub my hand across my forearm it meant "Let's get out of here as soon as possible."

I saw the number of people that the hairdresser brought and said to Roman quietly, "It's Tom". Roman said, "No way, it's George, no problem".

I started to play backgammon, and as usual I won. But this time the hair-dresser did not want to hand over the money he had lost to me.

He said, "OK you won; but I'm not happy how you won. You done something. I don't know what you done but I'm not happy with the way you won so you are not leaving here with the money. I got the money, and I am not handing it over. I got my friends here and they say you're not getting the money. In fact we think that you owe me the money you took last time."

Now he was right to be unhappy with the way I won the money. I had cheated. I had managed to acquire some crooked dice. They were classic red casino dice with white dots but they had iron behind the ones and behind the sixes. I had a huge magnet that I kept strapped to my left thigh inside my trousers.

The magnet did not show under my very loose fitting clothes. Whenever I wanted to get a double six or a double one all I had to do was move my leg so that the magnet was under the table where I threw the dice. When my leg was up, the dice were crooked. When my leg was down, the dice were straight. I had to throw the dice from a cup and keep the cup covering the dice until they came to rest because the magnet was so powerful it made the dice jump. If he had seen the dice come to rest he would have known that the dice were crooked.

If I turned the magnet with one side of it up, the dice threw double sixes; when I reached inside my trousers and turned it over the dice threw double ones.

Both his dice and my dice were crooked, in case he asked to change them over. I threw my dice directly in front of me, as the magnet was fixed to my trouser leg, with only the table top intervening. He could throw his dice anywhere on the table as long as he did not throw them directly in front of me. The magnet was so far away from where he was throwing, it would not have made any difference to his dice. That was why I was always happy to let him throw with my dice or use his dice.

The whole situation looked nasty now. Roman and I were outnumbered. Clearly we were going to have not only our money taken away but also these villains were going to teach us a lesson. I put my hand under the table and down my trousers. I grabbed the magnet. It weighed about eight pounds and was about nine inches long. I never carry a weapon but on this occasion I had something to hand. I smashed the hairdresser in the face with the magnet so hard that it left the impression of the magnet in his face. The others were taken by surprise that we had started first. We fought viciously. There is no point in fighting any other way and if we hadn't fought we would probably be dead. These boys didn't fuck around. Finally Roman and I locked them all in the kitchen and ran away. We had done some damage but not before Roman and I got several hard smacks each. My fingers were twisted, Roman's face was beaten up and we were both bleeding. This was not an elegant end to the coup. I hated it when people started fighting. The whole point was not to rob someone or use violence but to persuade someone to willingly hand over their money.

That was the most dangerous thing that we did because of the violence. It was the only coup that ended in a fight.

I got the crooked dice from a man in Buffalo who made them almost as a hobby. He made shoes with mirrors in them, shaved cards, loaded dice. He sold them to me for only $500. I still have them and the magnet and they still work fine.

After the fight, it was time for Roman and me to get back to London. Rigna was waiting for me — I was happy to see her again.

THE TIP

THAT LAST BACKGAMMON CON SET SYD THINKING. The hairdresser must have become suspicious because there was something in the build up that was wrong. He had managed to figure out that Roman was not his friend and that Syd was cheating. It was not enough to cheat perfectly. The whole scenario had to be unimpeachable from start to finish. Just because you haven't been spotted cheating doesn't mean, as Syd learned, that you won't get caught.

By now, Syd was back in Britain where Margaret Thatcher had just been elected as leader of the opposition. He had his hair cut short and neat in the fashion of mature men — the seventies were ending. The glitter generation were being pushed out of the nest by the smiling ruthless yuppies. There were "entrepreneurs" popping up everywhere. When she became Prime Minster a few months later, Mrs Thatcher encouraged everyone to break free from the security of cocooned employment and take their fortunes into their own hands. Those people, who a few years earlier went into a job because it was a job for life, were doomed.

There were lots of them. Many people, perfectly capable of running an enterprise of their own, prefer to have their wages paid and spend time with their friends and their families. They get "jobs for life" working for the post office or for one of the big banks. Historically these institutions have gone to schools and colleges recruiting bright young people with the offer of a lifetime's security. Many people sneer at the gold watch for forty years service. But many more people want the safety of knowing that they can work for that long for one benign employer without ever having to attend another job interview or risk losing employment. There are many young people who feel like this.

Those very institutions which had wanted safe but intelligent, well-educated staff whom they enticed by offering a job for life in lieu of higher wages were, under the leadership of the radical Mrs Thatcher, about to break their bargains. There were fights and arguments and the power of the trade unions was smashed which made the bargain breaking easier.

In justification, leaders of business wrote long tomes about "management". Industry leaders used the broken power of the trade unions to their advantage by sacking large numbers of people. Many communities, dependent upon one industry, became shattered and would never recover. Striking miners threw bricks at the men in blue and huge numbers of police enforced the newspaper publisher's right

to employ non-union labour. Within a few years there were no more miners but several very wealthy newspaper barons.

In America, unblemished by awkward unions, the economy went from strength to strength. Everything was fine except for the veterans of the Vietnam War, who were shamefully ignored or spurned. Having sent the young men out to fight, America ignored them when they came back maimed crippled and mad.

There was a mini boom in property in London; if Syd had turned his talents to property developing, he would have made a fortune. But he never held on to his capital long enough to do this and any bank unwise enough to make him a loan would have regretted it before long. Of course, he could have bought a house using some of his extensive cash winnings. But a house can't be hidden in a safe deposit box or packed in a thin brief case.

In the rest of the world, the Soviet Union and the Eastern bloc appeared a real threat to western democracy, while Islamic fundamentalist terrorism emerged. But good old Britain just lurched from one economic crisis to another. A couple of years into her term it was clear that Mrs Thatcher had not woven her magic and income tax rates were barbarously high; some people were paying ninety-five per-cent of their income away in tax. Husbands died and widows had to sell the home that they had lived in all their married life to pay huge amounts of estate duties. Everything seemed a muddle and many people simply had no ambition — what was the point if everything you worked for and risked is taken away by the government?

Syd had no such qualms. He had never joined the income tax system, even though legally the "profits" of his scams were taxable — the government takes its share of everything, even fraud.

Syd and Roman left Canada just in case there were comebacks, legal or illegal. They found Britain confused in its economics; it was in the grey period before change. Businesses could still survive and make money but no one felt really prosperous or really poor. This was when my partner and I hung our new brass plate outside a door of a building in Little Portland Street, confusingly numbered 37 Great Portland Street, and waited for clients. I needed a secretary. The people from whom I bought my offices did not need their secretary, a young, inexperienced, pretty girl. I hired her. She had a boyfriend called Syd.

Has anyone given you a great tip recently? If so beware. Syd could be behind it.

The tip is a classic scam and rather satisfying in the way that it targets people who end up getting exactly what they deserve.

ROMAN AND I DEVELOPED "THE TIP" in Canada but perfected it in London. The tip is a poker con. I had better explain head to head poker, which is the game involved in the tip. There are only two players in the game, playing each other. They take it in turns to deal. Each player gets five cards to start with, and can exchange or "draw" up to three cards each. You can only change cards once. Bets are placed and raised. The cards are not exposed to the other player until the

other player "calls" his opponent, which brings the betting to a close. The winner is the player with the best hand. You don't have to understand all the rules of poker to understand the tip. All you have to know is that certain combinations of cards beat others so that, for example two aces beats two kings.

People usually bet on stronger hands, but not always. Sometimes they bluff to see if the other player has got the confidence in his hand to match their bet. If he doesn't match the bet you win all the money that has been bet on the hand so far. If the players have the same, for example three of a kind, then the one with the highest set wins, so that three kings beats three fours. If no one has a set or a combination the player with the highest card wins, so that an ace beats a king. If they both have aces then the one with the next highest card wins. You get the general picture.

I got the idea for the tip from a Canadian called Eddie the Knife who is now dead. He was found frozen solid in the boot of his car in Canada with seven bullet holes in his body. The body had been there for four months. Eddie had upset someone.

This is how the tip works. Roman would meet a suitable punter and get round to gambling and talking about playing cards. He has to establish that the punter knows how to play. Most people who can play a little poker always think they are experts. Roman cultivates the "mark", giving the impression of being sharp, clever and quite well off, but not with any great fortune.

Then Roman would say to the mark, "What I am going to say now I never want you to repeat again to anybody. I want your solemn oath that when I tell you this story no matter what your decision you will never ever tell anybody."

It is terribly important to swear the mark to secrecy.

"OK, you can rely on me."

"OK" says, Roman, who proceeds to give the mark the tip. "I'll tell you. I have an American friend who is a lunatic gambler. He has got fortunes. He's blowing thirty, forty, fifty grand a night in the casinos here and it's making me sick. I want to play the guy but he won't play me because he's my friend. If I could sit down and play with him head to head I would take all his money — he's such a bad player, but he's my friend. He likes me to go out with him. He won't play poker with me because he's my friend. He keeps calling me to go with him. He thinks I'm his friend. He goes out with hookers and gives them £2,000 each; the man is a lunatic and he's such a bad player. Now the only game he plays, because he's American, is five card draw poker."

The mark now thinks that he is part of a scam, not the object of one. He listens intently.

"What I'm going to do is this: I'm going to sit beside him and I'm going to tell you by a signal every single card that he has in his hand. When he gets his first five cards I will tell you whether he's got a pair, three of a kind, nothing or whatever. When he picks up his cards I will give you exactly what he's got in his hands so you can't lose. I'm going to bank roll you £20,000 as playing money, then I'm going to give you ten percent of what we win."

Roman mentions that the mark is going to Las Vegas or Monte Carlo in a few

days time so they have to take him on quickly. Roman offers the mark ten per-cent. The mark usually asks for fifty/fifty. Roman reacts by saying, "fifty/fifty! You're not doing anything. All you'll be doing is picking up the cards, putting the money into the middle. I'm giving you the money; you can't lose — you're going to get ten percent of whatever you win."

Nine out of ten people will say that they want fifty percent. My partner argues until eventually the mark offers to put in half the money. In the end my partner gives in and lets the mark put in half of the money. Roman has to give the mark the impression that it is so easy he only wanted the mark to get ten and he is a bit sick about having tipped off the mark.

The mark is so pleased that he is no longer on a ten percent "salary" and that he is now a fifty percent partner that he loses sight of the fact that now he can lose. Instead of playing with our money he is now putting up his own money that he can and does lose. His greed makes him put his own money into the ring and when he does this he has already lost.

Roman signals my hand to the mark like this. A clenched fist is the signal to show that I have nothing in my hand; one finger raised shows that I have got one pair. Two pairs are signalled by the thumb sticking out, three of a kind, flush, straight are signalled by two, three, four or five fingers. The signals were easy to learn. During the game when I get a nothing hand, say jack, nine, eight, seven, four, I bluff. Good poker players never show a losing hand unless they have to because it shows that you bluff. I always show my hand, whether I have been bluffing or not. The mark soon realises that not only am I a bad poker player but I am also an idiot.

I show my hand to the mark because I want to show that I am a bad poker player and that my partner is giving reliable signals. The mark might be a bit suspicious to start with but when he knows that Roman is signalling correctly he relaxes and gets more and more confident.

During the game when Roman gives the signals he does it in such a blatant way that when the mark sees him, he looks faint. The mark looks at everything in the whole room except at Roman. He is scared stiff that I will catch on to the signalling.

During the game when I go to the toilet the mark says to Roman:

"You cunt, you cunt. Don't make it so obvious — he'll see you."

"Oh," replies my partner "the guy is an idiot — he won't see me."

"Don't make it so obvious."

The mark is terrified that I will get onto him by seeing my partner doing the signals. "Oh my God," the mark is thinking, "He's going to catch him any minute because the signals are so blatant."

The mark is always frightened that he is going to be caught cheating. So at first he tends to be a little apprehensive. He will start off slowly because he might not really believe that my partner is going to tell him what cards I am holding. Poker players are a suspicious lot. But after we have played a dozen hands, the mark cannot wait to throw his money in because now he knows. He's getting the right signals.

Finally, after the mark has won just under half of the money, it is my turn to deal. I deal the cards out. I get five cards; I pick them up quickly. I look at them but only glancingly. My partner picks them up and looks at them after I put them down.

The mark has got ace, king, four, five, and nine. He throws away the four, five and nine and keeps the ace and the king. He draws his three cards. His hand ends up ace, king, queen, jack, and eight. Me? No cards, thank you. Roman gives the mark the nothing sign — the clenched fist. I have got nothing and the mark knows that I have got nothing.

I do not look at my hand again. Roman picks it up, looks at it again, and gives the "nothing" signal — a clenched fist very strongly — even more strongly than usual.

I then say "You know what? You're so lucky, I've been unlucky all night, so this is the time to make an end. How much have you got in front of you, £26,000? That is the bet."

My partner is giving the mark the nothing signal. The mark does not think that he can lose. His ace will beat my nothing because even if my nothing is an ace he's got the next highest card, a king, and even if my next highest card is a king he's got a queen, and so on. He pushes the £26,000 across to the middle of the table and sees me.

I say, "Flush."

That throws the mark. Has Roman let him down?

Roman says, "You ain't got a flush, Syd — you've got nothing!"

I say, "Don't be silly. What do you mean nothing? No, look, ace, king, queen, jack, nine! Oh it's a nine of hearts and I've got all diamonds. Ace, king, queen jack and nine. Jesus Christ I've got nothing! Well, fucking hell, I've done it wrong."

I pause as if I am ready to concede the whole pot. I wait a second and then look up at the mark, "What have you got?" I ask.

The mark says, "I've got ace, king, queen jack and eight!"

My nine has beaten his eight!

I have won £26,000 with nothing in my hand. The mark cannot believe it. Now I've been bluffing with nothing all night, trying to win with tens and eights. But I say, "Flush. — I've got a flush."

I have won and I am pleased but suddenly I get tense and suspicious. I say, "Wait a minute how could *you* call *me?*"

The implication here is easy to understand for a gambler. I've made a big bet thinking I had a flush. My opponent knew he only had ace high. Why was he prepared to bet all that money on such a poor hand, a nothing hand? My question is tantamount to asking my opponent if he is cheating.

The mark usually says, "Well you know you bluffed lots of time before with nothing."

I say, "Oh yeah that's right, oh yeah that's it, lucky me, I'm so lucky" and all the tension in the atmosphere disappears.

How do those cards get in? I do that as I'm playing — that part is easy. I have

a deck of cards that are loaded with the cards so that they come out in the right sequence. When it is my turn to deal, I call for a new deck of cards. I shuffle them. I am a poor shuffler but the hand is quicker than the eye. Only the bottom cards are being shuffled. The cards that I have loaded into sequence stay where I put them.

In the course of the evening, I have from time to time, called for new cards when it was my turn to deal. There would be nothing unusual in this. When I break open the seal on the new deck, the mark does not know that I have previously opened and resealed the pack.

Now I go to the toilet leaving Roman with the mark.

"You fucking lunatic that's my last lump of cash — you blew it! What did you bet all that on nothing for? Look at the money he's got. He's always got a brief-case full of money and now he's got our money too. You were winning £15,000 and in one fucking hit you had to throw it all away. You could have ground him out for three or four hours and got the whole case full of money — and he's got more in the hotel safe."

The mark says, "I'm sorry, what can we do? Play again tomorrow?"

Roman reminds him that they cannot — in the course of the play I have already dropped the fact that I was leaving next morning for Las Vegas. Usually the mark offers to go home for some of his own money.

The mark always comes back with £15,000 or £20,000. I always say I will not sit down if the other player has not got enough money. So if the mark comes back with £5,000 that's not enough money. I am not going to stick up my bankroll against £5,000. So they've got to get at least £15,000 or £20,000. So they can come back and play, sometimes they come back three times, in fact one punter ran up the stairs to get there before I had gone.

The second time round I win immediately on the very first hand and again, of course, I cheat, but this time I win with a pair of aces. I play the hand face down so that no one can see the last card that I have drawn. The mark has a pair of aces and I win because one of my other cards is higher than his. The unseen card gives me a pair of aces and until then I have nothing.

The only weakness in the tip is if the mark sees me working the cards. But he never sees anything. It is impossible because the hand really does move in a way that the eye cannot observe.

There has never been a mark who has won any of my money. A few times while shuffling the cards to deal the hand, I've inadvertently shuffled them properly and the hand does not come out right. But as soon as I pick up the cards I know it is wrong, so I put my hand flat on the table. That means something is wrong. I play it as a straight hand, and then wait for my next deal. My partner knows by looking at my hand it has not come out right and then we have to wait for the next hand that I can deal.

When the mark blows it for a second time, Roman reacts by saying it was bad luck. Previously he had shouted at him but this time the mark has the consolation at least that Roman is not shouting at him. Roman's standard patter was, "That

was on. I mean you were twenty-five to one on going in there! What a dirty lucky mother! But still he ain't going anywhere. We've still got him."

The mark usually says, "Well, what else can I do when I get a pair of aces?"

"You couldn't pass, you had the guy dead, you were right that time, John, you were right. You know that was just bad luck — a million to one shot, but you did the right thing."

Now you cannot slag the mark for doing the right thing, because in a normal straight game he had to play the aces. I don't know if the mark ever stops to think about it afterwards. No one has ever come back and said that we have conned them. Roman sometimes met the mark a few months later.

"I've forgotten about it," says Roman, "Don't apologise. What you did there was crazy, it's best forgotten, don't even mention it because it makes me sick every time I think about."

When I am playing poker in the tip I pretend that I do not want to be playing cards really. All I want to do is to get out and get a hooker. I'm getting drunk. I'm already drunk. I put brandy behind my ears, rinse my mouth with brandy and act generally drunk. All I want to do is call a hooker. Roman constantly assures me, "Yeah, yeah, I'll call you one in half a minute."

The mark gets terrified that I will leave before he has got my money. "Don't call a hooker!" he mouths at Roman.

"Now where's that hooker then?"

I want to get out because I'm losing — what is the difference — I'll play again tomorrow night but in Monte Carlo. The mark and Roman are doing everything in their power for me not to call this hooker. "Her telephone is busy," or "She'll be here in an hour."

They always come back once. One mark came back twice and one mark actually came back three times. On the third time, he came back with French francs — he was going to France on holiday with his family and couldn't wait to lose his holiday money.

When I play the tip I always play a soft guy, never a hard guy. Sometimes I pretend to be gay. I try to give an impression of being a fool. I never give any indication that I'm a hard man or that I'm a gangster. This makes the other guy at ease — he has got nothing to worry about. I won't start any trouble.

Roman has to give an explanation about how I, the mooch, get all this money that I play with. There is always a story that we have to work out before. I sometimes play an American, or a Canadian. My father is in property. I've got to be rich. Most of my money is from my father and I can have whatever I want. If I lose £60,000 or even £100,000 all I have to do is give my father a call and there is more money on the way. There is absolutely no limit to how much money I have. The punter only meets me once or twice before we play.

I always get it in the story that I am leaving tomorrow. When he loses I tell him not to worry as I will be back in a month. I ask for his card, and tell him I will give him an opportunity to win the money back when I return.

THE SWEETEST GUY I EVER DID was, well, let's call him Joe. Joe was a book-maker, and an unusual character in that he was a gambling bookmaker. Most bookmakers try and make a round book — they're more like mathematicians who work out the odds so that they invariably get a return. Joe had a gamble with the punters and did not play the percentages or lay off bets. His wife was the driving force behind him. For her age, she was a tasty lady: lovely house, lovely home, lovely jewellery, lovely family, but a greedy bastard. She was greedier than her husband — if she had come to play she would have brought £50,000, not £20,000. His wife was an absolute dog. She was in her forties and would fuck anything in trousers.

Roman laid the story down and booked a table at Grosvenor House in Park Lane for himself, his girlfriend, me and my girl, and Joe and his wife. I arrived at Grosvenor house in a limousine.

When I was at the dining table, Joe, and his wife, who also knew the story treated me royally, because they looked on me as the mark. I had only spoken four or five words to Joe's wife (who I shall call Jean) when she asked me, "How long are you here for?"

"I don't know, not as long as a week, maybe two or three days at the most."

"Well," said Jean, "my husband's a bookmaker; did you know that?"

"No, I didn't."

"We've heard all about you and you can have as much credit as you want," and she gave me their card. I got talking to Joe, but nothing about gambling was mentioned.

We had a nice evening. I enjoy company, even the company of people that I'm going to con. After I had gone, Roman asked Joe what he thought. Joe said he couldn't wait. Roman said that he would put the money up and offered Joe ten percent. Joe said, "No way — I'm going to put up all that money and I'm not going to go even partners with you. I'll put up all the money and give you ten per cent." Roman said, "No way," and left it at that.

A couple of days later, Roman got the expected telephone call from Joe. He wanted in on the action. If he didn't then Joe would go it alone with me. Joe pointed out that he could put up a lot more money than Roman could. Roman said no, he cried and screamed, but in the end Roman capitulated, and told Joe that he needed the money and agreed Joe's terms.

I was then staying in a suite at the airport hotel, because I was supposed to be flying out the next morning. Joe and my partner came to see me in the hotel and we had dinner. After dinner Roman got the conversation around like this:

"By the way — you know what a player you are, well this guy, Joe — he's even worse than you."

"There's nobody worse than me! Tell you what, let's go up to the Curzon House and have a good game of poker. I'll bring twenty grand, you bring twenty grand and we'll knock them all out."

"Aren't they too good for you guys?" said Roman.

"No," said Joe, "I don't really like to go in there with a player like you."

"They are not too good," I said. "We'll show them."

"Say," said Roman, "why don't you two have a game? That'll be a terrific game."

"Yes," said Joe, "How much have you got?"

"Forty thousand. What about you?" I asked.

"I'll have to go out and get it," he said

"Well, bring a minimum of £40,000, otherwise it won't be worth it," I said.

"OK, I have to go and get the money," said Joe.

"While you're out," I said, "will you buy the cards?"

Joe and Roman left my room and pretended to go and get the money that Joe had all along. They did not want to make me suspicious by having it with them so they had to drive around the airport for about thirty minutes and then came back to play. Joe brought the cards, and he also brought a gun with him. He put it in his jacket pocket. I think at the back of his mind he may have thought that we were going to rob him. We played in my suite. We each put the money down and changed it for chips.

I always change the money for chips. Cash is hard to count, and when you do count it out to make a bet you start realising that it's money you're playing with. I gave the excuse that my girl was sleeping in the next room (she was not), and if she came in, I didn't want her to know how much I was playing with. The story about her was that she wanted me to spend the money on her not on gambling.

That is the reason why you play with chips in the casino and never cash. Chips are more convenient, easy to count but most important of all the casinos want punters to feel that they are merely playing a game with tokens not losing large amounts of cash. I wanted my punters to have the same feeling. Ten chips on a pile look fairly innocuous and would not prevent a small-time gambler from think-ing about risking them on a game (where the odds are loaded in favour of the casino) in the hope of winning some money. If, however, the same gambler were to put down £10,000 in £10 notes — a thousand notes — he would soon have second thoughts. Even in £50 notes £40,000 is the size of a large fat brick. That would make most people think twice.

After about fifteen or twenty minutes, Joe was winning. Now he did not even think about the gun; he has taken his jacket off, and hung it up. I knocked him out at two o'clock in the morning. He must have phoned twenty people for money and no one had any cash. He could only raise £5,000. I said that I wasn't going to play for that, I was going out, and would put my money back in the hotel safe. He was frantic because I was leaving in the morning. But he couldn't raise more than that in cash, so I refused to play any more.

When I took his money he couldn't wait to have another game. As I had al-ready laid the story on him that I was leaving tomorrow, I couldn't decide to play him again tomorrow, because that would look wrong. Even today he asks Roman "Have you ever seen that Syd? Where is he?"

Joe is still ripe for me now, but of course I have retired. If he reads this book he'll now know, won't you Joe!

The kind of people who get caught in the tip are greedy crooked gamblers. They are people who cannot pass up the opportunity of stealing my money. They have to have a little larceny in their heart. Most people have. It is dangerous to work it with these people, but I go on the assumption that they will never find out that they have been conned. Really, that is the best type of con trick — one where the victim never knows or even dreams that he has been conned.

AS ROMAN AND I WERE PERFECTING THE TIP, Bushey and Bruce, two Australians in London, were perfecting shoplifting. They were pickpockets who operated in London and were sharp people. I think that they were the best pickpockets that the country has ever seen. They were certainly the best shoplifters. They did not shoplift from Marks & Spencers, but they targeted very expensive jewellery shops.

This is how they worked. They would target a particular piece of jewellery. They would usually see it in the window and surreptitiously take photographs of it from as many angles as possible. They would then have an identical copy piece made up in Hatton Garden. They always used real gold, but had the stones made up from zirconium. The cost was several thousand pounds, which would be a fraction of the piece that they had targeted. They would then go into the jewellery shop with their girlfriends and switch the fake stone for the piece with real stone while pretending to buy it. The jeweller then unknowingly returned the fake to stock and frequently never found out that the piece had been switched. I often wonder how many fake pieces the jeweller sold after a Bushey and Bruce "switcheroo".

I loved Bushey, but Bruce was also a very nice guy. I was fascinated with the concept of switching something real for something fake. I had never thought of it. We used to pal up together. Roman and I knew what they were doing and they knew what we were doing. They admired how good we were with the cards and we were impressed with how clever they were picking pockets. They could lift something out of a pocket and you would not feel a thing. They were unreal. They were both big guys and had enormous hands. That made me wonder how they could pick pockets so delicately but they did.

They used to steal from tourists in the middle of London. They dressed up exactly like the most extreme kind of tourist, with cameras around their necks, shorts, loud shirts and all the other paraphernalia. As they mingled in the crowds, they lifted wallets, cash and traveller's cheques. They always seemed to get a lot of traveller's cheques that they cashed straight away at different outlets. They made plenty of money. They were spenders like us. They used to go to work every day.

They were a strong pair together. They were the best workers (that is to say the best at getting hold of money) that I have ever seen. And they always paid their debts on time. Most criminals never pay their debts without a hassle. If you lent someone money, you knew that you would have to ask dozens of times before you got it back. But with Bushey and Bruce, if they borrowed £500 then the very next time they saw you, before they did anything else, they would pull out

the money they owed you and pay you.

They worked with their girlfriends. Roman and I never did that. Roman rarely kept the same girl for long. He loved going out with prostitutes and spent a large share of what he made on them. I only ever used one of my girlfriends in a coup and that was Rigna, who brought the shoe into the casino hidden in her bag. Roman never had a girlfriend for any length of time. His idea of a good treat was to hire two or three whores for the night!

Bushey and Bruce's shoplifting was the inspiration for Roman and me to pull off a great coup, rather like shoplifting. Roman and I couldn't do a switcheroo under the eagle eyes of a jewellery shop assistant. You had to have years of practice and be very skilled to do one of Bushey and Bruce's switcheroos. But we could con the jewellers into handing over some jewellery given the right conditions.

We hired a Rolls Royce, changed its number plates and borrowed a two-year-old child. We borrowed the child for just half an hour for two days running with its mum's consent. Mum had been given a few pounds by a third party, who explained that someone needed the child. Of course no harm would come to the child.

Roman dressed up as a chauffeur. I dressed up as an Arab. A girlfriend of mine dressed up as an Arab's wife. We went in the car, with the child, to a very expensive jeweller. I am not going to tell you which jeweller, nor even tell you the country where this took place because all cops have long memories and I am still alive.

Roman parked the Rolls Royce outside the jewellers, opened the doors and I got out dressed in my Arab robes with my wife, also well covered, and the child and we all went into the shop. I carried an expensive briefcase that I placed on the counter. I asked to see diamond necklaces. They showed us their most expensive items. The Arab and his wife argued over whether the necklace priced at £73,000 was nicer to look at than the one at £78,000. The child sat quietly on a chair as good as gold. After a long discussion, we gave the necklaces back to the salesman and went to the door, but I suddenly remembered that we had to buy a present for the nanny. We went back in. My wife chose a Rolex watch, not too expensive a model, and to pay for it I opened up my briefcase. It was absolutely full of piles of cash. I chose one of the piles, counted out the money for the watch, paid for it and left, promising to return tomorrow about the necklace.

Next day the Rolls Royce pulled up and parked outside the shop. The chauffeur stayed in it, as did the wife. I got out with the child and my briefcase and went into the shop. I put the briefcase and the child on the counter. Of course they remembered me. I asked to see the necklaces again. Looking at both of them carefully I decided that the cheaper one was the one that my wife wanted. I asked if I could check it with her — she was still in the car. The child was sitting quietly. I left the child and the briefcase in the shop, took the necklace into the car. I closed the car door and started talking to my wife. When there was a suitable gap in the traffic Roman drove off. The briefcase was locked but it was empty. I left a note in the child's pocket with his address. That kid was a champion.

It was a good coup but the trouble was that this was the sort of coup you could only do once, because the word gets out. The next Arab who walked into a jewel-

ler's shop with his wife and a kid would be arrested.

One day I got a phone call from Bushey; I had not seen him for a while. I asked him how he was. He said that he had run away to Spain. Bruce had been arrested and while in jail had grassed Bushey and eight other people. Apparently Bruce was entirely unrepentant about this. He had grassed up his best friend to get some time off his sentence. They had both been arrested together. Both got bail but while Bushey had fled the country, Bruce grassed on his mates. Bushey said I was to be super careful of that Bruce.

I found out that Bruce had been talking to my friends. I did not have to be a genius to figure out that Bruce could make things hot for Roman and me by getting himself in good odour with the police. Roman decided to cool his heels in Toronto; there was no point in taking a chance. He was off on the first flight.

Through Bushey, I had got to know and like two Italian crooks. One was called Johnny Gatto (or Johnny the Cat because he had been a cat burglar) who was now ringing cars and selling them in Belgium; the other was a large stocky man called Enzo. He was married to an English girl and was thickset, hard and confident. If you had to imagine a picture of a Mafioso you would picture someone looking like Enzo, whereas Gatto was as thin as a drainpipe. Enzo dealt in crooked Alitalia airline tickets. England had also become too hot for Enzo and Gatto and they were off to Italy. Would I care to come with them? I did not need a second invitation.

I was a bit worried about leaving the country. It was possible that Bruce, whom I had taken into my confidence so much by swapping stories of coups, had grassed me up so much that the police had put me on the wanted list and travelling under my own passport would be dangerous. The only passport I could get was that of a middle-aged woman; she did not look like me, except she was the same size as me. I used her passport disguising myself as a nun in borrowed habit and crossed from Dover to Calais on the ferry where the French immigration officer was most kind to the English nun and where the French railway guard made sure that she had a good seat on the train to Milan.

Before I left it was time to say goodbye to Rigna. There was no easy way to do this, so I took the coward's way out. I asked my mother to speak to her. My mother did, explaining that I was no good and that Rigna should do something good with her life before it was too late. I asked my mother to give Rigna most of my money. It wasn't too much. As usual I was living from hand to mouth, although very extravagantly. Rigna listened to my mother and she went to Holland. People from Bonair have the right to live in Holland. She stayed there and made a new life for herself. I never saw her again but I always think fondly of her.

ENZO AND I SHARED A BEAUTIFUL APARTMENT IN MILAN. I very quickly got to appreciate Milanese style, life and cuisine. I liked spaghetti pompano so much that I ate some every day. Enzo and Gatto were into some skulduggery; we needed a hand so I sent for Tim the Idiot.

In Milan, Enzo, Gatto, Tim and me went to a night club where there was a fabulous black stripper called Monique del Rio. She started stripping to Woman,

Take Me In Your Arms, Rock Me Baby. Tim and I started singing "Woman, take me in your arms, fuck me baby," while all the Italians in the night club sat po-faced. She looked at us. She looked at me and from that moment she was mine.

Monique went all around Italy with me. We went for a holiday together on Lake Lugano. I liked the lake so much that I used it for one of my aliases, "Placido Lugano" who was born of an Italian father and English mother who separated when Placido was three months old. My English mother had, I said, returned to England and that was the reason why I never spoke Italian.

Of course when Italians heard this story they immediately said that I looked like an Italian, in the eyes, or the chin or whatever. People believe what they want to believe and see what they want to see.

Placido Lugano had an Italian passport, driving licence and identity card. I used them all over Europe, except of course in Italy. That is the rule of using forged papers — never use them in the country where they were supposedly issued.

Monique was both the most sophisticated and the least sophisticated person in the world. She could speak intelligently about opera and art to the most cultured person. But if we were out in the car and she wanted to pee she thought nothing of getting out of the car, lifting her dress up and peeing behind the rear wheel, in view of everyone. She was terribly jealous. She was my girl while I was in Italy. She never joined me on a coup, and when I left Italy she stayed behind, but I still smile when I think of her and her wild ways.

At this time in Italy, the drugs scene started. People were beginning to get big money for dealing drugs. Until then, Enzo used to be involved with scams and smuggling cigarettes and pornography into Italy. We used to go to Yugoslavia, quite near Trieste, buy pornography from a Yugoslav dealer in bulk and smuggle it into Italy in a boat. We had our contact in Yugoslavia: he imported the stuff into the country; we sampled it, bought it, paid him in cash for it, loaded it into Enzo's boat and landed the porno in Italy when the authorities were not looking.

The pornography was just the normal Swedish and Danish hardcore that you can now buy legally all over Britain, all over Italy and all over Europe but in those days it was illegal in Italy and bringing it into the country was a criminal offence.

We sold the porno to a man in Italy who sold it as a middleman to a man who broke it down into small parcels and sold it to secret porno shops. We could sell it for very high prices, so everyone in the chain made huge profits.

When we were in Yugoslavia buying the porno, I went into a casino in Split. They only played blackjack and roulette, but I noticed that there were good opportunities for flimping money. When you go into a casino on a normal roulette game, you play with chips that you buy from the casino. Each set of chips has different colours and the house designates what your chips are worth when you buy them. For example if you ask for five $100 chips he will give you five, say, yellow chips and put another yellow chip on top of a $100 bill to remind him that your yellow chips are worth $100 each. You will be the only person playing with yellow chips. Everyone else will have different coloured chips that mean different amounts.

I would buy, say, five $100 chips and get the five yellow chips. I would give two chips to a friend. I would get as close to the croupier as possible; the croupier would always be next to the wheel and the friend would get as far from him on the table as he could.

"I've been so unlucky, come on, spin the wheel, bring me some luck," I'd chant.

Then, at the far end of the table, a number would come up. My friend would have bet on the number with his own $1 chips, on say red. The friend keeps betting red until it wins and when it does, his hand goes to show the dealer that he had won. At that stage by sleight of hand he would put my two yellow under his own chip on the winning number. His chip was for $1; mine were for $200. At thirty-five to one my $200 became $7,000. It was not too sophisticated, but it worked provided that the dealer spun a number between thirty and thirty-six, because those numbers were the furthest from the croupier.

Of course, these days even the smallest and most humble casinos have hidden cameras that display and record the games on CCTV so this little coup is not possible. I don't think that it has ever been possible to do this sort of thing in a sophisticated casino, but then, in Yugoslavia, it was easy.

So Enzo and I made big profits from porno, cigarettes and "betting" in the Yugoslavian casino but there were bigger profits to be made in drugs.

When drugs became big business, Enzo started dealing in them and asked me to join him. He would smuggle drugs into different parts of Italy in his boat. I told him that it was not a good thing to do. I refused to touch it — Enzo said that he had a big boat, a great apartment, all the best clothes a new car; how could it not be good? He said it was a great life.

I said that I did not want to be part of that and talked Gatto into staying out of it. Shortly after that, our porno business came to an abrupt end. Suddenly the government made pornography legal in Italy. The market collapsed overnight, the profits weren't in the trade because the shops could buy direct from the producers of porno in Denmark and Sweden. Worse still, the Italians started to make their own pornography. With the illegality gone, the whole trade that I was involved in came to an end and people like me were replaced by so called reputable businessmen who made fortunes operating at one tenth of my margins, with no risk of prison.

Strange, isn't it? One day you do something and if you get caught you go to jail for five years and have all the profits confiscated. Do the same thing the next day and you are a proper businessman, no jail no confiscation, just taxes!

If the authorities ever made drugs legal, I am sure that the same thing would happen. Although I have always been opposed to drugs, many of my friends have been into them. If drugs became de-criminalized in the same sort of way as pornography, I am quite sure a huge amount of crime would cease overnight.

It was time to leave Italy and Monique. I got a plane back to London and it was only when it touched down that I realised that I never said goodbye to Monique. But that did not matter. I was sure that within twenty-four hours she would have found someone else and forgotten all about me. Good luck to her!

MARIE LLOYD

LITTLE PORTLAND STREET IS IN THE HEART OF LONDON'S WEST END. It is close to all the big stores of Oxford Street, a short distance from the expensive boutiques and jewellery shops in Bond Street and a stone's throw from the centre of English medical expertise in Harley Street. The British Broadcasting Corporation has its art nouveau headquarters nearby. The inelegant boutiques of Carnaby Street and the sex shops of Soho are all close by.

For years Little Portland Street — a narrow one-way street between the grander Great Portland Street and Great Titchfield Street — was the centre of the clothing industry of Britain. The rag trade area, known as "the Mile", dominated the district. Clothing manufacturers were close to their chain and department store customers and in the early eighties, the district was still dominated by the industry. Those were prosperous times when people were beginning to make money in Mrs Thatcher's Britain. Cars and vans double-parked to unload garments and no traffic wardens came to chase them away. The whole area was vibrant and optimistic.

All kinds of people were making money and everyone running a business had dreams of "going public" — selling shares on the stock exchange and retiring with wheelbarrow loads of money. They worked out their sums on pocket calculators, not spreadsheets, and all carried sleek flat briefcases. Everyone was confident, hopeful and sharp. But inflation was still very high and Mrs Thatcher, now firmly ensconced as Prime Minister, took it upon herself to bring it down. And yet inflation gave many smaller business people a start. Their stock in real terms often became more valuable and this hid many mistakes.

There was still a fashion garment industry in Britain then. Hundreds of small fashion companies owned by Greeks and Jews copied Paris designs, simplifying them and sometimes doing their own interpretation of them. They sold their designs to the large stores and then got hundreds of small immigrant-run factories and homeworkers to make up the garments. The business needed little capital and if you hit on a winner you would make a lot of money in a short period of time. If your business failed you would often simply go into liquidation and phoenix-like arise out of the ashes and start all over again with the same premises, the same staff and the same machinery. As a point of honour you tried to pay the trade before you went into liquidation. That left the taxman as your main creditor and no one, except the tax man, thought it bad if you did not pay him.

About this time the Customs and Excise, responsible for collecting Value Added Tax from traders, went on strike. This was serious because at the time they collected over a quarter of the government's income. Businesses were unable to pay this tax — most of them used the money as part of their cash flow. Others, less prudent spent it. But the customs strike didn't really affect Syd; his VAT bills were extremely small.

Close to the corner of Great Portland Street, near a bookshop, next door to my solicitors' office, clothing companies, textile converters and a newly opened McDonald's, is a two-storey building with an extensive basement that extends right out into the middle of the road. The place was built as a fashion sweatshop and the upper floor is still a garment workshop. The ground floor and basement had their own separate entrance and had for many years been the premises of the Marie Lloyd Club.

London café society was not yet born. There was a shortage of cafés, clubs and cheap restaurants where you could spend a few hours in the company of friends. Pubs were too traditional; their opening and closing hours too tightly regulated. If you finished business with your buyer or client at three in the afternoon there was nowhere to go and unwind with him or her over a few drinks, unless you were a member of a club, and there were not many of those. However, there were a number of drinking clubs and the Marie Lloyd was one of these.

IN LATE 1977 I GOT TO KNOW OF A CLUB in Little Portland Street. It was called the Marie Lloyd and it was very run down. Marie Lloyd was a famous West End music hall star in the Edwardian era. Apparently her maids became fed up with cleaning up after her parties and they made her buy the Little Portland Street premises for her to hold her after-show parties. Eventually it became a members' club that kept the name and decorated the premises with pictures of the music hall beauty. It was supposed to be owned and run by the members but that was just a front. It was in reality owned by a gangster called Charlie Mitchell who is dead now. I knew Charlie well, he was a good friend.

He had many interests then but the club was one of his less successful ventures. It had a reasonable custom but the food was terrible and the atmosphere inadequate. It felt a bit like a worn out place with Formica on the walls in the style of a sixties golf club (there are some of those still around today). Charlie had a manager who ran the club, but the manager, a gambler, was stealing to feed his gambling. I approached Charlie and asked him how the club was doing. Charlie said that it was not making more than £100 profit a week because the manager was no good. I saw that the lease was good, the liquor licence was good and the potential was huge. I offered Charlie £15,000 for the club. He accepted. I gave him the cash and from that day the club was mine. We didn't draw up a contract or sign or exchange a document.

Barry Law used to work in the jewellery business in Hatton Garden; he used to come into the club to sell bits of jewellery. I liked Barry and he was always smartly

dressed. He came from the North East and was a hard man who could look after himself. But he knew how to behave in the club. He smoked over forty untipped, full strength Capstan cigarettes a day. That eventually gave him lung cancer and he died, but at the time when we worked the club together, he was healthy, strong and very reliable. In fact he was one of the few people that I ever trusted one hundred percent. He was married to a beautiful South African lady who loved him very much; Barry lived and worked for his family.

I suggested to Barry that he could have half the profits of the club provided that he ran it. I said that I would help him for the first few months. The good thing about Barry was that he was honest, in the sense that he would never cheat me, and always willing to help out in a fight or a bit of bother.

I kept on one member of staff, a man called Tommy Harris who was an ex-professional footballer with Chelsea in the days when they earned peanuts playing in front of crowds of 70,000 people. I liked Tommy so I said he had a job, but everyone else was out. I helped Barry get the club going for the first few months. As soon as it was doing well, I left it to him. The club became very successful and I tried to keep the gangsters out.

Upstairs was a bar and a couple of fruit machines; downstairs was a much larger area that extended under the street. This was divided up into a large luncheon area with tables and chairs and a small kitchen where we prepared the food. The market traders and boys running the small scams in Oxford Street (like selling fake perfume) stayed upstairs; down stairs was for a different type of member, like lawyers, garment manufacturers, Harley Street doctors, actors and producers from the BBC. We laid out a buffet on a pool table covered with a large board and a cloth. After lunch, the table converted back into a pool table on which the members could have a game.

Barry managed to find a highly efficient girl to run the bar called Kim. She had big tits and everybody loved her — she was very friendly and very good at her job. She handled all the fine details that Barry and I couldn't bother with or didn't know how. Without Kim we would have been lost.

Although the club was "owned" by me in a way that a members' club is not supposed to be owned, none of the members bothered to ask for accounts. All the surpluses were meant to be used for the benefit of the members. The club should have been a non-profit making organisation. It was non-profit making as far as the members were concerned. But Barry and I made enough out of it. And for all of that, the members still regarded it as their club, a place that they were interested in and a place where they would help out if we were short-staffed.

I was very proud of my club. It was not the most sophisticated place in London but I had created something good. I was at heart a villain, but here I was running a clean place where people liked to come. Compared with what I had in Trim or Fulham or Wandsworth prison this was luxury. The atmosphere at the club was great and the menu that I worked out seemed to be very popular. If the chef was ill I rolled up my sleeves and did the cooking, I enjoyed that.

One day Elton John came down. He came in with Roy, a promoter who used to

borrow my Rolls Royce to go to football matches and he would take Elton John with him. One day he brought Elton John back to the club. Elton was very unimpressed and said to Roy in a very loud voice, "I don't know why you brought me here, Roy, I don't like this place."

Roy looked at me and could see that I was getting the hump. I glared at Elton John. He carried on, ignoring me. I moved towards him slowly, he seemed unaware of me until I put my face three inches from his.

I said to Elton John, "Do me a favour, fuck right off, and don't come down here again, you piece of fucking shit. Get your fucking arse out of here." Elton John ran off and Roy ran after him. When Roy came back I said to him, "Roy, don't bring that fucking faggot in here again and you can't borrow the car any more because I am not having that dirty bastard sitting in my car."

You could say that I was upset with Elton.

Barry said to me later that I should have kept my mouth shut because Elton John would have brought all the big spenders into the club. But it was very hard for me to keep my mouth shut. I felt my temper rising and thought that there was something wrong with Elton John looking down his nose at my club. I was as good as him. I didn't look down my nose at him. What right had he to behave the way he did? If he hadn't run away, I'd have given him a slap. There aren't many people I've wanted to hit as much as I wanted to hit Elton John at that moment.

One film star, Ronald Fraser, often walked into the club with a pretty girl on his arm. He would see me and say "Sydney, your best bottle of wine!" and then out of the side of his mouth so the girl would not hear "Bring the shit, Syd." One fledgling star, an Irishman, who is now very successful with his own TV show, used to say, "Is it possible, Sydney, for me pay this year's subscription in July? And can I have a bit of credit as well until then?" He always asked me for credit and he always paid me. And I am very pleased that he is now very successful, with his own show on TV.

The club was a good place to meet people. I met one chap who introduced me to Prince Phillip. He took pictures of me telling a joke to Prince Phillip and I had the pictures blown up and framed. When the police raided my home looking for me they found the pictures on the wall. Ten years, later they questioned me and referred to the pictures, which they returned to me. Seeing my photograph with Prince Phillip impressed the police.

Because the club closed at seven o'clock, I was able keep the people who came in the club separate from my other activities. While I would bring marks in the club to play poker or backgammon, I would never mix them with the club's customers because I brought them after hours. I always said that I knew a very nice club where we could play and never let on that I owned it. When I went into the club, Barry would treat me like any other customer. If it was after hours I could gamble, play poker with juice, play backgammon with crooked dice, plot and hatch schemes or hustle pool. I kept the juice and the dice behind the bar.

There was a kind of community at the club. Most of the patrons were hard-working honest people. They became friends, and although it would have been

very easy to con one of them, I never did.

Take the case of Peter Harper, for example. Peter was a fashion agent who managed to get an agency to sell Finnish clothes in England. He was a self-made man with a great sense of humour from the East End of London. Whenever you spoke to him he smiled. He loved hearing jokes and told some great true stories about his adventures travelling from Finland by car into the old Soviet Union and the games he played on the Soviet border guards.

Peter was not a gambler, but he would have been easy to con. He trusted me. Someone from the club suggested that I could mastermind a con against Peter. I knew that if I did that, Peter would never know that he had been conned; he would put it down to bad luck. But even in the jungle there are rules. There have not been many rules in my life but one of the most important ones has to be you do not con your own friends or fuck their wives. Peter was a friend. Not only would I not pop him, but I made it known that I wouldn't allow anyone else to pop him either. Peter was off-limits.

Roman came back from Toronto and in his perpetual search for new hookers, he took me to a club in London's Soho. The place was full of hookers and Roman was as happy as a pig in shit. I started talking to one of them. She said that her name was Liz. She was black and beautiful. She had a ten-year-old daughter. We dated and soon we started living together. I told Liz that she didn't have to work any more, ever again. She didn't like the idea of not working. She told me that although we were living together, she wanted to have her independence. She would stop hooking, but would stay at the club earning commission by getting the patrons to drink the "champagne" that they sold at silly prices.

I soon found out the real reason for Liz wanting to work. It was nothing to do with her wanting to be independent. She wanted to buy me presents. I had plenty of money and plenty of things but almost every day she bought me something. Sometimes it was a tie, sometimes some shirts and other times cufflinks or jewellery. But almost every day she had to buy me something. I told her that I didn't need anything but, if anything, telling her this made her buy me more. What could I do? I didn't want to hurt her feelings so I made sure that I bought her daughter lots of presents and kept Liz as happy as I could.

The only problem with Liz was that she was incredibly jealous. She hated the thought of me being unfaithful and made sure I knew that this was not allowed. Very soon in our relationship she took me to her cousin's wedding party. All her relatives were there. I think I was the only white person in sight but that did not matter to these good people who made me welcome and treated me as one of the family.

At the party I started dancing with Liz' other cousin. There was nothing sexual or wrong in it but Liz didn't see it like that. She attacked her cousin and starting fighting. The whole party was spoiled.

This incident seemed to make Liz even more jealous. She started to phone me from work, every half hour to check up on me.

On the way home one day, driving my Rolls Royce with Liz sat next to me in the

car, I saw a pretty girl in a short skirt on the pavement. I looked at her, as you do. I mean everyone does that, don't they? Not with Liz.

She grabbed hold of my hair pulled it and then pushed my face down on to the steering wheel of the car with as much force as she could. She knocked me out and when I came to I found myself bleeding, looking through a broken windscreen at apples and vegetables — I had crashed the car into a greengrocers' shop.

I got my face fixed at hospital and left Liz. I like an exciting life but there are limits. Liz was a short interval in my career. When you're in love it slows you down, or it does me, and stops you thinking too much. Out of love, I could now concentrate on increasing my income. The club was a good steady earner as well as a front. It gave me all sorts of opportunities. It would be best if I did some work away from London. Somewhere close so I could pop over do my work and pop back.

Antwerp was the centre of the diamond trade. It wasn't too far away and I had no criminal record there. Someone had given me a list of all the major diamond dealers in Antwerp and I thought I might be able to put that list to good use. Barry's invaluable knowledge of the diamond industry and Bushey and Bruce's switching of jewellery gave me something to think about and when I had thought about it all, I decided to become Mr Cole.

DIAMONDS

SYD BECAME A CLIENT OF MINE and I did bits and pieces of work for him. I think I advised on some fire regulations and how they applied to the club and drafted a new constitution for the club. He and his secretary split up but Syd stayed on as a client. I suppose that we were conveniently placed for him.

He did not seem to be at the club very often. Much later I found out why — he was setting up a con against the orthodox Jewish community in the diamond trade.

Imagine a mysterious secretive community. The men all wear hats and dress in smart dark suits with long black coats. They speak the language of the place where they live but also have their own expressive tongue that very few outside their community can understand. They trade diamonds with each other and with jewellery manufacturers. They study hard about the different types of diamonds and they watch prices carefully. They all know each other and get to know the best sources, the best manufacturers and cutters. But they all need customers.

Imagine a close society where all the merchants know and trade with each other. Their parents and grandparents have often known and traded with each other for generations. They understand the market and the way it works. They understand the black economy and the way it works. Imagine a suspicious community which has been oppressed and learnt from this that they should not display their wealth or trust anyone they do not know. If you have imagined all this then you have imagined the Jewish diamond community in Antwerp. Although many people associate diamonds with Amsterdam, the real deals are done in Antwerp.

Regular customers tend to be the expensive jewellery shops which have the stones set into rings, necklaces and earrings and other ornamental jewellery. There are dealers who have premises, established customers and an established trade. There are also dealers, usually but not always, younger men setting out on their careers. These men borrow stones on approval (sale or return) from their friends and relations and try to make a living selling them to customers. They trudge around the buying departments of the jewellery stores showing their stock and hoping to turn a couple of percentage points on a sale. Sometimes they get lucky — they find a private buyer where the percentage points can be higher. These dealers are not wealthy men. They deal in very expensive stones but the value of the stones they deal in far outweighs the income they achieve.

They can be secretive even amongst themselves. Some of the very rich deal-
ers live as simply as the very poor ones. You can't tell the difference by just
looking at them.

"IS THAT MR GOLDBERG? Mr Cole here."

"Yes," replied the Jewish diamond dealer in Antwerp, very cautiously.

"You will not know me but I've been told by friends that diamonds are a very good investment. I understand they rise in price terrifically, and, instead of carrying cash, you can have just a small bag that is worth a fortune. I also understand that you are one of the oldest established and most reputable dealers in Antwerp, and you can help me acquire some stones."

"Oh yes," he said. "Where are you?"

I said the so-and-so hotel, suite such-and-such.

"I'll send a car round for you." He sent a car round which brought me to his office which was a very a big room. In the middle of the room was a big iron cage. In I went, into the cage. Goldberg locked me in with him. Goldberg was there with another man, younger than he, probably his son-in-law. Settled comfortably in the cage, Mr Goldberg asked, "What can I do for you?"

"Well I don't know if I can open up to you; it's very difficult, very sensitive."

"You can confide in me, Mr Cole."

"I am very ignorant about diamonds. I don't really know what I should tell you; I don't really know how to go about it."

"You can tell me, you can trust me."

"Well, I've got some cash, money that I have, well, not quite paid the right amount of tax on, sort of forgotten to pay the tax on, and it is liquid cash and I want to turn it into diamonds. I have been advised by some friends of mine that diamonds are a wonderful investment. I can have a little packet instead of all those bank notes that devalue each month. I can have a little bag of rare diamonds that goes up in value each year, particularly now when I am told prices are cheap. It sounds good to me but I don't know how to go about getting the right diamonds."

Mr Goldberg asked how much money. Very nicely he asked me how much I wanted to spend.

"Well I don't know; possibly a lot. At the last count I had four million pounds, but let me tell you right away I'm not going to buy four million pounds at first. I would start off with something much smaller."

I also told Mr Goldberg that I was advised that I should employ an expert to help me buy the diamonds. I have to have an expert to tell me what is what but I don't want other people knowing what I am doing because the money is black. I knew that I could trust him because I would be paying in cash. But how could I trust an expert or official appraiser? He might go to the taxman.

"Oh sir, what do you need an expert for? We have been in the business for 500 years, my father and his father and before him his father, and we are trustworthy

— everyone in Antwerp knows us. You don't want to get a valuation. An expert will only tell you what the stones are worth and we can do that for you. You have to have trust," he pointed out, "because you don't want people to know about it."

"You're quite right. I'll tell you what I'm going to do. I don't know whether I can trust you but obviously you are an old established company and you yourself are very pleasant. I really have a good feeling about this. So what I'm going to do is this. I'm going to, say, let me just start off small, say with a purchase of £150,000."

I could see Mr Goldberg's eyes light up. He did not actually rub his hands together but he was very pleased.

"How do we do it?"

"Well, let me show you."

He went to the safe in the middle of the cage and opened it. He pulled out a big tray. "Look at this one, sir, two carat pure white, see?"

"Well, I don't know anything about it."

"Look, look." He gave me his glass.

I said, "Oh yes."

It looked lovely! But I could see a big lump of rubbish in the diamond which looked like a miniature coal mine. There was nothing pure about that stone.

"I'm telling you it is a perfect stone! How much is that, Martin?"

Martin told us the price.

"Hmm," said Mr Goldberg, acting as an arbitrator in his own case, "Not a bad price! Not bad at all! You made him a discount as though he is in the trade, Martin. And what is more, this used to belong to a member of the English aristocracy who has a title and jewels but no money."

"Well, I'll tell you what you should do, Mr Goldberg. You must recommend a quantity of diamonds that I should buy worth £150,000. But they all have to be as good as that one."

So Mr Goldberg made up a collection of suitable diamonds going through a whole patter about each stone, telling me that this stone came from Lady so-and-so who was short of funds and he broke up her tiara. This stone came from the wife of an American industrialist and so forth. Every time he recommended a stone, he did so at outrageous prices. He came up with what he valued to be £180,000 worth of stones.

It did not take a genius to guess that the diamonds were worth less than half of that amount. Some of the stones were badly flawed and all of them were being sold at well above wholesale prices. Every now and then, after careful examination under the glass, I rejected a stone. It made them smile to see that I now considered myself an expert.

Jewish diamond dealers have got to be incredibly cautious. They certainly do not give credit to strangers. They usually deal in cash. They can easily lose their whole stock to robbery. They do not usually carry insurance. Once the stones are gone they are impossible to trace. Many of these diamond men in Antwerp went through Nazi concentration camps — Jews have experienced being swindled, robbed and murdered for their assets and also state confiscation of assets by the

Nazis. If they managed to get their money out of Germany, they deposited it in Swiss bank accounts but after the war the Swiss banks denied holding these deposits. All of this breeds caution in men like Mr Goldberg.

Nevertheless, the prospect of making some easy money causes dealers like Mr Goldberg to lose generations of inbred caution which makes it possible for me to pull off my coup.

I complained that £180,000 was well above the £150,000 that I had said that I wanted to spend. Mr Goldberg said, "What's £30,000 here or there?" So I said OK.

I then asked that if I were to buy this particular parcel of stones how would I know I was going to get the same stones. He said that surely I was going to take them with me. I said, "You don't think I've got £180,000 with me right now do you? You don't think for one minute that I'm going to take them into England and pay the twenty-five percent duty on them do you? Surely an established company like you has got an office or an agent in London?" I knew full well that they did not.

"Yes of course we have sir."

"Then there is no problem," I said. "All you have to do is transfer them to my London office — how you do it I don't want to know. Have your London agent come to my office and bring me the stones or I'll go to his office."

"Oh we don't normally work like that."

"It's the only way I work. I told you the money is black and I can't declare it and I certainly don't want to bring things like that through customs — supposing I get stopped?"

"You won't get stopped sir."

"I don't want to take risks. Look, I'll spell it out to you in detail. I have to come over here first with the money — £180,000 in cash. I am only allowed to take out £30 from England legally." There was exchange control to worry about. "Then, having smuggled the money out, I have got to smuggle the diamonds back in or else pay duty on them. Oh dear, oh dear, no, I don't think so, I thought you had a London office." I stood up and picked up my coat.

Mr Goldberg and his assistant went away to have brief conference. They came back and said, "Yes sir, don't worry. We'll have them for you in London at your office in two days."

I had selected the diamonds that I was going to buy, and we agreed that we would put each of the selected diamonds into packets that we would seal with sellotape and I would sign on top of the tape. We would then wrap all the small packets up into one small parcel that we would also seal with tape and I would sign across the tape so that I could identify it. We had all the stones that I had selected parcelled up within a few minutes.

They sellotaped it all up. I could see my writing through the tape. With every stone I had to do that, every stone, then they put all the smaller packets into one big packet and they put paper round it and sellotaped it.

"Now when I get to England, get your London people to bring that parcel to my office. When I see my signature under the tape, I'll know they'll be exactly the

same stones that I had chosen under your guidance in Antwerp. I'll have the money then for you in cash in pounds sterling."

"Thank you Mr Cole."

I gave Mr Goldberg a business card. I had taken an office at Brentford near the airport. I took one small room in a big building, but I fixed the secretary downstairs in the foyer. I said that I was trying to establish a business. I said when the phone rang for me, I wanted her to give them the impression that I owned the whole building and Mr Cole was always in conference. I took her out to lunch and gave her a few quid.

After a few days, the phone rang in my office. "Mr Mendlech here for Mr Cole."

"Sorry," I said, "I don't know any Mr Mendlech." Clunk. I put the phone down. He rang back immediately.

"Mr Cole, it is Mendlech here. Wait, you don't know me but your friend, Mr Goldberg, in Antwerp sent me; you remember Mr Goldberg in Antwerp?"

"Of course," I said, "but I'm afraid it is not convenient to speak to you now. Would you mind ringing back in two hours?" Clunk.

He rang back, and I arranged for him to come to my office. He brought the parcel with him. He showed it to me. There were my signatures under the sellotape. I decided that I couldn't be too careful about this, and took the parcel to the light, by the window to check it very carefully.

"It is the right parcel, alright, Mr Mendlech," I said, giving it back to him. "Those are my signatures."

"You don't want to open it?"

"No, there's no point. I saw Mr Goldberg put the stones in the parcel, and I know it's correct. Now I have to give you the money?"

"Yes," said Mendlech, waiting.

"Well I don't keep it here! We have to go to my safe deposit box at the bank. You keep the parcel until we get to the safe deposit box. Come with me and I can count you out the money there."

I picked up the phone and buzzed the receptionist to have my chauffeur ready. I had previously slipped a uniformed chauffeur some folding money to let me use him and his boss' Rolls Royce for an hour that day. The chauffeur knew nothing about me except that I was Mr Cole. We drove to a bank in Twickenham and we got out of the car together, with Mr Mendlech holding his parcel for dear life.

"Just a moment," I said as we entered the bank. "I forgot the key to the safe deposit. Just wait inside the bank and I'll be back in two minutes."

So I got in the car and slowly drove away and left him there still clutching the parcel.

I had made a second parcel, signed the signatures and covered it with sellotape. When I had examined the signatures by the window on the genuine parcel I switched it and handed Mr Mendlech the phoney one that I had made up.

The valuation on the diamonds was £110,000 when I had them professionally valued by an expert before I sold them. I was supposed to pay £180,000 at rock

bottom prices, so Mr Goldberg tried to stuff me for £70,000.

Mr Mendlech waited in the bank but I didn't show. When he asked, no one had heard of me at the bank. They did not have any safe deposit boxes anyway. He went back to his office and he rang up Mr Goldberg in Belgium.

"I don't know what happened — I went to his office, we went to the bank he went back for his key and never came back. I don't know what happened. But don't worry I've still got the parcel — it has not left my possession." So he sent the packet back to Mr Goldberg.

When Goldberg in Belgium got his parcel back and found that it contained glass he thought that Mendlech in London fixed him. Mendlech was convinced that Mr Cole in the office in London had definitely not screwed him — he hadn't had a chance, had he? Perhaps Mr Goldberg had set him up?

I had a list of Jewish diamond dealers in Antwerp. I wanted to work through that list doing the same thing each time. I was sure that they wouldn't tell each other about the con. If one ever told another about losing a parcel of stones, he would lose his credit in Antwerp. It's a small community and every diamond man would know that the loser was a bad risk. The dealers all borrow stones on a sale or return basis from each other and from manufacturers. A dealer who loses parcels becomes a bad risk and is only allowed to borrow more stones if he puts up the cash value of them.

When I left Mr Mendlech waiting at the bank while I ostensibly went back to get the safety deposit box key, I could not resist telling the chauffeur to go back to the bank, half an hour later, where Mendlech was still patiently waiting. He saw my car and waved to me. I could not restrain myself from giving him a slow and happy wave.

Roman didn't get involved in this coup. I used Tim as the man in London to answer the phone while I was in Belgium. I had to pretend to be a businessman. If someone rang the number on my card, Tim could answer it, take a message, and keep up the London end of things.

The diamonds coup was a solo act and apart from manning the London "office" while I was in Antwerp, there was no need for anyone else to help me. I hired Tim to mind the office. This was a simple job that he could do while I worked my way through the list of diamond dealers.

AT THE SAME TIME AS when I was scamming diamonds by switching parcels, I performed "the robe" in Belgium to Belgians on their on home ground. The robe was a scam that I invented all by myself. I was still working with Tim at the time; his was to drive me to Belgium. After I collected the proceeds of the robe, Johnny Gatto or Enzo would drive me from Belgium to Italy where I would sell the stones that I had acquired by the robe.

It started like this. Enzo knew a Jewish diamond dealer in Belgium who was a lunatic fruit machine player. He used to blow over £1,000 a week on them. He had a wife and child, but he used to lie to them because he spent all his money playing fruit machines.

Enzo suggested to him that he could get hold of some money by introducing us to his friends. We would scam them and pay him some money after we were successful. It's not very nice to scam your friends. I have never done that, yet he did it without blinking an eyelid. Enzo never told him how we would scam them. That was how I got an introduction to each diamond dealer that I could scam.

When I got to Antwerp and booked into a hotel, I called a diamond dealer from my hotel suite in Antwerp and mentioned the name of the lunatic fruit machine gambler saying that he had introduced me. I asked the dealer to bring me some samples to look at. I couldn't go to his showroom. I always took a two-roomed suite at an expensive hotel. That was a critical part of the scam.

I would never use Gatto or Enzo, who looked too tough. Tim looked like an idiot and was ideal for this. I also worked this with Roman; he too looked an unimposing figure.

The first time, the dealers would always come empty handed. I would explain that I was leaving in two days. I didn't want anyone to see me in Belgium with all this cash that I managed to smuggle out of England. I wanted £150,000 worth of diamonds. I'd pay in cash. I didn't want any rubbish, I didn't want people to rob me or cheat me, I didn't want my face seen in any diamond business or any diamond house. If he did not want to do it, I was sure I could find somebody else. Where are the yellow pages?

The dealer said, "No, no, no. I'll do it. What do you want?"

I said, "Cut stones, minimum one carat, none bigger than twenty-two carats and I want $240,000 worth." I got to know about stones.

The dealer would come round, and show me some stones. Whatever he showed me, I was unimpressed with and made an appointment to see him in my hotel the next day, with more and better stones.

The next day, I would send Tim down to bring the dealer up to the room. When he got there, he would find me sitting there in my bathrobe, but nothing else. I would sit with my legs open, exposing my penis. In the room there would be clothes strewn about the room, a few drinks, a packet of cigarettes, a jacket over the chair, a tie over the jacket and a half empty case.

I would take my time looking at the stones, and haggling over the price. In the end, I would let them charge me a lot more than the stones were worth. We finally agreed a price in dollars, which we had to convert into Belgian francs. I would have negotiated an odd figure, say $168,000. I would pick up the stones that were in packets, put an elastic band around them, give them to Tim or Roman and say, "Take these down to the safe; get $170,000 out of the safe." Before Tim went down, I would make a fuss to check that the dealer had brought change. "You have got $2,400 in Belgian francs, haven't you?" I would carefully work out the exchange rate to make sure we agreed the exact amount of Belgian francs that he was going to pay us. The dealer would double check, and often pulls out his cash to prove that he had the change. Tim would then go out of the room with the stones into the hotel lobby.

When Tim reached the lobby, he would telephone my suite on the house phone.

I had previously disconnected the telephone in the living room part of the suite. That meant that the phone in the bedroom rang. I would say, "Excuse me," go into the bedroom and start talking on the telephone. "Yes Tim, No! Really? No I don't have to come down, yes, yes." I then put my head around the door to speak to the dealer, "I won't be a second." I then switched on a tape recorder of my voice talking, ironing out some imaginary problem with Tim (it lasted for half an hour). While the tape was playing, I walked out of the bedroom door, in my robe, into the hotel corridor, down the lift, through the lobby in my robe and into the car that Enzo had brought outside the hotel, where Tim was waiting. In the car was a change of clothes and we would be across the border within twenty-five minutes, while the tape was still playing, into Germany and then into Italy.

Because we knew the steerer who had introduced us, we found out later that more often than not the dealers waited in the hotel suite for us to come back for four or five hours.

I did lots of these because one dealer would never tell another dealer because he would not want to look like a fool or lose his credit rating.

One dealer showed me some stones. He asked me if they were not nice. I said they were lovely but he had only brought $60,000 worth of stones and I needed $150,000 worth of stones. I asked him to take the stones away. No, no, he said, he would immediately get me more stones. I explained that I was in a hurry and maybe the best thing would be to take the stones away and I'd find someone else. No, no, keep these here and he would immediately get more. Do not call anyone else. I said take them with you and bring back the better ones. He said no sir, leave them here, leave them here. How long would it take? He would be back in one hour. He left the stones on the table. I said to Tim "Oh this is a little coup! We've got $75,000 for nothing. Let us wait because if he's left this he's certainly going to come back with a whole bunch more." Sure enough he came back.

He brought back a big chunk of stones and I mean a really big chunk. He had emeralds. I didn't ask for emeralds only diamonds but he brought emeralds, a few rubies and a few sapphires.

After we agreed the price and before I sent Tim down to the safe deposit box, the dealer asked me for a favour. He was worried about carrying all the cash back to his office. Could I help him? Of course, I promised him that I would send Tim with him as a bodyguard and he looked mightily relieved.

Sometimes, if the dealer was a bit nervous, I would put the diamonds in my pocket and send Tim to get the money. That would reassure him, so that when I took the telephone call in the bedroom, he thought that the diamonds would be in the bedroom with me.

I suppose that when I got the dealer up to the hotel suite, I could have hit him on the head, stolen his diamonds and escaped. But that would have been no good. If I hit him over the head, his own innocence would be established beyond doubt. This way, there would be a sneaking suspicion that the dealer might be making it up and that would deflect enquiries from me.

All the dealers wanted to do the deal because they were outrageously over-

Syd in Germany. (Man on left not known.)

charging me for the diamonds because I was stupid. I pretended I didn't know anything about diamonds. They all claimed that their prices were the best in all Antwerp. Certainly they would be the highest but as I didn't pay I wasn't too worried.

One dealer actually called the police after I left the hotel. But the police didn't believe him because they thought that he was trying to steal the stones. The dealers all get stones from each other on approval. If they lose them, they have to pay. The dealer who had lent him the stones called him a thief.

I took the diamonds to Italy and sold them immediately in Milan — I used to get about sixty percent of their value. As soon as I got the money I spent it. It did not matter to me then. I could always get some more money. The game was simply to get the money and spend it. That was all.

Tim, unknown to me, decided that he would improve my coup. He found a copy of my list and started working from the bottom of it while I was working from the top. He telephoned one dealer told him that he wanted to see some stones. He persuaded the diamond dealer to come from Belgium to England where Tim arranged to meet him to look at the stones. At the meeting, Tim robbed the poor man. When the man resisted, Tim beat him up and left him in a car park.

That was out of order. The poor man was only trying to earn a living. However Tim's real crime was that he was spoiling my scams and using my list of diamond dealers. When I found out about what he was doing, I rang up Tim's wife to ask where he was. She told me, nervously, that he'd gone to see his cousin in Cork and that she didn't know the address. I realised that he must have gone to Antwerp and that being a man of limited imagination must have booked into the

same hotel we used when we did the robe. I took the first plane to Antwerp.

I asked at the desk and found Tim's room number. "No, please don't announce me," I asked. "It will be a surprise."

Knock knock.

"Who's there?"

"Clean the room," I said in what I hoped would be a Belgian accent.

The door opened a little and I pushed it open the rest.

I carefully closed the door behind me. Tim knew why I was there and tried talking to me, making his excuses, but I did not listen.

The previous times I had given Tim a smack I had done so with some regret, because they were punishments that had to be administered because of Tim's stupidity. This time it was not a case of him being stupid — he had been disloyal and tried to screw me. I hit him with relish to teach him, and any one who knew him, that I could not be double-crossed. I must have broken his ribs and his nose. When he collapsed on the floor I gave him a good kicking. I found myself thinking as I kicked him that I could be killing him. I found myself not caring if I did kill him. He was unconscious in his own blood when I cleaned myself up in his bathroom and quietly left.

If, as a normal straight person you break the law, you expect the punishment that follows. If you are caught speeding you pay the fine. If, as a crooked person, you break the rules that apply to your own kind, you expect the punishment. It comes quickly — as soon as you are caught — and without formality. There are no courts, no proof required. For the benefit of your own crooked society the punishment is administered. The punishments are harder and there is no appeal. In crooked society there is still capital punishment.

Strangely enough, the punishment seemed to have no effect. Tim tried his robbery act again in Belgium but this time the police were waiting for him and Tim was captured. At his trial he was sentenced to twelve years imprisonment. It was a nasty, vicious crime and as much as I like Tim, I know he deserved what he got. His sentence would have been longer but for the fact he saved himself some prison time by grassing on me. He claimed that I had made him do what he did, that I was the brains and he was just a pawn in my hands. He said that I made him do it by beating him up regularly and showed his broken face and ribs to prove it.

I was tried in my absence in a court in Belgium and I got sentenced to three years in prison. I got an official looking letter written entirely in Flemish and I took it to be translated. The letter said please come and serve your three years in prison that the Belgian Court has given you. Please report to the prison at so-and-so on such a date when the authorities will be waiting for you. I never turned up; I often wondered if they were seriously expecting me to turn up. I had visions of the Governor of the prison being told (in Flemish), "Syd ain't turned up," and being really surprised.

So I cannot go to Belgium any more because I've got a three years sentence to serve there, but I'm never going to go to Belgium again. It's not very nice there, anyway.

IT WAS TIME TO COOL MY HEELS in Italy again and I met up with Enzo who was happy to work with me again. I caught up with Johnny Gatto who was now dealing drugs in a big way. Again, he tried to persuade Johnny and me to join him. I tried to persuade him to stop. Neither of us persuaded each other although Enzo promised to work with me if I could think up a big scam.

I telephoned a diamond dealer in Antwerp (I got his name from Mr Fruit Machine's list) and after a series of telephone calls I agreed to buy £300,000 worth of stones if he could deliver them direct to my Swiss bank where I would give him the money. I wanted the stones in my Swiss bank safe depository. He agreed to bring the stones to my Swiss bank in Ciasso.

Now I have never had an account with a Swiss bank but I thought it was time that I opened one — a Swiss bank, that is, not a Swiss bank account.

Italy is only a short way from Switzerland, just a few minutes in the car. I never knew this at the time. I drove around the Swiss-Italian border with Enzo looking for a suitable place. I was amazed at just how beautiful the mountains were and how neat and tidy everything looked. Switzerland seemed a good deal too neat and tidy for my liking.

Eventually I chose Ciasso because it was right next to the Italian border and the people in that part of Switzerland spoke Italian.

Enzo found nice corner premises, which were empty in Ciasso. I looked at them — they would make a fine bank. I arranged for Enzo to fit the inside of the premises as a bank, with the right partitions, counters, and a cash cage as well as some desks. We had a sign made "Banco di Ciasso" but we did not put it up immediately.

The merchant brought his stones to Ciasso. I met him in a hotel room to examine the stones and haggle over the price. We haggled for over two hours and the bargaining was highly enjoyable. Finally, we agreed a price and I said that we should go to the bank together to get the money.

Immediately before we got to our bank, Enzo's relatives filled up the bank as staff, customers, tellers and the sign was hung above the premises. As we walked in, it looked like a busy branch. There were leaflets and brochures in neat tidy trays; there were tellers counting out money, customers filling in forms. A pregnant lady and her husband were talking to an official. At the bank I asked to see the manager. The merchant and I were led past all the staff and customers into a small office where we were asked to wait for him.

After a short wait, Enzo came in pretending to be the bank manager, greeting me as though I was his best customer. I had been a bit reluctant to use Enzo as the bank manager. He did not seem quite to fit the part. His face was a little hard perhaps for a bank manager, but he was fat, and then perhaps all Swiss bank managers are fat with hard faces.

I explained to Enzo that this was Mr so-and-so, and that I was doing a deal buying $300,000 worth of stones from him. I asked him to put the stones in the vault and bring $300,000 in cash in Swiss francs. Enzo said certainly sir, and took the stones.

Enzo left with the stones. I said that I was dying to go to the toilet; please excuse me for a few minutes and I left. In a few minutes I was in Italy and clear with the stones. In fact as soon as the merchant had got into the office everyone left the bank, the staff, the customers, everyone. They were all Enzo's relatives and were back in Italy just before me. The merchant was left waiting in empty premises and we were in Italy before he even realised what had happened.

I only did that scam once. It was quite hard to get the right premises.

TOPS AND BOTTOMS

I GOT MY FIRST INKLING of Syd's professional activities when he asked me to arrange a translation of a letter that he had received from Belgium, written in Flemish. It was the letter that asked him to report to prison on a certain day.

The Falklands War came and went, starting as a farce but ending in tragedy. Syd took no notice. He had no argument with the Argentines. Like most crooks of his generation he was patriotic, but not patriotic enough to make him change his behaviour.

He was becoming famous in his own crooked circle. He was known as a con man although the other crooks didn't know how he did it. He kept his techniques secret. He had respect. He was successful and was good at what he did. He spoke and people tended to listen. He was also a hard man and that was an essential qualification in the crooked world — if you don't want to hurt people you can't be a successful criminal.

I have asked Syd about hurting people — why he does it, what he feels. He is intelligent and articulate about everything. I think he hurts people purely to achieve a goal and not as a goal in itself. This makes it like a chore, a job, but when he gets carried away and his temper takes over then I think that at times he enjoys inflicting pain and punishment. He wanted me to paint him as a soft and gentle con man. But he is not a non-violent person, whatever image he wants you to have of him.

He comes from a milieu where violence plays an integral role. Crooked society has different rules from straight society. The rules are broken just as often as the laws and regulations are broken. That is when violence is used to punish and deter, but most of all to punish. In straight society there are three principles in the theory behind imprisonment — punishment, deterrence and reform. There is no concept of reform in crooked society; they do not pay lip service to it. Once you are part of crooked society, it is hard to escape; you end up following the rules just as carefully as a law-abiding person follows the rules of straight society.

Syd was becoming successful.

Most criminals spend their money as soon as they get their hands on it, and many end up donating large chunks of cash to the bookmaking industry in a hopeless effort to take money from the bookies. In his weaker moments Syd bet and lost, but professionally Syd knew that gambling was a mug's game. Bookies took

money off you, sooner or later. That wasn't good. Better to take money off the bookies. Syd had his own way of taking money off the bookies and it involved gambling, but without the usual risks.

If Syd had used his talents in business he would have found that from time to time he would be owed money. In the normal world when this happens you employ debt collectors, issue court summons, threaten the recalcitrant debtor with black- listing. We have to go to court, issue writs and let the law's delay and expense wear us out. Even when we have won judgment we still have to collect the money from the debtor. Ultimately if the debtor has not got the money there is nothing we can do, except write off the debt and sigh.

Of course the rules that apply to the ordinary citizen do not apply to the govern- ment. If you don't pay your taxes or your council tax or your licence fee you can easily end up imprisoned. The government's rights in this respect differ from those of the ordinary individual.

Collecting money owed to people such as Syd is not the same. The Syd system of collecting debts is very different from an ordinary individual's methods in four key respects. Firstly, it does not involve the legal profession and its associated costs and inconveniences; secondly, no writs are issued; thirdly, like the govern- ment, he does imprison people and fourthly a coffin can always play a part in more ways than one.

But that comes a little later. Let us look at Syd's unique method of betting on races.

THE DERBY IS THE GREATEST HORSE RACE IN THE WORLD. Each year about a million people travel to Epsom Downs to watch this short race for thoroughbreds. The richest people in the world put their horses into the race and the rest of us bet on which horse is going to win.

Epsom is crowded with bookmakers who ply their trade with members of the public. Being bookmakers they only take cash. They do not take cheques and do not give credit unless they really know you well. Huge amounts of cash change hands before every race — the same happens at Aintree for the Grand National and at Cheltenham for the Gold Cup; that is the race that all the Irish gamblers follow.

I wanted to con those sharp-witted people, the bookies. The first thing is to get the bookmakers interested in you as a gambler. I would ask for odds up and down the line of bookmakers, trying to see who would give us the best odds for big money bets. Roman did the same and he became famous amongst the bookies. They called him the Yankee Kid.

The big gamblers bet a lot of money. In those days the biggest notes were twenty pound notes, called "Shakespeares" because of the great man's portrait being printed on the reverse. Later they printed twenty pound notes with Fara- day's picture on them. "Faradays" never caught on, but now they're changed to Elgar's portrait perhaps who is equally anonymous to the people who deal in

large quantities of cash. Elgars will never be the new name for a twenty pound note.

Gamblers and bookmakers don't want to waste a lot of time counting out money so they usually take packages of banknotes sealed in clear cellophane by one of the high street banks. Neither the gambler nor the bookmaker would like to break open and count a sealed package because once you have broken a packet open it has to be counted every time it is used. That's what I banked on.

I managed to get the same clear cellophane and the same type of sealing machine that the National Westminster Bank used to seal parcels of notes. The machine did not cost much. I went into a branch of the bank and asked for a supply of paper bands to wrap up money. The cashier handed me over a small wad of bands for five, ten and twenty pound notes over the counter; I discarded the five and ten pound bands. The rest was easy. Putting a real twenty pound note on the top and a real twenty pound note on the bottom of a bundle of paper cut to size, I sealed up a number of parcels. I called these "tops and bottoms." Now I could place £1,000 bets and if they lost I would lose £40 but if they won I would win as though I had placed £1,000 bets.

The first time I used my tops and bottoms I didn't know if they would work. The great danger was that a bookmaker would break open the pack in order to check the notes. I took Jaffa with Roman. The bookmakers knew Jaffa very well.

Jaffa was a ticket tout. He could get tickets for all the events, Wimbledon, the Cup Final and so on. He even once got tickets for the Queen's garden party! We called him Jaffa because his hair was orange and with the million or so red freckles on his face his whole head looked like a Jaffa orange. Jaffa loved champagne; he never drank anything else.

His job was to "smother" us, in other words to stand close by and when Roman or I gave a bookie a packet of money. If the bookie looked like opening it up Jaffa was supposed to step in quickly and shout, "Hey, don't open that — I'll have it and give you the money loose." He'd grab it and give them real unwrapped money in exchange. He was supposed to be there for me first, and then Roman.

I went up to the bookies and looked for Jaffa next to me. He was miles away. He was pretending that he couldn't get to me. The truth is he was scared. I had rowed him into the coup; the first race was nearly off and Jaffa was nowhere to be seen. I took the plunge and made the bet. The bookmaker didn't even think about opening the packet. He went to give me a ticket. I told him that I didn't want a ticket and asked him to remember me. I asked him to save the sealed packet for me if I won and instead of slipping it in his bag he put the packet into his side pocket.

I then had to go and watch the race. I didn't know if the bookmaker would open the packet or not. I had given Jaffa strict instructions to watch the bookmaker who had got the tops and bottoms like a hawk from the moment I left the bookies' enclosure to watch the race. Of course, I had to be seen to watch the race. When I came back after the race, my horse won, it was all sweet. The bookie reached into his pocket, got my packet out, gave it to me as part of my

winnings. From then on I knew that it would be safe. I had him. I didn't need Jaffa.

Of course, having seen that everything was sweet, Jaffa stood next to me every time I handed other packets over. He could see that everything was now sweet, so he was happy to take the risk for his share of the coup. After the first day when I was sure that the scam worked, I didn't need Jaffa's help. We didn't need smothering at all. After that I downgraded Jaffa's role to that of a driver and minder.

Now it wasn't easy to find winners. It is the hardest thing in the world. I was up all night studying form. I bet my tops and bottoms and kept winning. I didn't win every race, I only had to win a race a day to make money, but betting with the same bookies meant that when I did win I got my tops and bottoms back and their own real money. Then I stopped betting.

One day I lost on every race. To make matters worse, the horse came a close second in the very last race of the day. I was sick. At odds of eight to eleven I had put £5,000 worth of tops and bottoms which stood to win over £3,600; Roman had bet £11,000 on the same horse. The bookie had our tops and bottoms packets and we were scared that he would give them out to somebody. We got back in the car and went home. I told Roman that I was so hungry that I had to have some pie and mash. We stopped in Hammersmith for pie and mash with lashings of the green gravy they serve with it called liquor. There was a bookmaker's shop next door so I went to see how another horse had got on in another race.

On the board, which was written up in chalk, was the name of my horse as a winner of its race. I told the girl working there that she had made a mistake. She said, "What do you mean?" I pointed out the horse came second, not first. She told me that no, it had won. There had been a steward's enquiry and the first past the post had been disqualified for something that happened at the start.

We drove back as quickly as possible. The bookmakers were getting drunk in a beer tent together. When my bookie spotted me he called me over and gave me my winnings. He gave me all my packets back, and he gave Roman all his packets back except for one. We were one packet short. We didn't know who had it.

Next day I decided to go to the racecourse to get some more money and hopefully get my missing tops and bottoms back. It was unlikely that the bookies would have given it away. They know that punters are superstitious and try to look after their customers.

Roman and I had been driven down to the racecourse by Jaffa. Jaffa gave me the tops and bottoms in a plastic bag and hung on to the real money. As I started walking to the track I got a feeling. I told Jaffa to give me the real money and I gave him the tops and bottoms. I told him to sit in the car, stay there, not to come into the track, not to move under any circumstances. I told Roman that we would only bet real money today.

Inside the track I noticed that the bookmakers were not very friendly to me. They tried to appear normal but something was wrong. I told Roman that something was up and to leave the course at once. I approached the bookies' boards and studied the odds. All of a sudden five big men who were obviously plainclothes policemen surrounded me. I shouted to the bookmaker "Quick! Quick!

They are trying to rob me!" The police identified themselves, arrested me and took me to the local police station.

They told me that they had a report from bookmakers that I was betting with phoney money. I said that was nonsense. These bookmakers did not like losing. They had the hump. They had been losing to me that was all. Take me to these men — I wanted to confront these terrible men who had accused me of cheating.

First the police wanted to ask me a few questions. Could they look at my money? Yes of course they could. Could they open the packets of money? The policeman in charge took a pair of scissors and started to cut a packet open. "Oh for God's sake," I said. "Don't do that; it's hard to get these from the bank." He smiled wryly and cut the first packet open. I had another thirty packets and he opened every one. The money was real. I could see his face dropping each time he cut another packet open.

They took a statement and escorted me back. I went to the bookmaker and swore at him. "You told them that I was giving you dirty money! You bastard."

"It wasn't me."

"I don't care, you are all together." I asked the policeman, "Was it him?" The cop confirmed that all of them had given information against me. I told the bookie that he would never see me again. He had lost me forever.

The police asked me how I got there. I told them by train and they gave me an escort to the railway station because of the large amount of cash that I had on me. Roman had left as soon as he saw that I was arrested; Jaffa had deserted even more quickly than that. I met them at the Marie Lloyd.

I asked Roman what he had done. He said he left as soon as I was arrested. I said that was the best thing he had ever done because he didn't know what I was going to say. "But," I said, "the cops nicked all the money as evidence."

"No," said Roman.

"Yes," I said, "but the cops gave it back."

"No," said Roman.

"Yes," I said.

Funnily enough years later when I was watching horse racing on TV I saw that fat old bookie, still taking bets at the race meetings. He looked prosperous, but then they all do. You don't see any poor bookies, do you? This one was no exception even though he had lost quite a lot of money to me.

ROMAN AND I USED TO GO to the Cheltenham festival every year. Cheltenham is a big horse race meeting favoured by the Irish who come over especially and which takes place over three days. Roman and I always took different rooms in the Queens Hotel and to everyone there it was as though we never knew each other. I adopted the identity of Mr Goldman.

On the first morning of the festival I used to sit in the hotel lobby, have a cup of tea and play patience with *The Sporting Life* by my side. I looked like every other punter who had come up for the races and was whiling away his time in the early morning. Perhaps I was a little more bored than most.

Invariably an Irishman would come up and say "Do you play cards then?"

"Oh, I'm just playing patience," I'd reply. I was playing with juice.

"Do you fancy a game of cards?"

"Not really; it's not much fun, is it, just two of us?"

"What about a game of poker?"

"I'm not very good at that," I said, "but I will play if you can find somebody else."

He would look around the lobby. He saw seven or eight people. He would ask them all if they wanted to play. When he came to Roman who just happened to be sitting a few yards from me he would find someone keen to play.

"Goddam it, I've been sitting here pissing myself. I sure as hell want to play with you boys."

The Irishman would then find Jaffa, then Wank-Dog all sitting around the lobby, all wanting a game. We would play in the lobby. People would watch, and as one dropped out, his place would be filled by another. Tim would drop out first and his place would be taken. Then Wank-Dog would leave, and his place would be filled. Eventually we would have five or six punters all eager to make their contributions. As we knocked one out, another would take his place at the table.

We played there in front of a crowd of 200 people all through the day and the night and every time we won they clapped and cheered us. They might not have been so enthusiastic if they had known that we were playing with juiced cards.

As soon as one lost his money another grabbed his place. One Irishman said, "Don't anyone take this fucking seat." He pointed to the chair with his size ten shovel hands as he spoke declaring his precise interest. "I am going up to my room to get some more money. If anyone takes my place they'll have to answer to me." He waved a huge fist in the air. If he had known that I was cheating he would have used those hands on me.

He went up to his room, got his money and came down and lost it to us. They were queuing up to lose money to us with our crooked cards. It was great fun.

BACK AT THE MARIE LLOYD, Jaffa told me that he had a source of buying "moody" airline tickets very cheaply that he could sell at full prices.

The Marie Lloyd was a good place for business opportunities. People unwound after a hard day's work and loved to talk to each other, bouncing ideas around for exploiting all kinds of business opportunities. I could have gone into real estate, clothing, food processing, minerals, stocks and shares or record production. Jaffa's opportunity was in the travel industry.

He asked me to join him in it. It sounded suspiciously too good to be true. I didn't know much about airline tickets — if I needed one I bought one from a bucket shop — and I did not fancy spending days learning all the ins and outs of the travel industry. I did not know how the industry worked or how I could convert any moody airline tickets into cash. I didn't fancy taking a plane with a moody ticket.

I have always made it a principle of not meddling in things I don't understand.

I didn't understand the way of selling moody airline tickets, the controls that the airlines put in place for this or how the buyer could get full value for them if he was not going to use them himself. It also seemed to me that the airlines, by selling to the cheap bucket shops, had carved a niche of their own in moody airline tickets and I knew that I just did not have the expertise. I told Jaffa that I was not interested in this and if he wanted to, he should carry on by himself. Jaffa told me that I was crazy. It was a great coup, he said.

He bought a few of these airline tickets. He resold them to people in the club for a very good profit. The buyers travelled on them and there were no complaints. Jaffa then bought a very large amount of tickets, seeing how well the trial had worked — or rather, he paid for a large amount of tickets but never got delivery of them. He had been conned.

Three or four months later, when Jaffa finally realised that he was never going to get the airline tickets, he asked for my help. He told me that he had been buying the airline tickets from a midget. As soon as he gave the midget a big lump of cash he never got any more tickets. I asked Jaffa what he wanted. Jaffa thought that he had to frighten the midget into giving the money back. I agreed.

There was no way that I was going to harm the midget, but I figured that if he was scared he would give Jaffa his money back. The rest of what I describe happened entirely on the spur of the moment. There was no pre-planning involved; everyone seemed to know what to do and what to say. And although all of my other scams have been meticulously planned and rehearsed, the work that we did with the midget was entirely made up as we went along.

I said that we had to first capture him. Barry, my partner in the club, Jaffa, Roman and me all drove to the midget's house. We rang the bell and his girlfriend opened the door. She was well over six feet tall. She invited us in and gave us a cup of tea because her boyfriend was not at home. She smiled at all of us as she brought out her best china on her best tray and made sure that we had small paper napkins for the biscuits. The five of us were juggling our tea and small plates of biscuits on our laps and making polite small talk.

She was a very sexy looking lady, and while I could understand why the midget wanted her as his girlfriend I could not understand why she wanted a midget. Sometimes life is so mysterious.

After a short while the midget came home. He was extremely ugly, even for a midget, and that made his girlfriend's choice even kinkier. He saw us all drinking tea in his living room.

"What's the matter?" he asked Jaffa, who was the only one of us that he recognised.

"We have got to talk to you," I responded. "Can you come with us?"

"Of course I can," he said.

He finished the cup of tea that his girlfriend had given him, stood up, kissed her, walked out of the house and got into my car, which was a large Lincoln Continental. As soon as he got in the back of car we made him lie down on the floor and drove off.

It was late November and cold and misty. Fog was gently floating all around. Jaffa had the keys to a wholesaler's fruit store in old Covent Garden, so we drove there. When we arrived the setting was perfect. The store was in the old market, in a road covered with cobblestones. The fog made the place eerie and it was very quiet. The cobbled street was very narrow and the Lincoln just managed to get through. The store had a wooden roller shutter, and when we opened it, it made the most frightening noise, like something out of a horror film.

As soon as we opened the doors we threw the midget into the office, which was divided into two rooms, separated by a glass partition.

"Now listen, you midget," I told the midget. "Jaffa got the money he gave you from me. I want my money back. I'm sorting this out. Right, get in that fucking room." I pointed to the other half of the office. Barry and Roman followed him in there. "Right Jaffa," I said, "You stay here you because you're first."

The midget couldn't see through the smoky glass partition. But he could hear what was going on and see the shapes of people. Barry switched the light off in the midget's room but I left my room in bright light. The effect was brilliant.

I looked around. I found a melon, a lump of wood and a large bottle of tomato juice. I said to Jaffa, growling at the top of my voice, "You have fucking had it."

"No!" said Jaffa playing his part to perfection.

"Yes," I shouted. "Right, Jaffa, where's the fucking money?"

"I swear to God, I don't know!" screamed Jaffa.

I hit the melon with the stick as hard as I could. It made a dreadful sound. Jaffa screamed.

On the other side of the glass the midget turned white. "That fucking Syd has gone offside now!" Barry said to the midget in darkness.

Whack! I hit the melon again and threw some tomato juice over the glass partition.

"Oh!" screamed Jaffa, "no more!" Jaffa deserved an Oscar.

"Oh dear, he's way offside now," Barry whispered confidentially to the midget.

Whack whack whack, the melon took a real beating. The midget became more petrified. Whack. More tomato juice over the door and glass. Whack whack!

"It's the midget, he's took it!" Jaffa blurted out. At last! He had grassed the midget. He did not grass him right away, but he grassed him in the end.

Whack whack whack! I thought that the melon deserved a few more whacks even though Jaffa had coughed up.

"You're next," Barry told the midget. Roman came into the room with the midget and Barry. He shook his head at the midget. His eyes were full of pity.

"Listen, listen…" he stuttered.

"Right throw that cunt in the fucking basement," I ordered. Roman slowly turned away and almost reluctantly did as I ordered.

Barry picked a limp Jaffa up and threw him in the basement, pretending to be rough with him. "Bring that fucking midget in here," I ordered.

"But he's only little," protested Barry who had now become a friend of the midget.

"Bring him here!"

"Sorry boy," said Barry, as though the midget was one of his very best life long friends.

"Bye kid," said Roman heartlessly. Roman had not formed the confidential relationship with the midget that Barry had.

They brought him in the room. I have never seen someone so petrified in my life. The lump of wood was covered in tomato juice; red stains were around the room.

"Sit in that chair" I ordered, but before he could do so I hit the chair so hard with my lump of wood that the chair broke in pieces and there was nowhere for the midget to sit.

"Right you fucking cunt, you heard what happened in there. He said you've got the money, where is it?"

"I swear to God on my life you'll have it tomorrow."

I gave him a few whacks with my lump of wood. I hit him reasonably hard. As a midget con man he probably relied on his being a midget as a kind of protection. I hurt him, but not as much as I would hurt someone normally. He was after all a midget. He was now literally shitting himself. "Now take that midget out of here and throw him into the street. Get that Jaffa out of the basement and take him to the fucking hospital!" I growled.

Barry and Brian picked up the midget and carried him outside. His little legs refused to move for a second or two but then his instinct took over and the midget ran away as fast as his little legs could carry him.

The next day the midget paid up in full.

I got no money for that little performance but I did get paid for my acting skills in another play.

IN THE MID EIGHTIES many foreign banks established themselves in London and sought customers. London became free of foreign exchange restraints and all the rules that had previously existed for the protection of borrowers were abolished almost overnight. Foreign banks were queuing up to enter the market. It was a bit like the mad rush when Italy made pornography legal. Many solid, criminal, Shylock businesses were ruined in the process.

I met one foreign banker who was in charge of a large branch of his bank. He was a very tall thin man whose name, when translated, meant something like "Mr Small" so I shall call him that.

Charlie Mitchell introduced Small to me. Do you remember Charlie? He had sold me the Marie Lloyd. Charlie was a well-known gangster. I had a lot of laughs with Charlie.

Years ago Charlie asked me to come with him to collect arrears of rent from a Chinaman. When we knocked on the door of the debtor, a Chinaman answered. Charlie said that he had come to collect £25 arrears. This surprised me, as I did not think it would be worth Charlie's while to attend to this in person. The Chinaman did the "me no speak English" routine with Charlie. Charlie went ape shit.

"Don't you give me the 'me no speak English' crap" he said and started to smack the Chinaman. Suddenly, what seemed like dozens of Chinamen came pouring out of the door and attacked Charlie and me.

We were there for ten minutes getting the shit beaten out of us, with us trying to give as good as we got. In a short while we were beaten off but not before a few Chinamen had blood streaming out of their noses and the whole front garden was wrecked. When it came to fighting Charlie never went in for half measures.

When we left I asked Charlie why he bothered with all this for £25. He said, "You know I don't need the money, but it was a lot of fun wasn't it!"

Charlie Mitchell spoke in a deep whisper, a kind of hard growl. So if he said "no" it sounded terribly threatening and menacing. If he asked for a bottle of wine he made it sound as though he was threatening to chop the wine waiter's legs off.

Charlie was known for stashing money away. He always had a nice house but never wanted to show that he had money. He always wore the same clothes, drove a scruffy car — that did not matter to him. I suspect he had a network of safe deposit boxes (probably in places like Harrods) that he filled from time to time. I think that apart from his house and going on holidays the only luxury that Charlie permitted himself was to pay for his son's private education.

He used to tell me proudly, "The boy sorted three of them out today at that fucking school." He meant that his son had had three fights that day and had won them. Charlie's son was a nice boy and only fought because that was what his father wanted. It seemed to me to be a complete waste of a decent education.

But for all his faults Charlie was a fair man and he expected you to be fair back. If he introduced me to Mr Small I knew that Charlie would want something if I managed to work a scam on Mr Small. I myself was happy to reward him if I managed to work something. Charlie knew me as an expert con man — Charlie had no idea how to con, he left everyone to his own expertise.

I met Small under my name of Sydney Goldman in his swish offices. Charlie had telephoned to say that I was okay and to give me what I wanted. I explained to Small that I needed £40,000 for a deal which would be highly profitable but slightly unconventional.

He asked me what sort of deal. I said that I could buy £40,000 worth of top quality pornography from a good source, which I could resell for eight times that amount. I would reward Small by giving him a kickback from the pornography profits. I suggested twenty-five percent of the profits and he was happy with that. He stood to make £70,000 personally out of the deal. I told him that I only needed to borrow the money for three weeks; that would be how long it would take me to buy the porn and resell it to the buyer that I had lined up.

Mr Small thought that this was an ideal business proposition for the bank. We filled out some loan account forms, signed an agreement and then Small lent me the funds. I can't remember now what we put on the forms as the purpose of the loan. I know that I did not disclose that the loan was for the purchase of pornography. No doubt Small never told his bosses this, either. Small also pointed out that the bank would have to charge me quite a hefty interest in view of the fact

that the loan was unsecured. I agreed.

I took the £40,000 in cash with me when I walked out of the bank. It was nicely bundled in twenty pound notes.

Two weeks later I rang Small. "Bloody hell, you know that money you lent me?"

"Yes, of course."

"It's dreadful news; I do not know how to tell you. Well, I've been rolled. I turned up to buy the pornography but someone jumped me and stole all the money."

"Do you know who did it?"

"I have not got a clue. They hit me on the head and knocked me out. I've still got a sore head."

"Oh dear, oh dear, what can we do?"

"There is only one way we can get the money back. Buy some more pornography and use the whole profits to repay the loan."

"Would you do that, I'd be so grateful!"

"I would do it for you, but I need the money to buy the porno."

Small lent me another £72,000. He never saw Mr Goldman again. I gave Charlie £20,000 as a drink from the scam.

When I opened the account at Mr Small's bank, although I gave a false name I gave a real address, which was a friend's house. I last saw a bank statement sent to Mr Sydney Goldman a few years ago. The £100,000 I had borrowed was earning a lot of profit for the foreign bank. I now owed them £690,000. It made me wonder. Did this mean that the loan, which the bank must have known to be completely bogus within a few months of making it, had been carried in the bank's books for years? Was the £690,000 that I owed shown in the shareholders' accounts as part of the bank's assets? If so, what other Mickey Mouse figures are in the bank's published balance sheet on which investors rely? It makes you wonder, doesn't it?

ONE DAY CHARLIE ASKED ME to help him out with a problem. Now Charlie was a real villain. He would have gone to any lengths to get anyone who had screwed him. His business was importing stolen gems and reselling them. He received bundles from abroad, which he paid for, kept back a few stones and resold the bundles. If you agreed to buy gems from Charlie for a price, then Charlie gave you the gems and expected to be paid as arranged. It was no good delaying payment or giving him the stones back. As far as Charlie was concerned you owed him the money and you had to pay him.

Charlie told me that one guy owed him £40,000 for some gems. It was no good doing any violence on him, because the debtor would have Charlie arrested. Charlie did not want to be nicked because he would end up in prison. Charlie's problem was how to get the money without risking jail. He discussed it with me and I told him about Jaffa's midget. I advised that the only way to do the job was to frighten his man. It would be necessary to capture him first. I thought capturing

someone with Charlie would be going in a bit strong because you could never be sure what he'd do, but Charlie was insistent. I agreed to help.

I could never understand why people thought that they could get by without paying Charlie. And yet some of the people who dealt with Charlie from time to time thought that they didn't need to pay him.

Charlie bought a solid oak coffin. I do not know where he bought it but I can imagine Charlie going into a funeral parlour and buying a solid oak coffin in that harsh growl of his and having it delivered. When he got the coffin, he drilled some air holes in the bottom of it. He then put it in a transit van and I went off with Charlie, Barry from the Marie Lloyd, and two of Charlie's men to collect the man who owed him the money.

"Here, Syd, look at that coffin. That is none of your cheap cremation jobs. That is solid oak."

I saw the holes drilled in the bottom of the coffin.

"What did you drill the holes in the bottom for, Charlie?"

"So he can breathe."

"Won't he see them and know that we're not serious?"

"No, he won't see 'em. I don't want to lose him. I want me money."

"Looks strange, Charlie."

"Don't worry Syd, he won't see them."

When we arrived at the man's house late one night, he turned out to be a big fat man who perspired terribly. We knocked on the front door of what was an expensive house in Chelsea. The man opened it himself.

Charlie said, "I've come for the £40,000 you owe me."

"I'm terribly sorry Charlie, but I have told you many times that I just have not got it. It is impossible. I cannot get my hands on that sort of money, as you must know. Now I know that you are very disappointed but I am afraid that you must face the facts. It can't be done."

"What about you giving me some of it now?" growled Charlie, who looked very disappointed.

"Not a penny I am afraid. I just don't have any money."

"When will you have some?"

"Charlie, I just don't know. Now, I don't want to be a bore but if I haven't got it you'll just have to swallow it, won't you," said the man who was gaining in confidence as Charlie became apparently more despondent.

"All right, well if that is the case, I'll just have to swallow it," said Charlie and turned as if to go. But having turned his back on the man he spun around and punched him in the face so hard that he knocked him out. Charlie picked him up and between Charlie, me and the others, we put him in the back of the transit, locked it up and drove off. Charlie was sitting in the front of the van with his driver. Three of us were in the back of the van with the coffin and the man whom we tied up. We put a gag around his mouth but were careful to leave enough room so that he could breathe.

"You've had it now," Barry told him as they stuffed him into the van next to the

coffin. "You've really upset Charlie."

"Stick him in the coffin," Charlie shouted from the front of the van. We put him in the coffin.

"Hang on a minute." Charlie transferred himself to the back of the van.

"Right, you've had it," he growled.

He picked up a hammer and some nails and waved them threateningly. "Just you wait," he growled. We placed the lid on the coffin.

The van drove to Wimbledon Common, which is really not the place you want to be after midnight. We drove on to a quiet part of the Common, hidden by trees and stopped. We got out with Charlie growling instructions at us and lifted the coffin containing a wriggling man.

"Put it down," growled Charlie.

We put it down.

"Is the hole ready?"

"Yes, Charlie over here." Charlie walked out of sight of the man in the coffin.

"Are you sure that is six foot?"

"Yes Charlie."

"It looks more like four foot to me. Make it deeper."

We got some spades and the man in the coffin heard the noise of soil being dug up.

"Fix the lid."

We did as we were told. The man in the coffin started crying.

"Nail it up." We nailed it up.

"Right, lift it and drop it in into the hole."

We lifted it up. We had not, of course, dug a hole, so we lifted the coffin to shoulder height and then dropped the coffin on to the ground.

"Cover it up."

We shovelled some earth over the top of the coffin.

The man in the coffin was screaming.

"Stop," said Charlie. "Lift it out of the hole."

We picked up the coffin slowly and lifted it up and walked a few yards with it and set it down.

Charlie took out a crowbar and opened up the coffin lid. The foul smell of shit and urine hit us as soon as we got the lid open.

"I've decided to give you one last chance. Can you find the £40,000 by tomorrow? If you don't you'll go back in the ground!"

"Yes, Charlie, I promise you'll have it tomorrow if you let me go."

"Get him out of the coffin."

We did as we were told.

"Put him in the van."

We did what we were told.

"Fill up the hole."

We could not do that because there wasn't a hole so we mooched around with the shovels.

"Load the coffin and get in the van."

We took the man home and the very next morning he paid Charlie what he owed. What would have happened to him if he didn't pay Charlie after that performance? Well, let me tell you there was no way that I would have got involved in any rerun. Charlie would have killed him.

We got rid of the coffin. We put it on a skip that we saw on the way home. So, if you found a solid oak coffin on a skip outside your home in West London, a very good quality coffin but smelling somewhat and with air holes drilled in the base you now know why it was there.

Charlie died a few years later over the price of a bottle of champagne. He had always had heart trouble. He went into a nightclub in Marbella one New Year's Eve and bought champagne. When they brought him the bill he saw that they charged him £100 a bottle. Charlie disagreed with the price, refused to pay, had a fight with the bouncers, got badly smashed up and went home with his wife. Did Charlie enjoy his last fight? That night he died from internal bleeding. It really wasn't worth it, Charlie. Not at all.

I spoke to his wife several months after he died to see that she was well.

"Hi Pat, how's things? All right girl?"

She told me that she was coping. But then said, "You know, Syd, I never found where Charlie hid his stash. I have not been able to find a penny! He hid it all so carefully that even I can't find it."

And that makes you wonder what it was all for.

GOING, GOING, GONE

MRS THATCHER WAS RE-ELECTED AS PRIME MINSTER, but Syd didn't vote. Her government now encouraged enterprise and income taxes were being lowered. That didn't matter to Syd, who didn't subscribe to that particular club.

There were large amounts of money in the British economy inflated by the boom and some of it ended up in Syd's pocket — briefly, of course.

I did not see him that often but he sometimes came to see me with his son, David. The kid was a street-wise truant who was supposed to be unmanageable but he adored his father and would do anything for him. While Syd and I discussed his commercial affairs in my office, David would wait outside patiently, not talking to anyone. If the meeting went on longer than anticipated, Syd would pop out, give David a fiver and send him to the McDonald's on the corner for Big Macs and coke all round.

If, when you first opened this book, you thought that this was the story of a loveable rogue then you have found that rogues are not loveable. Syd drew no distinction between the people he swindled and although he enjoyed the irony of cheating someone who was trying to cheat him it was not essential to the coup that he disliked the mark. If you ask him, he will tell you that he mainly robbed from greedy bastards who were themselves crooks. But those were not his only victims. The truth is, he would show no scruples when it came to choosing victims — he took them wherever he could find them.

Around this time he was approaching the height of his powers. Money was easy to get hold of, ideas for scams were no problem and he had the security of a steady business at the Marie Lloyd Club that acted as a cushion. He had not been in prison for many years and apart from being picked up for tops and bottoms at the racecourse he had not been arrested or even come to the attention of the police.

But you can't carry on like this forever. Sooner or later the police, who are not stupid, get their suspicions and target the people that they think are up to no good. In Syd's case, I am sure that he was targeted but he was careful. He left no clues and meticulously planned his scams to avoid being caught.

He tells me that there are some aspects of his life during this period that he can never reveal, that the people he conned are very powerful and have long memories. So we will have to make do with learning about his scams against the less rich and not so influential.

IN LONDON THERE ARE FOUR MAJOR auction houses: Sotheby's, Christie's, Bonhams and Phillips. These places have had their share of scandals over the years. They present an image of great solidity, respectability and knowledge but over the years they have sold many millions of pounds of fakes or stolen art works. The staff give a great impression of being perfect gentlemen. But I have done this also, such as when I was the yellow-scarfed bandit or when I operated the casino in Bonair.

I thought that I might be able to win their confidence and pull off a kind of "long firm" coup against them. A long firm is one of the oldest cons around and has been perpetrated upon the business community for generations. What happens is this. A new customer wants to buy goods on credit. The seller does not know the customer so does not allow credit at first. After a few transactions, credit is allowed. The buyer builds up a greater and greater pattern of trade, getting more and more credit each time until pop — he never pays for the last transaction, which happens to be the biggest.

The first thing that I had to have was a new identity. I managed to get an official birth certificate of a black man who died in Canada called Vernon Eric Wilson. With the birth certificate I went to Toronto and got a passport in that name, and using the payment established my identity and opened several bank accounts and credit cards in that name.

Opening bank accounts was easy then. These days there are money-laundering regulations so when you go to open a bank account, a (false) passport is not enough. You have to provide a gas bill or telephone bill. This would not prevent me from getting one: when you sign up for a gas supply, the gas company does not ask you for proof of your identity and I do not understand how the authorities expect these requirements to prevent a money launderer, except the rankest amateur. That, however, is their problem.

I knew someone who regularly bought jewellery from the auction houses. He bought it, sold off any good pieces and sold the rest for scrap. He would make a small profit, but it was hard work. Using this as my inspiration, I thought of a coup to whack the auction houses. I hoped that after two months I would have the auction houses eating out of my hand. It took, in the end, three months.

I went to every jewellery auction. I know a bit about jewellery. Each time I went I bought some jewellery and then I sold it to businesses who dealt in second hand jewellery. Every time I either made a little money, or lost a little money. For example if I bought £10,000 worth of jewellery I would sell it for less, say £9,300.

I used to pay for every purchase with a cheque in the name of Vernon Eric Wilson. The auction houses did not know me at first. When I gave them the cheque I told them that I would be back three or four days later to collect the jewellery, after the cheque had cleared. That way they were not taking any risk on my cheque bouncing.

After a few weeks of buying, I started to collect the jewellery after two days — just before the cheque cleared. After two months trading, I went in the next day after I gave them my cheque. Eventually I would give them the cheque and they

would give me the jewellery at the same time. I made sure that every cheque cleared. This is an essential part of winning confidence. Trust had to be earned. The auction houses liked me. But they had to trust me. Trust was earned by dozens of transactions all of which provided good business and turnover for the auction houses.

After three months of this, all the auction houses knew Mr Vernon Eric Wilson. All of them trusted him. I was going to three jewellery auctions each week. Each auction house gave me my jewellery against my cheque. Each house had been comfortable doing this with sums of between £20,000 and £25,000. I was working harder on this jewellery business than I had ever worked before. And my losses over three auctions averaged £800 per week. I could afford that.

I also tried to do the same thing with Spinks, the coin dealers. The first time I went there, I wrote out a cheque and gave it to them and to my surprise they gave me the coins that I had bought there and then. They asked for an address and telephone number so I gave them that of a relative and left. The very next day I got a telephone call from them. I had given them a cheque for about £15,000, but I had made an inadvertent mistake on the cheque. The words and figures did not agree. How clever of them to spot the error! Oh no, they said, they did not spot it but their bank did. They had presented the cheque at the bank and the bank had spotted the mistake. Could I replace the cheque?

The man on the telephone sounded terribly worried. I assured him that I would be in immediately to give him a new cheque but I felt that he did not believe me. He thought, I am sure, that Spinks had lost the money.

I went straight away to Spinks and gave them a fresh cheque. Spinks thought that they would never see me again. It had been a genuine mistake on my part. But now I could have anything that I wanted from Spinks; credit was no problem. In the end I never did row Spinks into the coup because they never had an auction that was held close to the other three auction houses. For the purposes of my coup there had to be some auctions held close together and Spinks never had an auction around that time. It was a shame because after the mistake on the cheque, Spinks thought that I was one hundred percent trustworthy.

Auctions were held on Tuesdays, Fridays and Saturdays. I told all the auction houses that I had some special customers coming from America who wanted to buy a lot of jewellery. They did not have enough and I would have to go to all the other auctions and they still did not have enough. I showed great anxiety because I did not want to let my customers down.

I bought a lot of stuff on the Tuesday. I bought almost all the stuff in the Friday auction and most of the Saturday auction. Each time I gave a cheque. On the Friday auction, we got a friend to put some of my own jewellery in worth £6,000. I bid it up to £14,000. I included it in my cheque. Sotheby's had to pay me (through my friend) £14,000 for the jewellery, which was in my possession, even though my cheque had bounced. This was a coup within a coup.

Of course all three cheques bounced, Mr Vernon Eric Wilson disappeared, and I sold all the jewellery. It was a big coup, but a hell of a lot of hard work went into it.

I regarded the auction houses as fair game. They have sold stolen works of art, good works of art for less than they should and now resist employing a code of conduct to prevent them dealing in stolen works of art. I saw a television programme in which, surprise, they "revealed" that auction houses would be prepared to value an old master brought to them in the back of a dirty old van. One house had valued the painting six months earlier for the owner, then valued it again at one third of the price, not even recognising it and not bothering to call up the owner to ask what his painting was doing in a dirty old van.

It seems to me that being an auction house is not a business that can be run very well unless you are less than fussy about where your art comes from. Otherwise you will not have all that much to sell. It's a bit like a car boot sale.

I am not suggesting that it is right to steal from dodgy businesses, nor am I trying to justify what I have done. I know that stealing and fraud are wrong. But those have been my life from a very early age and in the end it becomes hard to live in any other way.

AS SOON AS I FINISHED THE AUCTION COUP, I was arrested — not for the auction coup but for a VAT fraud. It was nothing impressive. I simply defrauded Customs and Excise out of quite a lot of value added tax. I am rather ashamed because it was a common crime and very crude. What was worse, I got caught. I pleaded guilty but because of my record and the seriousness of the crime I was refused bail and sent to Brixton Prison while awaiting trial.

At prison I was transferred to the hospital wing. Only two types of people go to the hospital wing, sick people and murderers. I was one of the sick people because of my angina that was beginning to develop.

After a few months in the hospital wing, a prisoner was transferred into our ward. It did not take me long to figure out that the prisoner was a lunatic. I thought that he would end up attacking someone, so every time I was around him I had to be on guard in case he attacked me. He was a big lad and, I thought, completely, viciously insane. If you saw him and you heard the phrase "criminally insane" you'd know that one fitted the other to a tee.

One day I was in a small room with the lunatic and a hospital warder. The lunatic had been acting strange for some time and I thought that the signs were there that he would soon go apeshit. Sure enough when the warder was not looking he attacked him. He grabbed him around the neck and tried to break it. I could not let that happen so I jumped in as hard as I could and fought the lunatic. The warder was out of it, nearly choking to death. When I fight I fight viciously — there is no point in fighting any other way — and taking the lunatic by surprise I was able to lay him low. I didn't give him the slightest chance and concentrated on knocking him out. I took a few whacks but as I bounced his head on the tiled hospital floor he went down and stayed there. Afterwards the prison governor came to see me and thanked me for saving the life of his prison officer.

At my trial the prison governor wrote a private letter that they gave to my defence barrister. After I pleaded guilty, the barrister asked to hand the letter to

the judge (this time a very handsome man) and asked him to read it, but not out loud in open court. The judge read the letter from the prison that detailed how I saved the hospital warder's life. He said that I had done a very fine thing and, in all the circumstances, would sentence me to the time served on remand. I was free.

To celebrate my newfound freedom someone bought me tickets for a show. It was for a black musical, called *Ipi Tombi*. I took a girlfriend to see it. I was not very keen on seeing a black musical but the seats were good, right at the front. Much to my surprise the show was really good. One of the show's dancers kept looking at me. I waved to her. She waved back. That was Phyllis.

After the show I bought tickets for the rest of the week, all in the same front row spot. I went every day and waved to the dancer. She always waved back. I found out who she was and asked her out to dinner. She agreed, provided she brought a friend and I brought Roman for her friend. I took her to my favourite Italian restaurant in Richmond. We had a terrific evening at the end of which our dates started singing the songs from *Ipi Tombi*, which was fantastic. Everyone in the restaurant enjoyed it.

I married Phyllis and for the next year lived with her. It was absolute hell. First of all, she hated Roman. For some reason, she couldn't stand him, so I saw less of him as he concentrated on his coups and I concentrated on mine. We stopped working as partners — the unbeatable partnership was no more. It was broken by a woman.

I had to have a kidney stone removed in hospital. The day after the operation I asked the doctor if I could leave because I was making a book on the Grand National horse race. He agreed to discharge me provided that I sat very still at home. I could use the phone but was not allowed to get out of my chair.

I asked Phyllis not to go for a drink after work, but to come straight home. I needed her to help me. She agreed. But by three in the morning she had not come back. I couldn't urinate without someone bringing me a container to use. In the end I was so distressed I urinated on the floor. When Phyllis came home at four in the morning I asked her why she was so late but she claimed that it was only half past ten and she missed the last bus. She was stone drunk. Until then I did not know she was a drinker. She flew into a drunken rage but eventually fell asleep. Next day after she left for work, I was well enough to crawl around the flat. I found bottles of vodka in her clothes drawers and her handbags. Even her mouth-wash was vodka. I moved out as fast as I could.

From then on we lived apart. I was no longer interested in her. From then on, I never drank again. I saw what it had done to Phyllis. I hated the loss of self-control that came with drink. Phyllis turned me into a teetotaller.

ALMOST AS SOON AS I WAS FREE FROM PHYLLIS, I got a phone call from my first wife, Carol. I had been seeing Mark and David, usually on a Sunday. I never spent any time talking to Carol, who had got herself a new man.

"Syd, it's about David." Carol's voice seemed more vulgar than when I married her, more common.

"What about him?"

"I can't do nuffin' with 'im. 'E's too much for me to 'andle. 'E won't go to school; 'e won't do as 'e's told; 'e's uncontrollable."

"What's he up to?"

"He plays truant, nicks things, stops out late. 'E's always rude. 'E's making my life 'ell."

"Well, what do you want me to do about it, Carol?"

"You gotta 'ave 'im."

"No!"

"Syd, so 'elp me, you gotta 'ave im. It's the only way. I can't 'ave 'im no more. 'E's causing me so much grief. You gotta take 'im."

"How can I take him, Carol?"

"You gotta. I'm not 'aving 'im any more."

I had to. He wasn't going to school. Carol couldn't control him. I was his father. I had to take him. I knew my responsibilities.

So David moved in to my flat with me. I got a bed and put it in the spare room. I put in some other things I thought he wanted. I went back to Carol's house. He was waiting for me, ready packed. He was pleased to see me and told me that he was glad that I had picked him up.

"Look David, you are my son. I'll always look after you. But you've got to do what I tell you. We'll have a good time but you've got to do your lessons, get an education and behave yourself."

He was only thirteen years old, and it is not easy for a man who lives the sort of life that I lived to bring up a young kid. I got him a place at the London Stage School where he could learn drama as well as his studies.

In his school holidays he helped at the club, emptying ashtrays and washing up. When I went to a meeting he would come with me, following me everywhere and trying to be helpful. He would do anything for me, run any errand. When he fetched a hamburger for me he would run all the way there and run all the way back, arriving breathless with a big smile on his face, happy to have done something for me. Whenever I went to a meeting, he would come with me and wait outside the meeting for me to finish. While I could see that he was unruly, he was not as bad as Carol said. I enjoyed him being with me; it was nice to have him around. He seemed to calm down.

It was easier to live with David than I thought it would be. He was not uncontrollable, at least not with me. He was always anxious to please me. I realised that he would never be a clever scholar, so I got him into a stage school. Although he did the normal subjects that kids of his age studied, he also studied acting and the performing arts. He was not really interested in this, but he went to school to please me. It seemed to me that he didn't understand a lot of what went on around him; in no way was he sharp. But he was loyal and loving and liked nothing more than just being with me.

When you come to think of it, my late brother Eric was a bit like my son, David. Eric was a year younger than me. But although I was clever, Eric was stupid. He was a thorn in my mother's side — he was disruptive. He got married, had kids,

and went to prison a couple of times. Like me, he followed a career of crime from an early age but I never got into any crimes with him. He always seemed too stupid and I was frightened that if I did anything with him I would be caught.

There is always a place for stupidity in every profession, even crime. Tim was stupid and his stupidity was useful because no-one would possibly suspect him to be part of a confidence trick. Eric was stupid in a different way. He appeared to be not only stupid but also crooked. He was plainly untrustworthy, aggressive, and a little frightening because he was unpredictable. I didn't really like him and I had no use for him even though he was my brother.

Years earlier when I was starting off as a croupier, I came back home one night to find my mother very upset. Eric had robbed a house and was caught red-handed. There was a French au pair in the house he robbed. She told the police that Eric had sexually assaulted her as he tied her up on the bed. He had, she alleged, touched her vagina and her breasts. She made a formal statement and complaint. Nobody believed it, not the police, not the prosecution, not Eric's friends and certainly not his family. I couldn't imagine Eric doing that sort of thing. He just would not do it. The au pair must have been making it up.

The prosecution did not even refer to this allegation of sexual assault at Eric's trial. He was prosecuted, but only for robbery, not for sexual assault. The French au pair was totally disbelieved.

He came out after a couple of years. We all treated him as a normal criminal who had been caught during a burglary. He had only been out of jail for a few weeks when he was charged with rape. It was said that he knocked a girl off her bicycle in Roehampton, took her to the woods and raped her. At this stage, we were all half believing that he was a rapist. He was my brother, my own flesh and blood. I did not want to believe that he was a rapist. He denied the charge all the way through, claiming that it was a case of mistaken identity. But he was caught hanging around the woods where the rape had taken place and had no good reason to be there.

He was sentenced for a long term, twelve years I think. He got out after about six years and met up with me. By then I had the Marie Lloyd Club and he came to see me in the club after he had been free for a few weeks. He said that he was in trouble and wanted my help. Before I could however, he was captured by the police and charged with rape again.

He denied the charges all the way through this case but was found guilty and sent to prison again; this time for a very long time. The judge recommended that Eric serve at least ten years.

Although he was my brother, he was a rapist. I could find no excuse or forgive-ness for rape or any sexual crime. All crooked people feel this way. The most hardened villain in prison, who has been paid to kill people or has killed for some insignificant insult, is treated by his fellow convicts as a decent human being. A rapist or child molester is reviled, punched, kicked, hurt at every opportunity, so the prison authorities keep the "nonces" isolated for their own safety.

Eric had a heart bypass operation in prison. I saw him at mother's funeral,

Murderers together. Eric with baby David, circa 1969.

because he was specially allowed out of prison for the day in handcuffs and guarded by warders. After only three or four years, he was released on medical grounds. By this time, I knew that he was definitely no good. I refused to help him again.

He wanted to leave England and go to Greece — he had read something about the place in prison. I guess he thought that it would be a nice place to go. He bought himself a van and drove through Europe. The drive took him two leisurely months, stopping here and there in France, Germany, Austria and Yugoslavia before he reached the mountains of northern Greece.

One day in northern Greece, the local police saw a strange light in the forest, some distance away. It was summer and there had been some forest fires. They were on the look out for arsonists. They found the cause of the fire. Eric was standing next to the flames that were destroying his van. He had piled up most of his possessions in the van and set it alight. This puzzled them. One of the policemen decided to look in the surrounding woods while Eric was being arrested. He called his colleagues over. There was the body of a young, blonde American tourist in the undergrowth. She had been raped and then murdered.

They checked with Interpol. They found that there were a dozen similar cases across Europe all of which were unsolved and all of which happened at the same time and in the same places that Eric was driving through on his way to Greece.

He was charged with the murder of the American girl while police forces from all over Europe sent detectives to Greece to interview him. Before he spoke to anyone, he committed suicide in a Greek prison. Everyone felt thankful. One vicious bastard was out of the way and my brother would do no more harm.

KRUGERRANDS

LUCK SEEMS TO COME IN STREAKS — *Syd had got himself in trouble and was preparing for three or four years in prison when a lunatic attacked a warder and Syd's luck had saved him.*

Syd's life, never predictable, was settling into a pattern. Part of the time he was a loving father. He'd take David to school in the morning and make sure that he had whatever he needed. Afternoons would be spent scheming or at the club; evenings he'd spend with girlfriends or David.

His confidence increased, as did his knowledge. You have to have incredible self-belief to pull off a confidence trick. You have to think that you are the best and that you'll never be caught. I imagine that most crooks believe that they'll never be caught — that is why they commit their crimes — but confidence men who aim at big money scams have got to believe that they can sell their story to everyone. And they usually can.

Syd was mature now and at the time of life when he understood more. He saw through motives, understood what made people tick and worked on that. He knew how to exploit weakness. He had contempt of people's motives, which arose from seeing them clearly.

He had put himself outside the law and so what was inside the law was only relevant if he could turn it to his advantage. And like an artist he was always honing his skills. He now had the confidence to take up every opportunity that came by. Whether he understood what he was doing, now no longer mattered, provided he could get some money out of it.

There were so many ways of conning people and Syd could always be relied upon to think up even more variations on that theme. Some people achieve their best artistry very early in life. These are the virtuosi, able to amaze when they are young. Others start off as ordinary plodders building on their technique slowly and tortuously. They end up better than mere virtuosi — they have by practice and application acquired depth and subtlety.

If, before you read this book, you thought that you could never be conned, then you may now have changed your mind. And be aware that you have only heard about the tip of the iceberg. There are more ways to relieve you of the product of your labours than you could ever imagine. The human mind is a wonderful thing but when put to thinking up dishonest schemes, shows its true invention.

When I studied tax law, I was much impressed with a judgment of a House of Lords judge, Lord Templeman. The House of Lords is the highest appellate court in England and although most of their lordships' "speeches" are dry, one particular passage struck me. In it, Lord Templeman, speaking about tax avoidance said, "Every tax avoidance scheme involves a trick and a pretence." He could have easily been speaking of Syd's scams. Syd creates a trick that he executes against a background of pretence. If you can unravel the trick and ignore the pretence, you can avoid being conned.

THE BBC HAD THIS GREAT television programme called *Tomorrow's World* and on it they showed new inventions. They gave me some great publicity for one of my businesses.

I bought the rights to an invention called Saniboy. It was meant to clear drains, toilets and sinks by using compressed gas. Having bought the rights I needed to publicise the invention in order to sell franchises. I managed to get a researcher who worked on *Tomorrow's World* to put the invention on TV. A few pounds changed hands.

Saniboy appeared as a five minute spot at the end of the show. I do not know what the BBC thought that they were doing, because the invention had not been properly tested but off the back of that publicity I sold hundreds of Saniboys, until I got bored with it.

For a while it looked as if Saniboy would be a really good money-spinner, but they found that if you used it, the compressed gas could blow apart your drains and waste pipes. And it did. Lots of people complained, but by then I was no longer around. Saniboy might have made a fortune. It could have been cured of its faults and turned into a real money-spinner but that was too much like hard work for me. I needed to keep up my lifestyle because as usual money burnt a hole in my pocket. Even to this day I can't account for all the money I've spent.

I had to get some more money. What better place than where everyone who is not crooked gets his money — a bank?

Mr Scrubbins (as we'll call him) was a bank manager. He was highly reputable but had two problems. He had a nagging wife and an appalling dress sense. His wife nagged him day and night. She felt that he did not push himself enough at the bank and that he let people push him around. She made sure he knew her precise feelings, many times a day.

Mr Scrubbins was one of those people who always looked scruffy. He never seemed to shave properly; there were always bits of hair that he left on his face. If he put a new suit on, within minutes it would seem old, dusty and frayed. He could never wear trousers that fitted; they always concertinaed at the ankles. His shirts never matched his suits. His ties matched nothing but what he had eaten for breakfast. But for all that, Scrubbins was an honest bank manager of a high street bank.

I was becoming very good at switching diamond parcels and thought that Mr

Scrubbins might well be a suitable candidate for a "switcheroo" job.

I was introduced to Mr Scrubbins at the Marie Lloyd as Mr Sydney Gold, a man who needed finance from time to time. I was supposed to be very wealthy but had all my money tied up in deals and investments. One of my smaller investments was the club. I asked to borrow small sums at first, always under the amount that the bank allowed Mr Scrubbins to lend under his own discretion limit. I always repaid these loans so that Mr Scrubbins built up a picture of me as a good and reliable customer.

I can plan and plot a lot; I have had good businesses that have made a lot of money. Here, I was setting out to cheat someone as a business. There is no difference in doing something straight and doing something crooked except the ending is different. Everything has to start as a straight business even though you know that it is going to be crooked in the end. You run along a straight line until the time comes when you say to yourself. "I'll take that money," and then it becomes crooked. This was a case in point.

Scrubbins got used to me borrowing and repaying small amounts. I think that the bank limited his authority for unsecured loans to £10,000 and I always acted within that figure. I made sure that I always paid him back whenever I was due to repay the loan and after a while Mr Scrubbins had confidence in my reliability.

In I go. I introduced him to my assistant, Jaffa. Scrubbins sought to cultivate me and capture all my business for the bank. This was all very fine and proper. On one occasion, he took Jaffa and me to his home to have tea with his wife. She didn't like me. Afterwards Scrubbins told me that his wife warned him against me. "She told me that you look like a crook, and she said that I have got to be careful of you. She nagged me for ages saying that no good will come of it. What does she know? She is always nagging me, driving me mad. Now she wants to be a bank manager." His wife clearly had better instincts than Scrubbins.

Having got Scrubbins into the right frame of mind, I asked him if I could borrow £80,000 that I needed for a foreign deal, buying some gems from abroad that I could resell at a good profit. Scrubbins said that he could only lend me the money if he was given some kind of security. I told him that I had a parcel of diamonds that were worth about £120,000; would they do? He said that he could take them as security provided that he had them independently appraised. I agreed.

I had to get some real diamonds that would stand up to an appraisal by the bank's expert. They had to be worth at least £200,000 so that the bank would treat them as security for the loan. I know many dealers in Hatton Garden, the jewellery centre of Britain. I knew one who could lend me sufficient stones on the basis that I would pay for them if anything went wrong.

I took the gems to Scrubbins who sent for an appraiser. There were about a hundred diamonds. He telephoned me after the appraisal and said that the valuation was more than sufficient to enable the bank to advance me £80,000. I made an appointment to visit him, to sign the papers and get the money. I made up twenty parcels and put five fake diamonds made from zirconium in each parcel. I used small envelopes that I bought from the local stationers, sealed them, signed

over the flap and put sellotape over my signature. I hid the parcels of fake diamonds in my pockets, put the remaining envelopes and sellotape in my briefcase, put the pen in my pocket and went off to see Scrubbins with Jaffa.

Scrubbins had the real diamonds in his office when I met him. He showed me the appraisal. I asked him where he was going to keep the stones. He said that they would be kept in the bank's vault. I asked if I could insure them. He agreed it would be wise to do so and told me that I would have to arrange that. I said that I wanted to keep the stones in the way that we kept stones, in parcels of five, with each parcel being sealed, signed and sellotaped so that when I repaid the loan I would know that I was going to get my stones back and no one would lose them or give them to someone else by mistake. Scrubbins agreed that this would be a good idea. I opened up my briefcase and carefully put five diamonds in each envelope (I found some envelopes in my briefcase) and sealed each one as I went along. Scrubbins watched me carefully.

I pulled my pen out my pocket and signed the back flap of each envelope. I got the tape out of my briefcase and taped each envelope.

Then, while Scrubbins was momentarily distracted by Jaffa, I switched the envelopes with those containing the fake zirconium that I had previously made up.

I signed the forms and Scrubbins put the fakes safely in the bank's vault. Scrubbins said that I could now draw a cheque on my account up to the agreed amount. A cheque? Oh dear! I needed the £80,000 in cash. Cash? Mr Scrubbins only had a small branch and they did not keep that sort of quantity of cash on hand. I was perplexed. Could Mr Scrubbins suggest something? He could give me a banker's draft that I could cash at any large bank in the West End. I cheered up immediately and Mr Scrubbins telephoned his assistant to order the banker's draft.

While Scrubbins was on the telephone, I glanced down on the floor. There was a diamond parcel that must have fallen down while I was doing the switch. If Scrubbins saw it he would send for the parcels and check them to see that he had all the parcels. When he found that he wasn't short he'd know something was wrong. I could get caught. I whispered to Jaffa to pick up the parcel. Jaffa looked at it on the floor. His eyes rolled in horror; he started to sweat. He actually moved his chair further away from the parcel. I was now nearer to it than Jaffa! I mouthed to him to get the parcel. Jaffa looked at the ceiling, the walls, the manager's wife's photograph on the desk, everywhere but at the parcel.

There was no choice. Even though it was not very subtle, I bent down, picked it up, and put it in my pocket before I rose. Scrubbins paid no attention but gave me the banker's draft made out to cash, shook hands and I left with Jaffa.

We went straight to the biggest branch of the same bank closest to the club. Once there I said that I wanted to cash a banker's draft. The assistant led Jaffa and me into a small room. After a short while, a well-dressed manager came in.

He said, "This is rather a large sum of money that you have asked to cash. Would it trouble you greatly if I asked you for some form of identification?"

"Not at all." I handed over something that proved I was Harry Entwhistle.

"And just one more thing, I need to ring the branch that issued this, just to

verify it."

"By all means, and when you speak to the manager put him on to me." That branch, with Scrubbins in charge, did not know me as Harry Entwhistle. I was Sydney Gold.

As soon as he got through to Scrubbins and started to speak, I said "Let me speak with him," and took hold of the telephone.

"Hallo Syd," said Scrubbins.

"It's me," I said. "Mr Scrubbins, there is a gentleman here who just needs to know that the bearer bank draft for £80,000 has been properly issued and it is in order to give me the money in cash." I carefully avoided using my name.

I passed the telephone to the banker.

I could hear Scrubbins describing me, but not once did he mention my name.

It took the bank a good fifteen minutes to hand over the cash but it seemed to be more like fifteen hours. That was a very nervous time for Jaffa and me. When the banker handed it over, I could not resist one last thing.

"Would you kindly remind me of your name?"

"May I ask why you want to know?"

"Because I am so pleased with the way you have handled this whole thing. I am going to write to your head office and tell them how pleased I am with your service. Anyone could have stolen that draft or found it in the street. But you were astute and telephoned the branch. I am pleased that the bank is being so careful with my money and I shall dictate a letter to your managing director just as soon as I get back to my office."

With those words I left the bank, with Jaffa behind me not knowing whether to laugh, cry or scream.

There is a happy ending to this story. Not for the bank of course, they lost their money. They had an audit and the fake diamonds came to light. They blamed Scrubbins and sacked him. He came to see me and asked if I could get him a job. I managed to find him a job working for a pornographer in Soho, as an accountant. Scrubbins never knew I conned him. He blamed the appraiser for the loss.

Several months after he started working he came into see me at the club. He had a big plastic bag full of cash and he asked me to look after it for a couple of hours. When he came back I gave him the money back. It was his boss' money so I was not tempted. He explained that he was now happy. He had left his wife, the nag, and was living with a "lovely bird". The pornographer paid better wages for less work than the bank. It was easy. He was happy.

"All thanks to making that loan to you, because the loan went wrong. If the loan didn't go wrong, I'd still be working for the bank and married to the old cow today. I owe it to you, Syd Gold."

Yes, it was nice to see a happy ending. Scrubbins still wore concertina trousers and his breakfast on his shirt but then again everything cannot be perfect!

I gave Jaffa his share of the coup, which he spent nearly as fast as I spent my side of it. Don't ask me what I spent it on. I can't remember. It was my wages and I spent it like wages. Nothing special.

JAFFA HAD A FRIEND IN SHEFFIELD called Sheffield Bill. Sheffield Bill had a club and half a share in a casino. In those days of very high inflation krugerrands were the thing to have. They went up in value, being made of pure gold. If you had black money you hid it in gold krugerrands because they never, at least in those days, lost their value. Each krugerrand weighed an ounce and its price was directly based upon the current value of gold.

Jaffa asked me to help him pick up some krugerrands for Sheffield Bill. Jaffa was supposed to buy the krugerrands and take them up to Sheffield Bill in Sheffield. Jaffa was worried that someone might rob him. He wanted to go up on the train and as the money involved was £200,000, Jaffa did not want to do it alone.

I agreed to help. Jaffa took me to an office run by two Israeli brothers who were dealers in krugerrands, to pick up the coins. Their office was seedy. It looked as if it had not been cleaned for ten years and there were holes in the carpet. They shared a desk but there were two telephones, some accounts ledgers and a pile of *Financial Times* newspapers.

There, Jaffa agreed the price and the two brothers took us to Selfridges department store safety deposit where they kept the krugerrands. Selfridges is a large department store in the West End of London. It is nearly as big as Harrods and nearly as famous. In its basement there is a large area for customers who want to rent safe deposit boxes.

There is only one way to get into the safe deposit boxes. Once you have proved your identity to the guard, you are let into a small room. Once inside, you have to go through a double set of gates. All the boxes are out of sight of the gates, around a corner and up some stairs so the customers can have their privacy. The Israelis kept their stock in one of these safety deposit boxes.

We went through the security. The brothers opened their box, counted the £200,000 that Jaffa gave them and then gave Jaffa the krugerrands for Sheffield Bill. Jaffa and I took the next train and in Sheffield, I asked Bill about the brothers. Bill said that they were very big in the business and could get any amount of krugerrands.

On the train going back with Jaffa, I told him that we could do a little coup here. I said that I could buy some krugerrands and I was going to pop the brothers. It was a suitable case for tops and bottoms and Jaffa wanted to be in on the scam.

I rang up the brothers and said that I could not speak on the telephone, but I wanted to meet with them to discuss buying some krugerrands. I arranged an appointment with them at their office.

I said that I wanted to buy krugerrands on a price fixed today but for delivery tomorrow. I said that I needed about £20,000 worth. I had some black money and I wanted it to be a cash deal with no records. They assured me that this would not be a problem. I said that I owned a couple of casinos and had accumulated quite a lot of cash that I wanted to change into krugerrands. This was the real reason that many people bought krugerrands. They were an inflation-proof way of hiding large sums of money (inflation was running at more than sixteen percent a year then) and the gold coins were readily exchangeable in every country in the world.

The brothers and I struck a bargain that I would buy the krugerrands at a set price and bring them the money the next day when I would take delivery of the coins. After I left him, I struck a bargain to sell exactly the same amount of krugerrands with another dealer. The other dealer gave me a very similar price to the one I had agreed with the Israeli brothers. In all, I would lose a few pounds on the deal. The next day I took the agreed amount of cash to the brothers. Jaffa had contributed some of it, another friend, Brian Patterson, had contributed some more. I gave the brothers the money in real cash at Selfridges safe deposit and they gave me the agreed number of krugerrands that I immediately resold. When I got back to the Marie Lloyd, I gave Brian Patterson and Jaffa their money back, less their share of the small loss that I made on the transaction.

I should tell you about Brian Patterson. He is a kind, gentle man of about my age, who looked like a hardened criminal with the face of a pugilist and short cropped hair. And yet he wouldn't have harmed a fly. I don't know of him ever committing any act of violence, even in anger. But you wouldn't have started with him, the way he looked. His whole demeanour was threatening, yet he was placid, even tempered and had a very relaxed attitude.

He never seemed to work in his life. He only had one business venture. Ever. And although he was a partner in it he never worked in that, either. The venture was refurbishing catering equipment. He and his partner Tony "Wimps" bought in dirty second-hand stoves, fryers, hobs and stainless steel catering equipment. They refurbished it at their warehouse and the refurbishment seemed to consist of Wimps scrubbing off all the caked-on grease and grime while Brian sat in the office, reading the newspaper. This business lasted two years — it took Wimps that long to figure out that it was not a fair division of labour. But that, I am sure, was the only job that Brian ever did. He lived thriftily when he didn't have any money. When he had money, he was a big spender. He was highly adaptable.

I bought and sold krugerrands four or five times. On average we lost about £500 each time, although one time we caught a rising market and made a good profit. Each time I told the brothers, "When I can trust you and I know that the krugerrands are good, I am going to buy a very large lump off you, maybe £250,000 worth."

They said that their coins were good, and I replied that I wanted to be sure especially when I was buying a lot of them. They answered that they were specialists in this kind of transaction.

My comment about their krugerrands being "good" was understandable to them. When you buy krugerrands in bulk they come in cylinders of coins wrapped in paper. Each coin is an ounce in weight and in those days priced at about $350, even more expensive than they are today. If you bought krugerrands in quantity you did not get loose coins, but wrapped rolls, for which there were opportunities for cheating because all that was exposed was a small circle of gold coin at the top and at the bottom of the cylinder. The wrapping hid everything else.

I got them to the stage where I rang up and agreed to buy £250,000 worth of krugerrands — adding that, although I would be buying £250,000 this week, I

would need over £400,000 worth next week. That way I set myself up as a continuing customer who would be doing more and more business with them.

In the meantime unknown to me, Jaffa, who was in on the scam and had put money into it, warned Sheffield Bill that I was going to sting the brothers. Jaffa was such a stupid man. Sheffield Bill was terrified that if I conned the brothers it would come back to him because he introduced me to them. He contacted the brothers and warned them to be careful of me. He said that I was a con man.

On the day of the coup, Brian and I went to see the brothers at the safe deposit. In I go. I took what appeared to be £250,000 in cash, wrapped up in 250 bundles of £20 notes all in a briefcase. There were two bundles of genuine £20 notes and 248 bundles of "tops and bottoms". These, of course, only had genuine notes on the top and bottom of each bundle. The rest was paper. So that meant that in all we had £11,920 (including the real notes in the tops and bottoms) dressed up to look like £250,000.

When I rang the brothers, I asked them for a price for about £250,000 worth of krugerrands, delivery next day. We agreed a deal and arranged to meet the next day. Shortly before the meeting I rang them and told them that I was in a hurry — I had a plane to catch. Could we meet them at Selfridges safe deposit where I could hand over the money and they could give me the krugerrands? They agreed. Previously when I had done a small deal with them I had done the "hurry up" and pushed the deal through quickly. I said that I would like to do only a quick check on the krugerrands because we knew each other by now. The brothers agreed.

When you go into Selfridges safe deposit you pass through a gate, which locks behind you, shutting you in a small corridor, before the gate leading into the safe deposit room is opened. In other words, for a short while you are sandwiched between two locked gates.

In I go with Brian. I asked to see the krugerrands. When they gave them to me, I got Brian to put them into his brief case. I gave them the bundles of cash counting out each package as I gave it to them. I said there is no need to count it all and I broke open the real packets to show them that the money was real and asked them to take the money away.

One brother took the money away to his safe deposit box. I thought he might be going to open the packets. I said to Brian to go with him. Brian gave me a signal that he did not want to go. I calmly asked Brian to go with him. I wanted to see that the brother did not start tearing the packets open. The actual boxes were out of direct sight of that part of the room where we were.

I started walking towards the gate with the case full of krugerrands. I wanted to get out of the door. I asked the brother who stayed with me to open the gate. He opened the first gate. I walked through it and so did Brian. All of a sudden, I heard the brother who was out of sight by the safe deposit box start shouting to the brother who was next to me, but he started shouting and screaming in a foreign language. I didn't speak the language but I didn't have to in order to understand what was going on. He had broken open the packets and was telling his brother to call the police.

I ran back into the room dragging the brother who was with me and confronted them both.

"You are going to get us all killed." I screamed in a voice as terrified as I could make it. "This is IRA money. This money belongs to the IRA. I am only the messenger boy."

Brian said, "Yes. Yes. We are messengers."

"Look, if we don't take this money or the krugerrands back to the IRA, I am going to be shot. And if they are going to shoot me I am going to tell them about you and they are going to shoot you."

They had a conference together for ten minutes in their own language. I did not know what they were talking about, but to encourage them I kept saying, "I am telling you that you are going to die and I am going to die and I don't want to."

At the end of their deliberations, they asked me how many packets there were. I said that there were 250 packets. One brother said, "OK, tell you what, we forget the whole deal, you give me back all the krugerrands, and I will keep the money and we will forget the whole thing."

I wanted to get out of there. I said, "I will take a chance; they are probably going to kill me anyway but I will take a chance." I gave him the krugerrands back. He kept the money. Brian and I started walking to the gate. The gate opened, Brian and I stepped in and it closed behind us. We waited for the other gate to open. But it did not. One of the brothers came and said,

"Now we have got you. Now you are in jail. You cannot get me and you cannot touch me and you cannot touch my brother. We are going to call the police."

I said, "Please call the police. I want you to call the police because that way I am going to be in jail and I am going to be safe. You are going to fucking die. The IRA don't fuck around. Brian, I am happy to go to jail."

They talked to each other for a while as we were caught between the gates. But in the end they opened the other door. "We let you go and we keep your money," they said. I shouted "goodbye" feeling that I should have a witticism for this occasion, but I could not think of anything witty to say so I shouted, "You fucking bastards!" and went back to the Marie Lloyd, thankful that they did not send for the police.

At times like this you feel that you should be able to make some devastating comment but all I could think of then was to shout "fucking bastards". I've had quite a few years to think about what I should have shouted at them but I still haven't thought of anything better.

For the first time a coup went badly wrong; I had lost some money, but knew that the Israelis would not be running to the police, who would confiscate the evidence. They would much rather keep the money.

Jaffa was waiting for us. He asked us what happened. I said, "What happened you arsehole? They knew. You must have told them."

"No, no, no," said Jaffa, "I didn't tell them, I only told Bill."

I had mentally already eliminated Brian as a source of a leak; I guessed that the Israelis had been prepared for us. My words to Jaffa were just a guess. But I

had said it with such conviction that he thought that I must have known for certain.

"You told Sheffield Bill! Those guys were waiting for me!" I told him what happened.

Jaffa thought for a moment and said, "I want my money back."

"You want your lousy five or six thousand pounds back! You get it off the two brothers."

Jaffa said, "Brian will you go for me?"

I said to Brian, "Brian if you go, you're fucking crazy! Do not go!"

But Brian ignored me. Jaffa kept on at Brian until in the end he had mesmerised Brian into thinking that all he had to do was collect the money. I advised against it but Brian did not listen to me. He agreed to go and get the money back. I tried to explain that sometimes things go wrong; we could always make money; I'd think up another scam — lots of them. Brian should not take any chances. But I was no longer, in Brian's eyes, the great mastermind. I was fallible. He listened to Jaffa, who was responsible for the thing going wrong in the first place.

Jaffa got hold of an old gangster and asked him if he wanted to help him collect some money. The old gangster agreed to go with Brian to get the money back. First Jaffa got Brian to ring up the brothers and demand the money. When they refused, Jaffa told Brian to tell them that he would be around in two hours and they had better have the money or else.

Two hours later Brian and the old gangster turned up at the brothers' offices. The old gangster had a big sword with him. I suppose he was going to use it to persuade them to give the money back. They asked for the money, made some threats and then out jumped the police who captured Brian and the old gangster. They had walked into a trap.

I didn't know, but I surmised that the only people in the world who knew my role and knew where I was were Brian and Jaffa. The old gangster didn't know that I was involved in this. I knew Brian would not say a word. Would Jaffa? I got a call from a friend of mine who was a cop. He warned me that I would be picked up at six the following morning. Who else could have put me in the frame but my old pal Jaffa? I packed my bags and got in a cab to Heathrow. I rang Barry and asked him to get me on the first flight out of the country — I didn't care where. I laid low while he got the ticket. He promised me that he would get Kim, the manageress of the club, to look after David until I sent for him.

I found out afterwards that the three of them were charged but only two of them were found guilty. Brian got three years for demanding money with menaces. The old gangster got eighteen months and Jaffa got off. Later Brian's wife complained to me that I had been responsible. I tried to explain that I had begged Brian not to go back.

Oh, and that flight that I caught at Heathrow? In the cab I looked at the ticket. It was for Miami. If I had been half an hour later I would have ended up in New York and the story would have been very different.

MIAMI SCAMS

HOW DIFFERENT IS SOUTH FLORIDA FROM ENGLAND! Florida has a sultry summer climate; in winter temperatures only drop to seventy degrees, just a little colder than an English summer. There are hurricanes, subtropical insects and no scenery to speak of outside the swampy Everglades. The land is flat and monotonous. By the roadside there seems to be more than the usual tangle of cables and advertisements that engulf American towns; most of the buildings that once looked good are run down, and buildings that are not run down look ugly.

Everything radiates from Miami, the real centre of Florida. There are districts that the Cubans have taken over, other parts where Colombians and Mexicans live. Most of the poor districts are rife with drugs and most of the poor people have attitude, as the Americans would say.

When you come from England you see huge differences between America and England but as you live longer in the United States, the differences seem less important. It becomes very easy to think and talk like an American and to slowly integrate into the mixed American society. You end up pronouncing words in the way that Americans pronounce them — tomato and schedule — and you use American versions of words, such as jello, to make yourself understood.

Syd has always been highly adaptable. Once he has found out how the land lies he will fit into a community like a glove, or at least into a section of it. I have no doubt that within a few weeks he was talking and behaving just like an American, except when it suited him not to!

I USED MY OWN PASSPORT to enter the United States. The immigration official asked me what my purpose of travel was. I told him that I had come for two weeks' vacation. I wanted to head for the beach and just recharge my batteries. He grinned.

"You've come to the right place for that," he said as he stamped my passport with a two month visitor's visa. "Have a nice day, Mr Gottfried."

I jumped in a cab and asked the taxi driver to take me to a hotel. He asked me what hotel. I said that I would leave it to him, but it should be near the beach. He took me to the Holiday Inn. I had about five or six thousand pounds with me. Later, I sent someone over with my jewellery and my clothes and Barry bought

out my share of the club for £25,000 so I had a small wedge, but when I arrived in Miami I was virtually potless.

I had lost a bit of money in the krugerrands coup. My Rolls Royce was hire-purchased, and it would be grabbed back by the HP company. I had some clothes in my suitcase, some cash and apart from that the only other asset I had in the world was the Marie Lloyd. I was forty-five years old and considering the money that had passed through my hands in the last twenty-five years I had almost nothing to show for it.

I ate in the hotel restaurant every night and the same waitress served me. Her name was Legia and she was moonlighting from her job as a hairdresser — I fell in love with her as soon as I saw her. I hated the restaurant food, but Legia was there and when it was not busy we would laugh and joke together. She originally came from Nicaragua.

I kept asking her out. At first she did not want to know me but I persisted and in the end she agreed to go out with me. She was divorced and had a most beautiful daughter from her first marriage, a darling of a girl, who eventually became as close to me as a daughter, whom I treated and loved like a daughter. Her name was Karla.

We went out for ages but Legia drove me mad. She wanted me to marry her. I eventually managed to get divorced from Phyllis and married Legia. I was very happy with Legia and Karla; I moved into their apartment in Dade and spent the happiest time of my life with them. Legia was a complete contrast from every other woman I have ever lived with. She was a good person, who was horrified by crime, stealing and all the other skulduggery that I had been up to. She was a devout Catholic and every Sunday would cover up her beautiful face and go to mass with Karla. She worked hard and honestly. She only had one weakness — me.

I have never been able to figure out how come someone good and kind like Legia falls in love with someone crooked like me. All of my ladies knew that I was crooked within a short time of meeting me. It didn't stop them living with me and loving me. Most of them were very good honest people. It didn't stop them being with a crooked man. She was honest, I was crooked, and she loved me and I loved her.

So living with Legia and Karla, being happily married, I thought about my two sons. The eldest, Mark, has always been an honest, regular person. I telephoned him from time to time to see how he was. He seemed happy and settled.

When I left David behind in London — Kim from the Marie Lloyd agreed to take care of him — I told him that I would send for him when I straightened myself out. I was worried about David. He needed me.

After Legia and I got married, I asked David to come over for a holiday. He spent two weeks with us and Legia was great with him. She treated him just like her own son, fed him, washed his clothes and looked after him really well, better than Carol did. We went out as a family, Legia, David, Karla and me to restaurants, films and Disneyworld. At the end of it I asked him if he wanted to stay; he did. He moved in with Legia, Karla and me. Karla was seven then. David was now

Legia.

thirteen years old and he got on really well with Karla. He played with her, looked after her and seemed very happy with us. I got him a permit to stay in the States (even though I did not have one myself), and fixed up a school for him. As far as I was concerned, I had done the right thing for David and needn't worry about him. Little did I know what was brewing.

One night a teacher rang me to complain that he hadn't attended school for five or six weeks. Instead of going to school, David hung around Miami Beach with some kids he met at school. These were dirty lowlifes, into drugs. I had constant, long distant telephone discussions with Carol about him but she couldn't help. I had arguments with David telling him to pull himself out of it. Sometimes he listened to me and was fine for a few weeks but always went back to truancy and lounging around the beach.

I bought a beauty shop for Legia and it was very successful until the recession hit Miami. I also opened a business in Miami that I called "Holiday Marketing". We sold holidays to Orlando and theme park tickets on commission. Until that time the money from the beauty shop was enough for us. Holiday Marketing made a bit of extra money without too much effort on my part and although I had less money than I was used to, I had enough.

Legia was careful with money but I encouraged her to spend it as we made it. I told her that I always make money. No problem.

Then America fell into a deep recession. In Europe we experience ups and downs of the economic cycle but in America when the cycle goes down a lot of people get hurt. In fact almost everyone gets hurt.

People were not having their hair done two or three times a week any more. They only came every month at most because that was all they could afford. Until the recession hit Miami I never did any scams there; the recession made me have to do more to keep up my lifestyle. The only more I knew was crime.

Crime is a habit. If you have been a con man you always spot opportunities to con people, even though you have no intention of carrying them out. It becomes like doing crosswords; you get addicted to them. Even today when I see something that suggests a coup the plot starts forming in my mind.

The first scam I did involved premium telephone lines.

At that time, the various telephone companies in the United States had just developed a premium telephone line. It was actually what I would call a legal scam. You could acquire a premium telephone line, which had a special number, and calls going to that number were charged at a premium rate, usually $1.50 a minute. Out of that, the telephone company kept something like twenty cents and passed the rest of the call to the line owner. The line owner offered some sort of service — the usual thing was sexy conversations with women, or gay men. Sometimes it was astrology. The trick was to keep the punter talking for as long as possible so that he would run up a huge telephone bill.

I wonder why the authorities make these sorts of things legal. I'm crooked but the telephone company is not supposed to be crooked. Premium lines are pure scams on the public. The sexy conversations are with bored middle aged women who go through set scripts and are organised so as to encourage men to masturbate while talking. The astrology is purely invented. Yet telephone companies all over the world do this, and the line operators make fortunes. To me, this seems a scandal, yet it is perfectly legal. The line operators use the frustrations of inadequate people to make money without even giving value. And the telephone companies are worse. I wonder how they justify profits that come from dirty talking. But perhaps they don't need to justify them. No one will arrest their directors and put them on trial for immorality. It's all legal.

I suppose the answer to why these things are legal is simple: corporations can make a lot of money out of them. It is the same with betting, casinos, and tobacco — they are all legal so that money can be made.

I decided to set up an office with thirty telephone lines. Each line was rented from one telephone company as a regular telephone line. I set up the office in Dade County, which is where Miami is located. I set up another office in Broward County, which is where Fort Lauderdale is. The Broward office lines were all premium lines and were rented from a different telephone company. Each office was under a trade name. I didn't have to form a company. I could call myself whatever name I wanted to (provided that the name was not already in use), so, for

example, in Broward I could be Broward Consulting Services and in Dade, say, Miami Enterprises. I then got the office in Dade to telephone all the lines at the office in Broward. At the end of the first month the telephone company sent the Broward office a cheque for $70,000. The Dade office never paid their phone bills.

Every month I had to change the locations and telephone companies and do it again. In the end after about five months all the telephone companies started to impose controls over giving people credit on telephones and made better enquiries when someone wanted to take a premium line, so the scam was at an end.

IN FLORIDA I LEARNT ABOUT TIMESHARES. They are one of the best scams of all time. A developer who sold property on timeshare sold it fifty-one times over. He made a lot of money but his selling costs were high because he had to pay high commissions. The developer also charged management costs each year on which there were no proper controls. As far as I could see most of the so-called management charges went straight into the developer's pocket.

I first saw timeshare selling in action at a resort in Florida called Orange Lakes where I knew the people running the resort. They thought that I would make a good salesman and asked me to join them. I told them that I would like to learn all about the selling by listening to their own salesmen on the podium.

Orange Lakes organised large presentations for people that they brought in to try to sell timeshares. Although most of the presentations were done on a one-to-one basis, every day a salesman stood up on the podium and went through the patter to a crowd of punters. Each salesman had a different way of presenting the benefits and virtues of time-sharing. I learned how to sell to America.

The premium rate telephone line scam came to an end, but I still had the boiler house with all the telephone lines. I decided to develop a system of market research. I hired thirty telephone salesmen and women. Each employee was paid $2 per hour plus a commission. They were given some pages of a telephone directory and a script that I wrote. This is what the sales people had to say:

"Good morning, my name is Mabel. I am calling you from a company here in Florida called Holiday Marketing. We are a test market company that tests new products for manufacturers before the release of the products for general sale. Have you ever tested any product before for any other company? No? Good.

"What we want you to do is this. We are going to send you a product; we want you to test it for thirty days and let us know what you think about it by filling in the questionnaire that we will send you. After you have tested the product it is yours to keep absolutely free. How does that sound? Great eh, yeah it sounds great!"

At regular intervals questions are asked that only require the customer to say "yes". This gets him or her in the habit of answering, "yes" to all the questions our caller asks. So, "Are you following me?" and "Do you understand?" and the telephone salesman uses "Sounds great, huh?" in order to give the customer the habit of agreeing with whatever the salesman says. I noticed that was how the Orange Lakes salesmen worked.

"As an extra thank you we're also going to send you a free two days and three

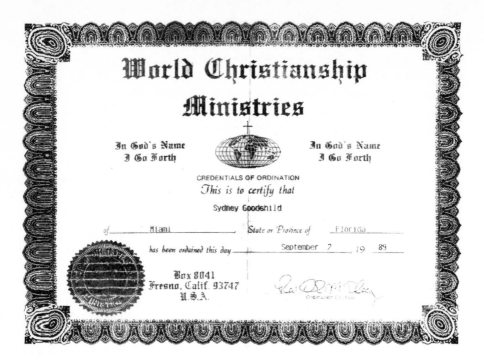

nights vacation for a family of four, that is two adults and two children for the Epcot Disneyworld area. Have you ever been there? The kids will love it, won't they?

"We are going to send you out a product and we are going to ask you to test it for us for thirty days and at the end of thirty days it is very important that you fill in the questionnaire and let us know what it is like so that the manufacturer will know whether it is right to market that kind of product. Will you do that for me?

"What kind of product are we going to send you? Let me tell you it could be anything from a car, a washing machine, a microwave a VCR machine, a TV — it could be anything — it could even be a tea bag or coffee — it could be anything. And we don't know what it is because our boss won't tell us because otherwise we'd send them to all our friends wouldn't we?

"What I want you to do is this. We are going to send them out to you by US mail. When the mailman delivers there is a small charge for shipping and handling of $9.95. We want you to give this money directly to the mailman, not to us, but to the mailman. Are you with me? Sounds good? Now the mailman will take credit cards, personal cheques with a bankcard or cash. You can make the payment any way you like. Now it is very important when you receive your packet that you call us back immediately and let us have the numbers on your Disneyworld vacation packet so we can put them into the computer and validate them. That means that you can go ahead and use them right away. All I want you to do, one more time because my job depends on it, is that you promise me that you will send back the questionnaire. That's great. Now I'll just check your name and address..."

Next day some one else had to call the customer. The person who called was

always a man and he too had a script that he had to stick to:

"Hi, Mrs Smith? I am Fred from the shipping department of Holiday Marketing in Florida and I have a package, a very large package that I will be shipping to you today. I am just checking that we have the correct name and address because we don't want this valuable package being lost in the mail. Is your address...

"Now don't forget you have to give the mailman $9.95. That is the shipping and handling charge that you pay direct to the mailman by cheque or cash or credit card. Is that OK? And don't forget that when you get you package I want you to call our special holiday hotline telephone number that is inside your package, and give us the number on you holiday certificate that I am putting in the box now so that you can validate your holiday certificate."

The ring back number had an answering machine on which customers recorded their certificate numbers. That way I would know who paid and how much the US Post Office owed us.

I had made up large parcels and sent them by the US mail to everyone who agreed to test their contents. Although the parcels were very big, they were very light because they nearly all contained thirty tea bags. Sometimes they contained thirty paper handkerchiefs, sometimes other low value, generic goods. The US mailman collected the $9.95 and, after the mail costs, I would have nearly $8 profit. I had to give $2 to the person who made the sale but even after I had deducted all the costs the profits were tremendous.

The holiday voucher that we gave them entitled them to three days and two nights at Orange Lakes timeshare resort where the salesmen would have three days to bully, cajole and push the people into buying timeshare. Orange Lakes were delighted to have the punters. They would have provided the accommodation free if anyone telephoned them and asked to view their facility. The punters had to pay for their own travel to Orange Lakes and pay for their own food but we never mentioned this when we made our pitch.

Not everyone went to Orange Lakes. Some people did not go when they discovered that they would have to pay their own fares and food, sometimes from places a long way away, like Chicago or Houston. Of those who did, there was a good chance that they would buy a timeshare because the salesmen pressured them. When one of our punters bought a timeshare we received a generous commission from Orange Lakes usually about twenty percent of the cost of the timeshare for introducing the punter to the Orange Lakes selling machine.

I suppose that this scheme is simply a more sophisticated version of the old con where someone suggests that you buy a "lucky dip" box, usually an attractively wrapped box that contains something worth less than ten percent of the price that you paid. It is similar to the people who sell racing tips at racecourses in sealed envelopes; the punter in each case has to pay the money before he knows what he has bought.

The variation that I introduced was to not sell a sealed package — that was free — but to charge only for shipping and handling in a way that the punter felt that he was paying the mailman and not Holiday Marketing. I also tagged it on to

selling timeshares, which gave the punter a free holiday and gave me a chance to earn some commission from the timeshare bandits who were pressure salesmen of the highest (or lowest) order.

I DID NOT FEEL TERRIBLY HAPPY DOING THIS. I was targeting the poorer members of society and often the more ignorant people. It's much better to con horrible greedy bastards. But in America, business is completely ruthless, far more so than in Europe. It seemed to me that the results mattered the most, and provided you made money no one cared very much if you were a high pressure salesman selling timeshare or something more respectable. In America it was all about how much money you had, not how you made it. They treat life like a bet. The result is all that counts. If you had the luck then you deserved the luck; if you were caught cheating you got thrown out of the game but if you cheated and got away with it, you should be congratulated on your success. That was fine.

In America there is public acceptance of the virtues of ruthlessness. In the end I could justify the tea bag scam. The victims were people who had the money to pay the mailman. All I had to do was get the money from them and provide something in return. I looked around for other ways to get money from people. All I had to do was find a product and supply that product. I thought about water purifiers — in Florida the drinking water tastes bad. It always seems to be slightly salty and musty. I thought that it would be easy to sell water purifiers in Florida.

The best way to sell any product at an outrageous high price is to use direct selling techniques. Over the years the same techniques have been used to sell things that people resist buying such as life insurance, double glazing, protective coating on buildings, fitted kitchens and pensions. Many of the companies employing direct salesmen have been thought to be highly reputable, but more often than not it turns out that they are scamming the public.

By its very nature, direct selling means that the salesmen earn very high commissions for every sale they make. These commissions can often make up a huge part of the price of the product. I took the whole of the direct selling business to its logical conclusion in four easy steps:

Step one: find a product. I chose water purifiers because they were cheap. I could buy them for $4 each, have them labelled and packaged to my own design for a couple of dollars more.

Step two: choose a pricing structure. These purifiers, I thought, could be sold for $69.95 each. That would leave plenty of leeway for commission. I would pay a commission of $20 for each purifier sold. That would leave me with a profit of $44.95 per purifier out of which I had to meet the overheads.

Step three: find a sales force. This was easy. Miami was in recession. There were plenty of people wanting jobs on a commission only basis. Americans are generally hard working people and in that economic climate they were keen to work for $100 per week. I advertised for sales people and when there were about forty applicants, I held a four day course which they could attend without charge to learn the principles of selling water purifiers. I started training sales people on

Monday. I taught them Monday through Thursday and Friday morning and fashioned them into a sales force.

Step four: sell the products to the sales force!

The five-day course took place in my Miami offices. I and two salesmen from Orange Lakes taught the applicants about how to sell water purifiers.

During the training course, we used to feed them coffee and donuts or bagels every morning. After a day or to we weeded out two or three people either in front of the whole class or privately in my office. I made the lessons interesting.

As part of the training I used to go to the toilet, take out a cup of water, pass it through the purifier and drink it. It tasted beautiful and sweet. The trouble was that the purifier had carbon filters and after a couple of gallons of water passed through it the filters became less and less effective, until after a few weeks the filters were not doing any good at all.

The trainees would all sit down, with fresh eager faces. I would stand in front of them looking over all their upturned heads. I would slowly smile. They waited. I stopped smiling and became serious:

"You may have noticed that Mary and Tony are not here today because they were not going to make it. I am not going to waste my time and John's time and Fred's time teaching you people how to sell if you ain't going to make it. So you all know if you get called to the office, you're gone."

At this the whole class became very attentive. It was wonderful. You could almost hear them thinking, "I hope that's not going to happen to me."

After three days of lectures we gave them a test on the Thursday night and I made the closing speech on Friday lunchtime.

"Let me first of all congratulate each and every one of you because you have all passed your first week's test. You have all shown enough ability except for those that we let go during the week. You are all here and now it is time to go out and prove to us what you can do.

"Take a look at me. I know how you feel. I know how you feel because I sat where you are sitting and I listened to somebody like me. I was just like you and so was John and so was Fred. Take a look at us now. We are all wearing Rolex watches and we all drive nice cars. I have got a Mercedes, John has a Cadillac and Fred has a Lincoln.

"I have watched you come to work all week and I have seen the cars that you drive. I have got to be honest with you. They are pieces of shit. They are clapped out cars. You do not want to be in that same position this time next year. You want to be in my position.

"It took me twelve months to get where I am. It took John fourteen months and it took Fred nine months because he is a super, super salesman. We all started just like you. I want you to come and work for this company full time. Each and every one of you. I want you to prove one thing for me — that you can sell one purifier. I want you to go home this weekend, you have got Friday night, Saturday and Sunday and I want you to come back on Monday morning with one deal: one cheque, one credit agreement or one cash sale.

"James who are you going to sell it to? The guy who has got the gas station? And you? The guy at the convenience store? Let me tell you, let me make it easy for you. Prove to me that you can do it. Go home and sell one to your family. Number one — your family need this product as you all know. Number two — it is the best play to sell it first off to your relatives because if you can't sell it to your own family how are you going to sell it to anyone else?

"I know you, James, are going to sell at least one. You, George, are going to sell three or four and, Celia, you will sell at least five. But let me tell you something. You are all going to make it because I know one thing. On Monday morning I am going to see forty-one faces with at least one deal each. Some of you will have two or three. But if you only have one don't be disheartened. It will come. You will all bring one. And six months, nine months twelve months down the line you will have the same car that I have got and the same watch that I have got.

"Go get 'em!"

At this stage, the sales force would burst into spontaneous applause. The faces were inspired, radiant. And off they went for the weekend. When they came back on Monday they had sold one unit usually to their immediate family. They earned $20 commission and I earned $44.95 multiplied by forty or more sales. After that, of course, the sales force had great difficulty selling a $4 product for $69.95, even in America and after a few empty weeks they usually left.

But everyone came back with at least one sale. Some came back with two or three sales. Everyone who sold a purifier was paid $20 commission and I earned a profit of more than double that on each purifier sold. I was prepared to pay each and every one $100 a week wages but on condition that after the second week they had to bring in four sales a week. If they sold more than four a week the commission would be paid on sales in excess of four; the commission would rise according to how many they sold.

Florida was in recession and people were happy to earn $100 a week. There was never a shortage of applicants.

I think that this was the most enjoyable scam that I ever did; all I had to do was give forty or so people a bit of training in how to sell the products. The scam was to get the $40 each for the purifier. I really enjoyed the teaching. It was great having an audience of forty people hanging on my every word. I felt useful teaching them things that they would not learn anywhere else.

And it made good money. If every sales person only sold one, then that was fine. In fact it was over $1,600 profit. If they went on to sell more, so much the better. The best salesman we had sold fifteen purifiers. He was brilliant. He's probably a multimillionaire right now.

I found other products worth selling. How about a showerhead?

"Good morning Mrs Smith, this is Holiday Marketing. Did you read the report in so-and-so magazine about showering? Have you got a shower?"

Who hasn't got a shower in the States?

"Did you read the report that said showering can be more hazardous to your health than smoking a whole carton of cigarettes a week?"

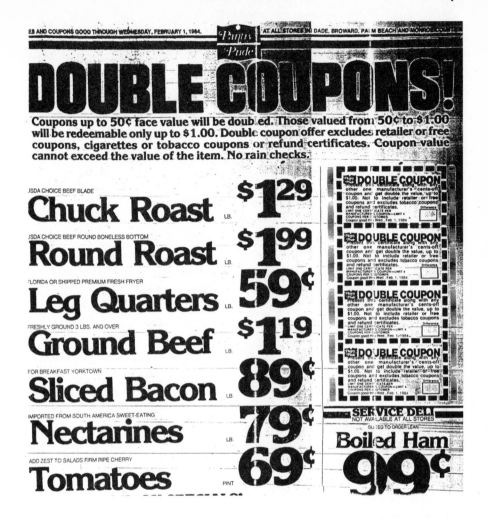

In fact there was an American professor who did make this claim and it was published in a magazine — of which I kept photocopies in case anyone asked.

"Professor X says that the toxic fumes from the hot water that you inhale when you are in the shower are very dangerous and can damage the lining of your lungs. Fortunately for you we have a product that neutralises the toxic radiation..."

People gave us their credit card numbers over the telephone for a $5 showerhead that we sold for $59.99.

As soon as we got the credit card number we shipped the showerhead. There is nothing like a scare story. But think of all those people that we saved from showering in radiation.

THERE WERE TWO MAIN NEWSPAPERS in Miami when I was there — *The Miami Herald* and *The Miami News*. The *News* later became defunct. But they had one thing in common, which is part of the American way of life — coupons.

In order to drum up business, manufacturers print coupons in the newspapers.

The coupon usually offers a specific sum of money off a product or a service, which can be obtained when a customer hands in the coupon to the shop or restaurant and buys the product or service. The establishment then sends the coupon to the manufacturer, who then sends back a cheque for the amount of the coupon. There is a whole section of Miami society who are wealthy yet cut out the coupons and hand them in to get, say, twenty-five cents off the price.

When I was there, the manufacturers wanted to push sales up in convenience stores (so named because they stayed open all hours), but being smaller establishments, had less buying power and were more expensive.

Every time I read the paper I saw the coupons, and was intrigued by them. I wondered how I could get my hands on them in bulk. A friend in the *News* told me that thousands of papers each day were returned as unsold and were pulped. I found out the person who had the contract to collect the unsold papers and send them to the pulp plant. He agreed that he would, for a small fee, allow my staff to go into his premises and cut the coupons out of the papers before they were sent to the pulp mill. He did not allow us to be there for too long.

I hired some people, bought eight pairs of good scissors and got them to cut out tens of thousands of coupons. Every day the coupons piled up and were sorted into order.

I knew that the manufactures of the products would only cash the coupons with retailers. I therefore bought a convenience store in a run-down part of town. I called it Syd's Store. It must have been the worse convenience store in the history of America — it stocked three cans of beans, what was left of the generic tea bags and tissues, about ten cans of warm Coca Cola and some stale cookies.

I had to put a man in the shop simply to be there and keep up appearances, and I opened a bank account in the name of Syd's Store. Every week I sent thousands of coupons from the shop to the manufacturers. All of them were in pristine condition, snipped from the papers. If the coupons were for the same manufacturer we didn't bother to separate them. Fourteen or twenty-one days later the manufacturer sent me a cheque for the value of the coupons I had sent. I cleared the cheque through the bank and drew the proceeds out in cash. After a while I stopped using the bank account because it took so long to clear the cheques. Instead I simply sold the cheques to brokers who charged a small commission and paid me in cash.

After a few weeks I closed Syd's Store; I didn't need to keep it open for the scam, I only needed its name and address. The manufacturers sold their products through distributors. There was no tie up between the records of the distributors and the manufacturers, so as far as the manufacturers were concerned we were selling huge quantities of their products against the coupons. I was collecting about $25,000 a month in this way and not one manufacturer visited my convenience store to see how come I was selling so many of its products.

In the end I could no longer get the coupons. My coupon supplier had lost the contract to collect unsold papers. I could not find out who got the new contract. The scam ended. But it was sweet while it lasted.

MURDER

EVERYTHING WAS GOING WELL for Syd in Miami. He was in love with a new wife; he had a great stepdaughter who adored him and he could play golf to his heart's content. He was generating money with the scams and enjoying it; he told me that of all the Miami scams he enjoyed the water purifier scam the best because he was teaching people. He would have made a great teacher, if he hadn't been crooked.

And I suppose it can be argued that the water purifier scam was not a scam at all. He sold a product at vastly inflated prices — but which business doesn't do that if it can? If you buy a diamond ring from a jewellery shop you will be paying three times or more the price that the jewellery shop paid for the ring and possibly ten times more than the value of the diamond and gold and workmanship. Is that a scam? Syd promised his salesmen a job, a job to whoever sold enough purifiers. It wasn't an empty promise.

There is an area where scams merge into so-called legitimate business practices. Is it immoral to hold out a product as being worth more than it is, or as having some intrinsic merit that cannot be proved? Is not the whole field of advertising something very close to the tea bag scam and the water filter scam? In politics we all think that politicians make false promises and spend much of their time organising propaganda. How different are the perpetrators of these scams from Syd? Certainly they have more education, but if anything that makes them worse, not better, than the out and out gangster who does them in perhaps a cruder way.

The largest mobile telephone company in Europe recently telephoned me. They told me that I was very lucky because I had been chosen to receive a free mobile telephone with lots of free accessories and all sorts of wonderful things. Of course there was a catch, like the tea bag scam. The relative value for money between tea bags and mobile telephones is of course different but the cold calling and hard selling is the same.

It was as though Syd finally had got the hang of living in Florida and making money there. He had a family and everyone needs a family, even crooked people; he could eat and live well and play golf; he had no fear of arrest. He was happy, Legia was happy, Karla was happy and David was happy to be well away from England.

WITH MY INCOME RESTORED from these scams, Miami suited me. I liked the people, the food and the golf. I gave David a job in my office selling vacations by telephone to keep him off the streets. I had a secretary called Lola, with whom he got on really well; I guess that she was a kind of mother figure to him. I asked a friend of mine to give him a night job in a restaurant, and altogether he was earning $200 a week, good money for a fifteen-year-old. I hoped that keeping him employed would keep him out of trouble. Instead, unknown to me, it financed a drugs habit.

He didn't have any special talent. He couldn't hold down a job. He spent most of his time out of school with dropouts hanging around the beach.

David met a girl and asked me if he could marry her. Her name was Ginger and he said that he was deeply in love with her. I said he couldn't marry her — he was only fifteen — but I gave him permission to live with his girlfriend in an apartment, with another friend called Nelson Molina and Nelson's girlfriend. Nelson struck me as a lowlife idiot. Nevertheless, I helped set up his apartment, organised some furniture and paid the first month's rent. With his earnings and with contributions from his friend, David could easily afford the rent.

I suppose having a fifteen-year-old living away from home entirely unsupervised wasn't the best thing in the world. I knew that at the time but I didn't want him at home any more. When he moved out I was relieved. It wasn't nice having him home. He would have mood swings, he would be dirty, and that would annoy Legia and he'd fight with me all the time.

After David moved into his apartment, he got worse. He started coming to work unshaven, smelling, with dirty nails and was always falling asleep at his work. I had fights with him about this. On two or three occasions I hit him. One day he raised his hand to me in the office and I hit him so hard that I knocked him ten feet back. I treated my own flesh and blood as ruthlessly as I treated Tim. It was the only way I knew how to bring him into line.

I found out later that he used to call Lola in the middle of the night, saying that he owed a guy money; and that he was going to have his throat cut if he didn't pay. Lola would get out of bed in the middle of the night, get in her car and give him the money. Lola was very fond of David and very kind to him.

He asked me again if he could get married. "David you're not getting married. You can't even look after your own prick, and look at this girl — look at the state of her — she's a dog. You're living like a fucking tramp, no you can't get married." Our arguments raged.

One Tuesday he broke into a friend of mine's motel, stole money and a twenty-five calibre pistol. The motel owner knew it was David. He tried to call me. I had thirty-four telephones in my office but the motel owner couldn't get through — all my telephone lines were busy on scams.

On the Wednesday I told Legia that I'd had enough and I would send David back to London. A friend from England was in Miami and I asked him to take David back. I told David what was going to happen and he said he wouldn't go. I told him he had no choice.

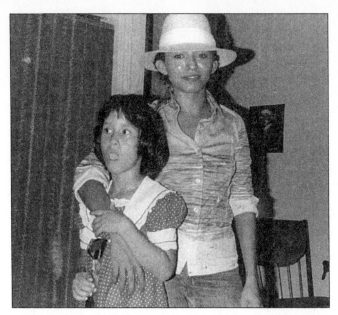

Karla and Legia.

On the Thursday night I did something very unusual for me at that time — I went out. My wife had to go to see a doctor the next day in south Miami. She didn't know how to get there. South Miami is a difficult place so we drove down, trying to find the way. We left Karla alone in the house. We got lost at one stage and had to ask a cop for directions. Eventually we found the doctor's premises and he spent a long time examining Legia and asking her questions.

When we came back we found Karla's dead body. Legia and I both helped the police until they eliminated us from their enquiries. I had to tell David about Karla's death. He was very close to her; he was staying with my secretary, Lola.

I went to Lola's house again and while I was there the police came and asked me if my son was there. I said yes, he was upstairs sleeping. They asked to speak to him and I said "sure". I offered to call him, but the police said no, they would go up. They brought him downstairs and asked me if they could take him to the station to question him. I said, "Was it one of his friends that did it?"

"We don't know yet, but he sure knows something."

"Take him," I said, "Find out, even if you have to beat the shit out of him."

I offered to go with them but they said no. They took David away at about 10:30PM. At 3AM in the morning I phoned the police to ask if they had got anything out of David. They said they had very interesting news for me and asked me to come right away. I explained that it was three o'clock in the morning and that I hadn't had any sleep for three days and still they asked me to come immediately. I could tell in the officer's voice that he wanted to arrest me. I thought that David might have told him I was wanted and I explained this to Legia. I then phoned Lola to tell her I was going to the police station and that I fancied they

were going to arrest me, so I asked her to come and look after my wife. She said she would meet me at the station.

When we got there the policeman in charge of the case, Detective Gordon Director, took me to one side and said, speaking gently, "I've got some bad news for you."

"What's that?" I thought nothing could be worse than what I had just experienced.

"Your son did it."

"What?"

"David killed Karla, him and his friend — a guy called Molina."

"There's got to be a mistake."

"No mistake, he's made a complete confession."

"How did you know it was him?"

"His girlfriend rang us and told us that he did it."

They asked my permission to question him further, which I gave. After I signed the paperwork for this, Detective Director said to me, "I've got some more bad news for you. David has told us you're wanted in England by Scotland Yard."

"Do you believe him?"

"We telexed Washington, and yes, there is a warrant out for your arrest. You have to go with this other officer to Qualm Detention Centre."

They handcuffed me, emptied my pockets and took me away to the same prison where they were holding my son the murderer.

They learned from David what happened. While Legia and I were out, David and his friend Nelson Molina knocked on the door. Karla let them in. They started rummaging around my possessions, looking for guns and money. Karla told them they would be in trouble when I found out. They decided that if they were going to kill me they had to kill Karla too. Nelson held her. David took a large carving knife and stabbed her seventeen times in the body. I don't know where they stabbed her first but I am sure that David stabbed her while Nelson held her. They then shot her in the head and threw her body in the bathroom. Karla's blood poured out of her body where they killed her and continued pouring onto the bathroom floor where it congealed in the warm Florida night air.

They then disconnected the bulbs from the chandelier. They took my shotgun, my forty-five and my thirty-eight and sat on the couch facing the door, waiting for me to come home. They got bored waiting and said, "Fuck it, we'll kill him tomorrow" and left.

My fifteen-year-old son had murdered my ten-year-old stepdaughter just before his sixteenth birthday. He stabbed her and then blew her face away. Bang! Happy birthday! And he was so high and so stupid that he did not seem to realise that he had ended a life, a young happy life; he had hurt someone who never hurt him.

My feeling on seeing and holding Karla's dead body was that this was a punishment, my punishment for the life I led. My crookedness deserved this, but not Karla, she hadn't done anything wrong. I should have died, not her. I understood that I was bad, that part was easy, but I couldn't understand why Karla's life should be taken away or who would want to do such a dreadful thing.

In prison, the same prison that held David, I was trying to come to terms with the fact that I had introduced David into her life. I was trying to cope, to understand and wonder what I should be doing.

If you were to ask me what my cell looked like I could not tell you. I was in a trance for those ten days. In the end, Scotland Yard sent the Miami Police a telex, which I saw, saying that they wouldn't extradite me because the evidence against me was so thin it wouldn't be worth their while. After that they let me go.

By the time I got out of jail, Legia had already been to Nicaragua with Karla and buried her. I missed that. I couldn't even say goodbye to Karla properly. I went back to the office and to Miami, but I couldn't work there. I couldn't face going back to the office, passing Karla's school, places she had been, places she had played. It was too much for me. I wound up my business.

KARLA HAD WANTED ME to be a comedian — every time I told her a joke she would crack up, she would completely crack up with laughter. This kid was not my kid but when I married my Legia this kid took to me like you couldn't believe. I was her dad and she wanted to show me off to her teachers to her friends. If anything had to be done she said "call my dad". If she hurt herself, it was me she ran to. She was the first person who has ever been proud of me.

Legia will tell you that she was jealous because the kid loved me so much. And perhaps David, in his drugged and stupid mind, was jealous too. He saw that I devoted myself to her, played with her, taught her (she was bright and easy to teach).

She wanted me to be a comedian because she said I was so funny. She would say to her friends when I was there, "Dad, tell them a joke!" Dad did as he was told. I even appeared on stage for her once in Fort Lauderdale; I went to the Comic Strip and did a half hour stint up there. I died on stage but she thought I was terrific.

Karla was ten years old but she was wise, ten, going on thirty. She could read, write and do everything that David couldn't. She was intelligent and she was bright. David was stupid and dull; he could barely write his name. She was a lovely little kid. Her feet were too big but that didn't matter. She was acrobatic, always good at sports in school. I loved her, she was my daughter.

Do I ever feel responsible for what happened? Yes, I did at first. Of course I did. My first thought when I could sit down and think afterwards, was it was my fault for bringing him over there. I put him into this woman's home and he killed her daughter, because if it were not for me being there it would not have happened. I expected Legia to say, "You are no good; your son did this," but no, she was the other way, comforting, loving and supporting, "it's not your fault". And it's not, when I think about it. Really it was not my fault. But perhaps it was my fault.

My son might have only adopted his way of life because I was not a good father. But then Mark didn't go that way. David idolised me and David followed me around. I was much more of a hero to David than I was to Mark. Mark never killed anyone.

Mark knows what I am, but he respects me. He is his own man. But David

wanted to be like me but could not do the things I did.

I think that Carol, who had David almost all of the time, didn't bring him up properly. She should have sorted him out in the beginning instead of letting him go from bad to worse. I'll blame Carol.

At the beginning when I took David from Carol he started to straighten himself out when he went to the acting school in London. When I had the club in London I had him all the time; he wasn't too bad then. He wasn't good but he wasn't too bad. When he went to the States I think the whole concept of Miami blew his brains. With the drugs and a joint he could do what he liked which was mostly lying on the beach stoned. That wasn't my fault, was it?

I had a duty to see what was going on at that stage. I could have stopped him. I used to say to him everyday, "Go to school!" and I thought he was going to school. When times got bad I was in the office from eight in the morning to eleven at night, six days a week. So it was tough. I used to come home shattered and go to bed. But my son was more important than my office. I should have realised it, I should have done something, but what? I could have spent all day with David, but I would still have had to go out once in a while and he still might have killed Karla.

It can be hard to think what I did wrong. But it's very easy to think up excuses. I could do that all day long. But I shouldn't. It was my fault.

Every time I bought a new car Karla loved it. She was proud of everything I did. When I had a heart attack I went into hospital; David never phoned but Karla phoned me ten times a day. She would get home from school and would phone me, before she'd go to school she would phone me, she would phone me in the night time before she went to bed. And David murdered her.

I want to kill David. Even now after all these years I still want to kill him. I would love to get him in a room for fifteen minutes, just for fifteen minutes. I told the prosecutor in the States that they should give him the electric chair. I said please try and give him the electric chair because it is the worse sentence you can get and the prosecutor did that. The prosecutor went for the electric chair at first but later dropped it and David got life imprisonment. I know that a lot of plea bargaining goes on, but I really don't understand why they didn't execute him after what he did to Karla.

If I got the chance I would personally pull the switch. I know it is a dumb thing to say because he is my son but I would go in there and pull the switch and watch him die. Even today I'd do that years after the killing. Imagine how I felt fourteen days after the killing.

Karla was dead and there was nothing I could do to bring her back, nothing in the world, nothing. So killing my son would be pure vengeance. Legia wants to see him die in the electric chair. She is terrified that he will come out and kill her. She thinks that she is entitled to her vengeance. Legia is soft, calm and very loving. I have never seen her cause harm to anyone or heard her say a harsh word. Except about David.

My ex-wife, Carol, came out to Miami with my son Mark when it happened to see David. When I went to meet Mark at the airport my ex-wife was there and she

10-year-old's killer still at large

SLAYING / From 1B

sters in her clas

Bill Cosentino. S

student, academi

who required s

keep up with h

said.

"She was shy

Cosentino said. "

used to the class,

friends. She se

friends right awa

Although ther

Friday because

work day, news

spread, Oak Gro

Richards said. Sh

pils trickled in to

were talking abou

"It's a horror

said. "A lot of m

apartments. It's

Unfortunately, th

ting a real first

grim side of life."

After classes l

Thursday, Gottfr

with her classm

9, and Quenga's c

12. They parted a

"We felt very

was a good frien

didn't know her

Shirley, who p

since the Gottfr

Oak Grove about

"She always talk

some candy, or w

offer, she'd offer

Police say the

and well-kept.

guardhouse, but

they were not c

was manned Thu

Tuesday, November 24, 198

British youth admits he killed stepsister, gets a life sentence

By AL MESSERSCHMIDT

Herald Staff Writer

A British student pleaded guilty Monday to charges that he brutal-

court Tuesday.

Gottfried agreed to plead guilty after the judge refused to suppress two confessions and after a week-

Tuesday, Jan. 31, 1984 / The Miami Herald 3B

Teen murder case to go to grand jury

By JOAN FLEISCHMAN

Herald Staff Writer

Sixteen-year-old David Gottfried, accused of fatally stabbing, shooting and asphyxiating his 10-year-old stepsister, will remain in Youth Hall while the Dade State Attorney's office seeks to have him indicted and tried as an adult.

The Gottfried case will be presented to the Dade County Grand Jury, prosecutor Leon Botkin said

the youth "alluded to premeditated designs." He allegedly told a few friends about the slayings; they tipped police, Nazario said. When officers interviewed him, "he was just acting normal — he didn't cry," Nazario said.

The gun stolen from the ground-floor apartment was a Derringer belonging to Sydney Gottfried, the boy's father, Nazario said. It was not used in the slaying, he said.

Molina convicted of 10-year-old's murder

By JAY DUCASSI

Herald Staff Writer

MIAMI — A jury convicted Nelson Molina of first-degree murder Friday, rejecting arguments that he was insane the night he kept a 10-year-old girl from struggling while her brother killed her.

"A 10-year-old girl brutally murdered. And for what?" Circuit Judge Ted Mastos said after the verdict. "Few crimes here make sense. This one here makes even less sense."

The judge sentenced Molina, 22, to three consecutive life terms for the murder of Karla Gottfried and for the armed robbery and armed burglary of her father's apartment. Molina will have to serve 25 years before he can be released.

Molina remained silent as the clerk read the verdict after five hours of deliberation and 10 days of trial. His mother, Riclda Molina, buried her face in her hands and was later led out through a rear door. She did not talk to reporters.

"I believe we had the fairest jury trial I've ever participated in," said defense attorney Ellis Rubin. "The verdict speaks for Dade County."

Rubin, who tried to show that brain damage and exposure to television violence left Molina insane, had said he considered it a "complete victory" when the state dropped its demand for the death penalty Thursday.

Prosecutors Susan Dechovitz and Jay Novick told the jury that Molina and

Gottfried found Karla Gottfried alone watching TV in her father's apartment when they went there Jan. 26, 1984, to rob her father.

Molina held Karla while her brother David stabbed her with a butcher knife, then shot her in the head, the prosecutors said. The two then dumped the girl's body in a bathroom in the apartment.

David Gottfried, 18, pleaded guilty Nov. 25 and received three consecutive life sentences. He called the state attorney's office from jail Friday and asked to be given the death penalty, Dechovitz said.

"The case involved one of the most heinous murders I've ever seen," Dechovitz said. "Obviously we're very pleased."

Dechovitz derided Rubin's television

violence defense as "nonsense, just a smokescreen."

Assistant State Attorney Jay Novick said the verdict should "show Mr. Rubin once and for all that television does not create crime, people create crime."

Mastos, who called Molina and Gottfried "misfits," spoke for 10 minutes about the case.

"I haven't seen a shred of remorse. I've never seen two people with as little human feeling in my 12 years on the bench," he said.

"I just don't know what kind of monsters. ... Look at the havoc they've created. They've destroyed families and they destroyed their own lives in the process."

started to cry and to say how dreadful it was poor David was in jail, and what was I doing to get him out. I blew up.

"You come over here and say what am I doing to get him out! I'd like to fucking kill him."

"How can you say that? He's your son."

"He killed my little girl — can't you understand that?"

She couldn't understand. She thought that I was no good because I wanted to get my hands on him. Mark understood.

I said, "Listen Mark, you can do whatever you like to help your brother but he no longer belongs to me now. I'm doing all I can to get him put in the electric chair and I said whatever the worse I could get done for him I'm doing. If he'd killed anybody else, murdered, robbed, stolen, whatever he had done I would have helped him, I would have helped him because he is my son. But what he did here was to kill his sister. I can't help him, no way in the world can I help him knowing that Karla is looking down at me, saying to me, 'How can you help him?'"

I couldn't do it; in all conscience, I couldn't do it. Not only could I not lift a finger to help but I also had to do everything in my power to make sure David got the maximum. It is a terrible thing to say because I have been in jail myself but he deserves everything he gets and more.

I have not seen David since the police took him away nor have I asked the prosecution or the police if I can see him.

He asked for me to go and see him but I wouldn't go. My secretary Lola went to see him many times and he never actually told her anything except that he wanted her to bring him stuff. One friend went to see him in jail and David would not tell him why he did it, either. He said he would explain after the trial, and was adamant that when he got out he would still try to kill me.

David would say that in prison, but if he were to come out and sit down next to me he'd shit himself. So he can say, "Oh when I get out I'm still going to kill him and I'm going to kill her too," because he knows I can't get my hands on him. At one stage I planned to get myself arrested for drunken driving so I could get into the Dade County Jail and get him, but then a friend who knows all about the procedures inside American jails, said, "No good, you're wasting your time, because he's upstairs on the top floor and you can't get up there. The drunks go to the third floor and there's no way you can get up to the top floor."

I am told he was kept in isolation.

After all that David told the police they gave me a hard time; not a very hard time, but a hard time. The police told me that my son had also said that I was a drug dealer. I am not and have never been a drug dealer but at the particular time of the killing I had a kilo of cocaine in the house that a friend put there. He apparently hid it by taping it underneath the coffee table in the living room, just a few feet from the blood-covered couch. There were dozens of cops crawling all over the house but they never found it.

NICARAGUA

IN THE MID EIGHTIES NICARAGUA was in a state of revolution. One side of the conflict was supported by Russia, and the other side was supported by America. This was a country that was strategically important so the rest of the World couldn't let it have its revolutions in peace. The United States was scared of "the Evil Empire" of the Soviet Union, and frightened of having another Vietnam on its own doorstep.

All conflicts and revolutions create large numbers of refugees both political and economic. Political refugees are regarded as heroes; they are people unable to practise their politics in their own countries and countries that approve of their politics welcome them. Economic refugees don't usually care about who rules the country, they simply want a better life and are prepared to work for it. These people are not usually accepted into other countries, they are supposed to stay where they are and suffer.

In these times countries like Britain and Germany no longer sought labour from abroad. They tried to stem the flow of relations and friends of the people whom they had encouraged to enter their shores thirty years earlier.

Legia, like many Central Americans, had left her own country for a better life in America. She was determinedly willing to work hard and chase the elusive American dream. It ended tragically for her in that Karla had died. She had buried the body back in Nicaragua while Syd was locked up in Qualm Detention Centre. Syd's money and that of well-wishers paid for everything including a new mausoleum for the family.

There is something deeply unsatisfactory about being unable to say goodbye to someone you loved and be unable to say a prayer as their body is committed. That is the purpose that funerals serve, but Syd, locked away from it all, could only weep and wait for the time to pass until he was released.

People of the same religion stick together. People of the same ethnic background stick together. Crooked people stick together, like glue. Syd's crooked friends in Miami paid for whatever Legia needed and they would have found the culprit if the police hadn't. When it turned out that the murderer was Syd's own flesh and blood they cried for him.

Something like this must burn your brains. Syd is as sharp as a new razor but he couldn't think. The nightmares began for him and for Legia and not much is

worse than a nightmare that repeats itself. You go to bed, praying that it won't happen. You fall asleep after thinking "if only" for hours. You wake up in the middle of the night cold with the wet icy sweat of your body, frightened by the dream. You get up, wander about, perhaps have a drink or a smoke, change your bedclothes and go back. You lie awake frightened of the nightmare coming back. You think "if only" again and then fall asleep, only to wake up two hours later scared by another nightmare in another cold sweat.

There was no counselling or therapy for Syd and Legia. They had to cope however they could, if they could.

I HAD TO GET OUT OF MIAMI; I had to get out of the United States. Karla's death had sort of slowed up my brain. I was not really thinking properly and now knew that the police in Florida must have had their own ideas about me after talking to Scotland Yard. Gordon Director, the policeman in charge of the investigation into Karla's death, was decent and straightforward but the unwelcome publicity surrounding Karla's death was very worrying.

I had already been pursued by a TV crew for some of the marketing scams I had done. You know the sort of thing: an intrepid interviewer sticks a microphone under your nose and asks for an explanation, in my case, of how come I had sold to the public these overpriced shower heads. Would I care to comment? I did appear on TV — or the back of my head appeared on TV as I ran away from the questions. I didn't care to comment.

Karla's death stopped all my operations. My money was drying up quickly and I had closed down Holiday Marketing. I didn't want to return to England. Karla's death was well publicised there because she had been murdered by David, an English boy. If I went back then every bit of publicity about the forthcoming trial would reach England and I would have the papers camping outside my door. At this stage I still hoped that David would get the death penalty.

But I knew, with all this going on, Legia and I should not stay in Florida or go to England. Karla was buried in Nicaragua while I was at the detention centre and I liked the idea of being close to the place where she was resting. Legia wanted to go back home. She told me that with a small amount of money we could buy a farm or a "finca" and just run the farm. Nicaragua was being torn apart by a civil war between the Sandanistas and the Contras. Legia said that we could buy our own protection and, for very few dollars, live a luxurious life. Legia also had become tired, stressed and tearful, and the idea of putting her through the trial in her condition was very unappealing.

I needed to raise as much money as I could. I had never saved a penny. As soon as I earned or nicked the money and it was in my pocket, I spent it. I spent it at a great rate, some people would say that I wasted most of it and they would be right. I had to keep making money one way or another because I had nothing put by. I liked the idea of a farm in Nicaragua. All I needed, or so I thought, was one last coup.

I also thought about Jaffa. He told Sheffield Bill about the krugerrands coup and Bill told the Israeli brothers. That set up the chain of events that led to me getting on the plane to Miami. I had never got even with Jaffa for that. But even worse, Jaffa had set up Brian Paterson that led to Brian going back to the Israeli brothers and getting caught. Poor Brian had gone to jail. This happened years before, but then Enzo had always said that revenge is a food best eaten cold and he was right. It was time for Jaffa to pay.

I had previously worked out a coup that I never used. I kept it in the back of my mind, almost like a savings account for a rainy day. That was the only kind of savings that I did. This is how I thought of it. Whenever I travelled abroad from Miami I used to go to the American Express Bank to buy traveller's cheques. They are a very convenient way to carry money abroad, especially if they are lost or stolen because the traveller's cheque company refunds your money without any quibble. American Express cheques are accepted all over the world.

Before I went abroad I would go to the bank and collect the traveller's cheques. The teller made me sign them before I left the bank. That was important to the bank because the cheques had to be signed in the presence of the bank and countersigned in the presence of the person accepting the traveller's cheque. That way the person receiving the traveller's cheque could be sure that the person cashing it had was the true owner. All he had to do was match the signatures.

One day I was in a hurry collecting my traveller's cheques at the bank. I asked the teller to hurry up, because I had a plane to catch. I started signing the first two cheques and then said, "Can I do these on the way to the airport?" She nodded, I took the traveller's cheques that I had bought and I jumped in a cab.

On the way to the airport I looked at my unsigned American Express traveller's cheques. They were in a completely virgin state. I could have signed the cheques in the name of Micky Mouse. Or I could have sold the cheques to some one else unsigned. And it gave me an idea.

By the time I got back from my trip I had formulated the coup in detail. I decided to keep it back for emergencies and now was the suitable emergency for me to use "the traveller's cheque coup". And Jaffa would be the mark.

I telephoned Jaffa who was in England. He, of course, had heard about Karla and David; he knew David from the club. But he never said a word about them when I telephoned him. He acted as though I had not seen him for a few days rather than years. I told him that I was ringing him because I had thought up a coup, the best and biggest coup ever but I needed his help and that I was prepared to row him in.

"There is a bank manager of quite a large branch of the American Express Bank at Biscayne, Miami. He is a crooked bank manager. He has been stealing from the bank and there is already quite a large shortage. The bank's internal auditors are due to come in two weeks time. The manager is going to do a runner. He has a girlfriend and he has decided to leave his wife and the country and run away with the girlfriend. He's going soon. He is going to clear out all the cash and foreign currency from the bank before he goes. He is going to keep it for himself.

He does not need anyone to tell him how to sort those out but he doesn't want the traveller's cheques. He's going straight from the bank to the airport and by the time he gets to South America, the traveller's cheques might well be circulated or else they might be able to trace him through the traveller's cheques. So he is prepared to sell me the traveller's cheques at one third of face value. But he wants to sell me all the traveller's cheques in one hit. He won't sell me just a proportion of them. He says if I don't take them he's got someone else lined up."

"I can only raise $55,000 in cash. The bank manager reckons that he will have $345,000 worth of traveller's cheques and he wants $115,000 for them, one third of face value, so I am $60,000 short. Can you raise the $60,000? If so, I would like you to lend it to me. I'll repay you when the traveller's cheques are cashed plus a ten percent bonus. That is not too bad for a few days' loan, is it?

"I want to do it on a Friday. The manager won't be missed until Tuesday or Wednesday. That gives us Friday, Saturday, Sunday, Monday, Tuesday and probably Wednesday to cash the traveller's cheques."

"This has got to be the easiest coup in the world. So the loan I need is really going to be very safe. You can come to the bank with me and cash the traveller's cheques so that way you'll make sure that you get your money."

Jaffa thought for a moment.

"How do we know that the traveller's cheques are real? How do we know that they are the genuine article or that there won't be some difficulty in changing them?"

"Good point, Jaffa. Look, this is what we'll do. I'll say that we'll buy the whole lot from him but first we have to buy a few thousand dollars worth just so that we can check them out."

"Yeah, and if he doesn't agree we'll know that there's something moody."

"I'm seeing him tonight. I'll organise buying some sample traveller's cheques from him then."

"Okay," said Jaffa, "but I am not going into this on a ten percent basis. You need my money and we'll go in according to how much money we put up. And don't buy any traveller's cheques just yet. I'll send over a pal called Harry. You can do the buying with him. If it works, Harry will report to me and I'll come over with the money."

That seemed fair to me and I said so.

Two days later I met Harry at the airport. He turned out to be a very fat kid — no more than twenty years old, who loved eating. After feeding him up on a huge steak and filling his face with weak American beer I took the fat boy to the Amex bank in Biscayne. There I met a man in a light blue lightweight business suit, with the fat boy watching a short distance away. We exchanged envelopes and I went back to the fat boy's hotel.

The day before I had been to the bank to collect $2,000 of traveller's cheques that I ordered. "Sorry darling," I told the teller who knew me by now, "I haven't got time to sign all these. I'll do it in the taxi." And with that I picked up the unsigned traveller's cheques. I put them in an envelope and gave them to a friend

with instructions to dress in a suit and meet me at the Amex bank where I would swap one envelope for another. The fat boy believed that he saw me talking to the crooked bank manager and "buying" stolen travellers cheques.

"I bought $2,000 worth," I reported. "Look I'll give us each $1,000 worth and we can see if we can cash them now. I divided the traveller's cheques between us. We signed them once using false names and left the hotel. Within an hour we were back. The fat boy had succeeded in cashing his share of the traveller's cheques without any difficulty. This wasn't surprising as I had bought the cheques from my bank all above board only a day earlier.

"It works," said Harry pleased. He telephoned Jaffa straight away to tell him. A few hours later Jaffa telephoned me.

"I'm coming over on the next flight," he said. "Count me in on the coup."

"Well I'll tell him that I want to buy the lot," I said, "and we'll all go fifty/fifty. Us three will put in half the money, and you can put in the other half."

"Wait a moment," said Jaffa, "Who said fifty/fifty? You can't buy the whole lot. You need my $60,000 to do that. What I am prepared to do is this. First you offer the bank manager $100,000, not $115,000. For that he has got to provide us with at least $345,000 worth of traveller's cheques. I'll put up $100,000. You put up nothing. I'll keep $300,000 of the traveller's cheques and you can have $45,000 worth which you can divide up any way you want."

That was not fair. I begged with him, I pleaded with him. I only needed $60,000 of his money. He shouldn't get more than one half of the cheques. It was not fair. It was my coup and I was rowing him in. But he was adamant. He said that I couldn't pull it off without him and he was leaving me with something from the deal. It was take it or leave it as far as he was concerned.

He had me in a hole. There was no way that the bank manager would sell me only part of the traveller's cheques. I had to buy all or nothing. I reluctantly agreed to Jaffa's terms, very reluctantly. I would, I suppose, still make $45,000. Jaffa had outflanked me. That was better than nothing. I agreed to meet him at the airport and book his hotel accommodation.

At the airport the next day there were two surprises. First, Jaffa did not come alone. He brought a crooked bookmaker with him, who himself had brought some protection in the form of two thug like animals. Secondly they had only brought $70,000, not $100,000 that had been agreed, leaving me to put $30,000 of my own money in.

I was upset with this. I decided to let them cool their heels in the hotel for a few days. In that time I sent Legia over to Nicaragua and tied up any loose American ends. I then put them off for a few more days. They were keen to collect the cheques but I preferred to keep them waiting even longer.

Eventually I told them that I had a call from the crooked bank manager and we were now ready to get the traveller's cheques. I planned how we would collect all the cheques. I would go to the bank with Jaffa on Friday. The crooked bookmaker and the thugs would drive us to the bank but wait in the car. Jaffa and I would pretend that we didn't know each other. The bank manager didn't know Jaffa and

wouldn't deal with him. I would go in to see the manager, give him the $100,000 in cash and collect the traveller's cheques. On the way out of the bank Jaffa would be waiting for me. I would slip Jaffa the traveller's cheques in a way that no one would notice. I would put them in a copy of *The Miami Herald* that I was carrying, and put the paper down next to Jaffa on the bank counter. He would pick the newspaper up and leave with it. I would leave a little later and we would meet at the hotel where we would divide up the traveller's cheques. We would each be responsible for cashing our own supply. I made it clear to Jaffa that I did not want to cash traveller's cheques for anyone else but me, and Jaffa said that the same applied to him.

The Friday of the coup arrived. I met Jaffa at the Hotel and the bookmaker whose money was being used drove us to the bank. His thugs were smartly dressed and alert for trouble. The American Express bank was full of people. The thugs and their employer watched from the car as I carried the money into the bank followed a short distance by Jaffa. As we were about to enter the bank, I told Jaffa to go to the counter get a form and pretend to fill it in. That would give him an excuse for keeping his head down which would keep his face out of the security cameras.

"Cameras?" Jaffa panicked, "What fucking cameras?"

"Yes," I said calmly, "All these big American banks have closed circuit TV where they record the faces of people in the bank." At this time it was largely true, although security cameras were virtually unknown in England at the time. Jaffa had not expected anything like this.

Jaffa went white at the thought of being captured on closed circuit TV, but he did as he was told and stayed very close to the entrance of the bank. I went to see the manager. I had to give him the $70,000 that I was carrying. The man in the blue suit appeared again and as he did so I told Jaffa that this was him and that I would be back in twenty minutes.

Within a few minutes, as Jaffa was getting more and more nervous, he was deafened by the sound of alarms and sirens. Doors slammed locked and lights flashed inside the bank. The bank was being robbed. Armed police arrived outside. Jaffa now was very frightened and tried to drift away unnoticed. He managed to do this because he had positioned himself so close to the entrance. Within seconds, as Jaffa was leaving the bank armed police were rushing in and the whole place was in turmoil. I watched the scene from the next block. Jaffa, sweating profusely got out of the bank and almost ran up the street as fast as he could. The bookmaker with his thugs in the car (engine running, just like in the movies) drove off more sedately.

And that was the coup. I helped myself to the $70,000. The key to the coup was to find a bank that had two separate entrances. I took Jaffa to the main entrance, collected his money but instead of going to see the non-existent crooked bank manager I walked out of the second entrance unseen by Jaffa. As soon as I got outside, I found the nearest telephone and rang 911. I reported that there was an armed robbery in progress at the bank. Four black men with sawn-off

shotguns were holding up the bank. I let the police do the rest.

I never saw Jaffa again.

But if I did run across him I knew what to say. The bank raid proved to be a false alarm. The police had entered the manager's office after I had given him the cash but before I received the traveller's cheques. I got out as soon as possible but had to leave the money. The manager ran away taking our money with him. I don't know where he went.

Jaffa must have had some problems with the crooked bookie (and his thugs) who thought that Jaffa had set them up. I enjoyed the thought of it as I settled back in my seat in the flight from Miami to Nicaragua with a one-way ticket in my pocket.

I later heard that Jaffa descended into his own private hell. None of his friends trusted him. He ended up borrowing money from all of them and never paid it back. One by one they discarded him. And he became less fastidious about his appearance.

His ticket touting became less successful as he let himself go. He developed a dependency on drugs and became almost universally distrusted and hated. I can't say that I'm sorry about that.

OUT IN NICARAGUA, Legia bought the farm. My stepfather, who was lonely after my mother died, came over from England. At the ripe old age of seventy he started a new life in Nicaragua and loved every minute of it. I started a new life as a farmer.

My job was simply making sure the hired help and the maids did what they were supposed to do. I paid them a pittance — a dollar a day — and was thought to be foolishly generous. We grew bananas, mangoes and coffee, all of which we sold to the local market. The weather was extremely hot, hotter even than Miami in mid summer, but after a while I got used to it. I picked up enough Spanish to get by, and soon fell into the normal Nicaraguan routine of sleeping for a few hours in a hammock in the middle of the afternoon.

The civil war was raging through the whole country. We lived in a part dominated by the left-wing Sandanistas regime. Frankly, I liked what I saw of them. They seemed to be genuine and had the welfare of the people at heart, unlike the US dominated "Contra" rebels who appeared to be as bad as animals.

Life would have been very easy, but for fact that I went to Karla's grave every day, to talk to her. I swore on her grave that I would never go crooked again. I would do things that she would have been proud of, not ashamed of.

One day I got out of the hammock after my siesta when I felt a bad pain in my chest, as though I had bad indigestion. I asked Legia what she put in the lunch that had made me so ill; she had served some spicy dish. The pain got worse and Legia sent for the local doctor. He diagnosed a mild heart attack. He said I should get some tests done and have treatment.

I didn't really trust doctors, least of all doctors in Nicaragua. I didn't like the idea of having tests. What if they revealed something? I put the whole incident out

of my life and got on with things.

About six months later I got a telephone call from Roman. I had last seen Roman in Miami; he had flown in to see me the day after Karla was killed and had switched on the TV in his room to be horrified at seeing David and Karla's faces on the news. Obviously we were in no state to work then.

Roman said that there was good poker action that he had found in Toronto. There were all kinds of marks who needed to be parted from their money. Could I be there? I was enjoying life in Nicaragua but as usual was spending too much. The money I had got from the traveller's cheque coup was largely gone, though I did have the farm to show for it. But the farm was becoming worth less and less as the civil war raged on. The prospect of making some more money was very attractive. It would come in mighty handy. I agreed to go to Toronto. I did not keep the promise I made on Karla's grave.

I got the next flight to Toronto via Mexico City. It was early January and although Nicaragua was boiling hot when I left, I arrived in Canada in the middle of a freezing winter. The whole of Toronto was covered in snow and ice. All my warm clothes were in my suitcases which some kindly soul had stolen in the course of my journey.

Roman had arranged for his sister to meet me at the airport. She was supposed to take me to a hotel but suggested that as it was very late she should take me in a cab back to her father's house (she did not know how to drive), where she would cook me a nice hot meal to warm me up. The prospect of some decent food, after hours on planes eating their plastic rubbish was very appealing. We caught a cab and got back to her father's house at about one in the morning.

Out of the cab there was only a short journey to the front door, up some steps. I didn't have a warm coat. I stood aside waiting for her to unlock the front door. She grabbed me, kissed me vigorously and told me that she always loved me. She then kneeled down and started to give me a blowjob, right at her father's front door. I had flown and hung around airports for over twenty hours. I had lost my entire luggage. I was feeling sweaty, low and tired but a blowjob is always a blowjob and you should never refuse one. As I finished I got a terrible pain in my chest. It was my second heart attack, more painful than the first. I was dying.

Roman's sister couldn't drive but she unlocked the door, found the keys to her father's car, carried me and put me inside it and drove, for the first time in her life, to the hospital. I don't know how she managed it — that saved my life.

I was in intensive care for five days and then I rang Legia. Roman's sister became very unhappy when Legia turned up; I suppose she realised that I wouldn't be leaving my wife. Legia took me back to Nicaragua just as soon as I was well enough to travel. I never did play those Canadian marks.

Life got kind of lazier and lazier on our finca, but as we did less and less so the countryside became more and more violent. I didn't venture out much, preferring my hammock. One of the maids did the ironing when I had my siesta in the hammock. She rigged up a device so that she could gently rock me while she ironed. Paradise inside the walls of the finca while outside the civil war involved

more and more people.

The Sandanistas, who were in control of our region, promised that they would protect my finca and its people but they became less able to fulfil their promises as the Contras, swollen by foreign (mainly US) aid, became stronger in our region.

My stepfather took to guarding the walled enclosure where we lived and most days he sat outside the front gate with a rifle ready to shoot anyone who ventured inside.

It was barely safer inside the walls. I several times found deadly scorpions and bootlace snakes in our bedroom that I had to kill. Outside the civil war waged and in the midst of it bandits, claiming to fight for one side or another, were on the look out for the main chance.

Legia's family came to us with stories that they heard. The local bandits were going to raid our finca and steal our possessions. By western standards we hadn't that much, but by the standards of the bandits we were fabulously wealthy. The local Sandinistas promised to protect us but there was no way that they could keep a round-the-clock guard in place. My staff were few and while I am sure that they would have fought fiercely to protect us they were hardly professional fighters.

The straw that broke the camel's back, as it were, didn't come from bandits but was fired from a bazooka by the Contras. Luckily their aim was not too good and while they caused some damage to the house no one was injured.

Strange that, isn't it? I was a crook and had spent my whole life stealing. I had thieved in America, thieved in England, thieved in Italy, thieved in Yugoslavia, thieved in Belgium, thieved in Switzerland and, well, thieved whenever I could. I knew that I was responsible for my actions. If I was caught I'd go to prison or if I was caught by one of the villains I had thieved from I'd probably be killed. I can accept that. I don't like it, but I understand it.

But the people who fired a bazooka on my finca didn't know me. I had never done anything against them. They had been given money by the United States to wage war against a government that the United States didn't like. They had been given bazookas that they fired on harmless homesteads. No one in Nicaragua was arrested. No one in America was arrested. No one in Nicaragua was punished. It was all right to fire bazookas on me, my family and the peasants who earned a poor living from us.

I can take a hint as well as the next man — the time had come to move on. I couldn't risk Legia's life there. I asked her mother to put the finca on the market for whatever she could get for it, and booked flights back to England.

My stepfather refused to come. He didn't care that his life was at risk. He was over seventy and loved the life in Nicaragua. He had always tended towards overdrinking but somehow the heat and local alcohol was good for him. He would stay in Nicaragua. So he did. He helped my mother-in-law run the finca until it was sold, and then he stayed on until he peacefully died in his sleep, several years later.

BIG DICKS

BACK IN MIAMI the State of Florida moved towards David's trial. David had confessed to Detective Gordon Director, (you can read his version of events at the end of the book) but the State of Florida cannot rely on merely an uncorroborated confession in a capital case. Murder has to be proved. David had committed the crime with one of his lowlife friends, Nelson Molina. The crime kept itself in the public eye partly by its own intrinsic wickedness and partly by the reporting and peripheral events that at times resembled a very black farce.

At first, as the news of Karla's murder broke on January 27, 1984, the newspapers' angle was that Karla was so trusting she often left the front door wide open in the ground floor apartment. The police released the fact that David confessed two days later, and within another two days Nelson Molina was captured. His sister, Sisy, was quoted as saying that Nelson "was not the type of person to do something like this to a little girl; he loves kids." She described Nelson as hardworking. She also said it was like a bad dream. She was right about that, at least.

Assistant District Attorney Susan Dechovitz, a young, pretty, but tough lawyer ran the prosecution case. By the middle of February she was assuring everyone that David would be prosecuted as an adult on a charge of first-degree murder but would not say publicly whether she would seek the death penalty. Syd says that she assured him, privately, that she would seek the death penalty for David.

In October and November, by the time Syd had left Miami, reports appeared in the papers claiming that David would seek a trial in England. Under English law a murderer who is British can be tried in England, no matter where he commits his crime. England retains jurisdiction over the case. Not all foreign countries wish to relinquish jurisdiction in the most serious cases and I imagine David's lawyer sought to use this little known loophole in order to avoid the death penalty for his client. By November 1984 the Miami papers were claiming that David was still trying to get what they quaintly called "the British Empire" to intervene in his case.

In the meantime Nelson Molina's lawyer was trying to claim that Nelson Molina was insane, and his insanity was caused by television intoxication. Molina's lawyer, Ellis Rabin, had tried this defence in an earlier case. The Florida court threw the defence out, so Ellis Rabin tried a new defence. He claimed that Molina's brain was defective and wanted to compare it to those of past executed murderers in the hope of showing a physical defect, hoping that brain lesions would be

revealed. The court, acting by Judge Ted Mastos, held that Rabin could not use Florida State money to conduct a brain comparison experiment.

On November 26, 1985, nearly twenty-two months after the crime was committed and while Syd was in England, David pleaded guilty to murdering Karla. Molina pleaded not guilty and threatened at one stage to call David to give evidence. The matter went before the jury who convicted Molina on December 14, 1985, rejecting arguments that he had been insane when he held Karla as David stabbed her.

The prosecution were by now no longer seeking the death penalty and both were sentenced to life imprisonment.

In a final twist, David applied to a Dade Circuit Judge on January 15, 1986. The nature of his application was astonishing — David asked the judge to sentence him to death on the grounds that he did not deserve to live. The judge refused.

Syd was by now spending his time living between Nicaragua and Britain as it was taking time to sell his finca.

In Britain Mrs Thatcher's period in office suddenly came to an end in a way that can only happen in a parliamentary democracy.

If he had been a businessman Syd would have been exploiting the opportunities of the fantastic currency fluctuations of the time. A Hungarian businessman made hundreds of millions of dollars speculating against sterling and his actions combined with the speculations of hundreds of other speculators and banks caused the British Government to do what they had solemnly promised their people they would never do. They pulled the sterling away from its European partner currencies. That decision was months too late and the delay by the Government caused hardship. Many people went bankrupt. The Government, in its failing efforts to prop up sterling, wasted over a billion pounds of public money.

In those circumstances Syd's wit and purposefulness, combined with his scepticism of authority would have made him millions. But he was not a businessman, he was a crook, playing at the periphery of the big game, looking at the economic confusion as an opportunity to cheat people out of hundreds of thousands, rather than make millions by a means that society deemed honest.

The Gulf War came, the Gulf War went, but the soldiers came back from the Gulf feeling ill. The Government, careful keeper of the public purse, insisted that they had to prove that the cocktail of drugs they were given or Saddam's chemical weapons caused their syndrome before they could be compensated.

In the nineties the communist regimes in Eastern Europe fell. The people now had their liberty but with that newfound freedom came unexpected poverty, in some cases starvation, and organised crime. Instead of people being subjected to state oppression they became the victims of criminals, particularly in Russia.

Syd was in his sixties and in imperfect health but that didn't stop him from chasing his rainbows. He found his style becoming more difficult in Britain; maybe because the things that he had regarded as scams were now being practised by large corporations against the public using lies, half-truths and hard selling. This scepticism and the mellowness caused by age and illness moved Syd on.

I DON'T KNOW WHETHER DAVID was genuinely remorseful. Somehow I doubt it. I suspect that he was having a hard time in prison because the Molina case had made sure the viciousness of David's crime would become known throughout the jail. The convicts must have taken it out on him. He tried to escape by death and found that he couldn't do it. He didn't have what it took to kill himself. He would have to get used to it. You can get used to anything — I know.

Back in England I had to try to earn a living. The club was still going, but Barry had bought my share of it while I was in Florida. He had been to prison for receiving stolen goods. He was paler and weaker than before and eventually he had to sell the Marie Lloyd. He had cancer.

Roman was out of circulation, in England at least. Tim was still in jail and although Brian Patterson had come out of prison he was retired now, living quietly with his wife in his penthouse flat in South London. My heart was not in the scams.

David had not yet been tried in Miami. The District Attorney wanted me to give a deposition and return there for the trial. I was worried about doing that — I had committed a variety of offences in America, some in the state, and some I worried might be Federal offences. I could get some sort of immunity from the state, but not from the Federal authorities. I was worried that if I went back to the States I might end up in jail, and that would do me no good at all.

After a lot of negotiating I gave a deposition in London in front of the DA's people who had to fly specially to London. I guess they were not too upset about doing that. Legia was trying to make sense of London after living in south Florida and Nicaragua. She was also trying to come to terms with Karla's death. That must have been the hardest thing for her. Every time she looked at me she must have been reminded that it was my son, who I had brought into her home, who killed her little girl.

And she felt things deeply. She said once, not to me but when I was there, "I really cannot understand why this terrible thing happened to me. I go to church, I believe in Jesus. I never did anything bad, I never did anything wrong. I don't know why."

I could not tell her why this happened to her. I wish to God that it had never happened. But you can never change the past, no matter how much you want to.

I had my third heart attack in London. By this time I knew what the pains meant. The doctors said that unless I had a bypass operation I would die; I had to face reality and I agreed to have the operation. I was taken to St Mary's Hospital where they told me that I would need a number of bypasses.

The surgeon explained what he would do. He would cut open my chest bone, with a saw. After he had done that he would cut my heart out, put it in a bowl of ice, cut my legs and drag out the veins. He would then use the veins to by-pass the choked blood vessels in my heart , put my heart back in put my chest together with wire and start me up. I asked what would happen if my heart didn't start up? He said not to worry, I would be dead. He said that there was only a ten percent chance of that. The surgeon was quite a comedian.

Just as they were giving me the anaesthetic I told the anaesthetist that I had

changed my mind; I didn't want the operation. He said, "All right, don't worry, we'll just turn you around and take you back." He jabbed me with a needle and put me under.

When I awoke, I had all sorts of tubes coming out of me and felt terrible. I saw the anaesthetist standing over me.

"You bastard, I told you that I didn't want the operation. What the hell were you doing?"

He smiled. "If you died during the operation no one would know that you told me that you didn't want to have the operation and you, being dead, couldn't say anything. Now aren't you happy that you had it done?"

After I was in intensive care they put me in a heart ward. Every night someone died and they wheeled out the body. Night-time was for wheeling out the dead. As a nurse was wheeling one body out I said:

"What are you doing?"

"We are just transferring him to another ward."

"You're not! He's dead, isn't he?"

"Shhh, you'll frighten all the patients!"

"Fuck the other patients! I'm frightened!"

After three days in the ward I was discharged.

When I was having the operation they told me that they had found that I was a diabetic. I now have to take insulin twice a day. I am supposed to be on a strict diet but I eat what I like. Maybe I should go on the diet and then I will get another four or five years of life.

I WENT TO MANCHESTER to see my family and introduce Legia to them. Up there I heard that timeshare salesmen were required for a new development in the Lake District. I could do that job. I applied and was accepted as a commission only salesman. Selling timeshares in England was no different from selling them in America. The techniques turned out to be exactly the same — it was hard pressure selling but at least I was earning a good living.

I also set up a business, which I called the Timeshare Advisory Service. For a small fee we would register timeshares that people wanted to sell or swap and advise people on the best way to go about marketing them. I ran this business from the timeshare company's office in the Lake District in my spare time, so I had no overheads.

In most cases people who buy timeshares are stuck with a white elephant. They end up paying maintenance charges that are not too far lower than what they would pay for two weeks in a hotel. They have no real protection against exploitation. Once they have parted with their money it can be almost impossible to sell a timeshare, especially in the economic gloom that was then, in the early nineties, rapidly settling over the world.

I expanded the service by advertising it in Florida. From there I got many members and I spent a great deal of time on the telephone with each one providing advice, for a fee, and suggesting how to go about valuing and marketing a

timeshare in a particular place. I also set up a valuation service where I valued second hand timeshares for a fee.

In fact the advice was easy to give. Most of the customers were under a false impression as to what their timeshare was worth; once they realised it (and spent some money with me to realise it) there was not a lot that could be done to help them.

The advice is usually not to buy a timeshare in the first place. But the most useful time to give the advice is before the customer has signed on the dotted line. I dealt with two types of customer. One type was in my official capacity as a timeshare salesman in the Lake District. To these people I extolled the virtues of timeshare ownership. The other type of customer I dealt with had bought a timeshare and was desperate to get rid of it. Although I tried hard to introduce these people to places where they might get some value for their timeshare, and succeeded two or three times in selling their timeshares, most of the punters had lost their money as soon as they bought the timeshare in the first place.

I kept in touch with the Florida members and with the progress of the sale of my finca in Nicaragua all day by telephone. I did my best to help them, provided they paid their subscriptions. I ended up with an impressively large list of members, every one a dissatisfied timeshare owner.

I was the best and most successful timeshare salesman in the Lake District. I was making reasonable money from selling timeshares and from advising people about timeshares. My boss was very impressed with my selling record, but one day he walked into my office with a telephone bill.

"This, Syd, is a bill for your telephone," he told me, waving it around in the air.

"Yes."

"It is for £8,000!"

"Yes."

"There is no way that you could have done £8,000 worth of telephone calls on company business, Syd."

"Yes, I agree."

"You agree?"

"Yes, I agree. I have been running another business from here."

"Well are you going to pay the bill?"

"No."

"Then you'll have to leave." He paused for a little while thinking hard. "Look Syd, I'll tell you what. You pay half the bill, and we'll pay half. And in future don't use our lines for your own business."

I looked out of the window. The Lake District was very beautiful. Legia and I had made some nice friends. But I was not making any real money. I felt restricted, hemmed in and wasted.

"No, I won't pay a penny."

"So you'll leave?"

I looked at the sky.

"Yes, I'll leave."

SO A FEW WEEKS LATER I was sitting in my very own office at the Timeshare Advisory Service in Lancaster where I had to pay my own telephone bills.

It is a bit lonely sitting in an office all day by yourself so I got myself a helper, Brian. He was a dour Lancastrian with a dry sense of humour and we would while away the time as we waited for the phone to ring telling each other jokes and reading the paper. It was a pleasant way to pass the time.

There was not much to do that day. Brian told me about an interesting piece in *The Sun*. A doctor in South Africa (let me call him Dr X) had gone to China and found out a way of making men's penises longer from a doctor called Dr Long. It involved a small operation. Dr X in South Africa had become an expert in doing this penis enlargement operation. Brian was laughing because the small operation had been invented by a Dr Long, but as he read, something clicked in my head. I asked him to read out the article again.

I thought that I could do well out of this. I roughed out a letter, and had it typed out. I rang South Africa and managed to speak to Dr X. I got his fax number from him and I faxed a letter to Dr X.

Now while I was in Florida, I became a Reverend. The World Christianship Ministries invited me to become ordained in their ministry. They said that I could, after ordination, carry on my ministry in the way that I felt the Almighty would direct me. I could use the title "Reverend" and generally further the work of this important institution. I needed to have one qualification to be ordained — twenty-four dollars.

I had the necessary qualification so I became ordained in the name of Sydney Goodchild on September 2, 1989, because I felt that Gottfried might be thought to be inappropriate for a Christian minister. I was given an ordination certificate, a certificate giving me my title (I chose Reverend, but I could have chosen "Pastor" or "Missionary" or "Dean" or any one of a number of other religious titles). I was given an honorary degree, "Doctor of Divinity", and a pocket credential card on which the name of the church and its logo were printed. I never actually used the "Doctor" title because I was concerned that people might confuse me for a medical doctor. I didn't want to mislead anyone.

When I wrote the letter to Dr X I decided to adopt my persona of Reverend Goodchild. This is what the letter said:

Dear Doctor X,
I have read a report of your operation for penis lengthening in the newspaper here with great interest. I have some members of my congregation who have this problem of short penises and I hold therapy sessions with them. However, the therapy has only limited success and what the members really need more than anything else are longer penises. This is a big problem amongst people and I am sure that it extends beyond my parishioners. Could we talk about having exclusivity for your services in the UK and Europe?

Within a few days, I negotiated a contract with the good doctor. I, the Reverend Sydney Goodchild, had the exclusive right to Dr X's services in all forms for the penis lengthening operation throughout the whole of Europe.

I brought Dr X and his wife over from South Africa. I paid for his first class air fares and his five star hotel bill; I spent about a week with them, brought them to my house, entertained them and generally found out all about the dick operation. He was a big greedy man, but he loved me and loved the idea that I was going to make him a multimillionaire. He trusted me straight away. He sent me cheques that I had to pay into my bank account and after they cleared I had to send them on to his secret account in Switzerland. I guess he was fiddling exchange control and taxes in South Africa.

I phoned up *The Sport* newspaper and put in a quarter page ad for the operation. Three days after the advertisement appeared I had half a sack of mail. I faxed details of the operation to all the men's glamour magazines — *Playboy*, *Penthouse* and *Mayfair*. *Penthouse* gave me a two page write-up. And it was all free.

I answered every enquiry as Reverend Goodchild. I was at pains to explain precisely what the operation entailed in writing to each enquirer.

> *The operation takes considerable skill and experience and cannot be performed by inexperienced surgeons. This procedure was pioneered by Chinese surgeon Dr Dao-Chow Long. Dr X spent six months tracking him down to Central China where Dr Long instructed him in the technique. Dr Long has performed this procedure more than 1,000 times, with his patients reporting a dramatic improvement in sexual function. Most men he has treated are in the twenty to thirty-eight age range, but age is no barrier. Dr X has performed this operation on numerous occasions and has a very long waiting list in South Africa.*
>
> *Every man has been told that penis size does not matter, but any honest woman will tell you that it does. The whole idea that penis size does not count is rubbish; it is undeniably important to men and women alike.*

I then went on to explain as precisely as I could the medical background to the operation. The patient would have to spend just one day in the clinic, but I assured the patient that the clinic would be most luxurious.

The patient would have to shave his own pubic hair from his penis to his belly button. Having done this the patient would be anaesthetised and the surgeon would open the patient up and loosen the penis. The penis is attached to the pelvis by a ligament. The ligament would be cut and the penis moved forward and secured in a new position by stitches. The skin in the pubic hairline would be pulled down to cover the new length of penis. In other words what the surgeon would do is effectively bring that part of a penis that is normally within the body, usually about three or so inches, to outside the body.

At the end of the operation, the angle of the penis would change by about fifteen degrees, but its other features would be unchanged. Penis thickening could also be provided for an extra £1,000, but this would only work in suitable cases.

This procedure usually resulted in increasing the erectile length of the penis by fifty percent and the flaccid length by sixty percent. There would be a small thickening around the base of the penis.

I warned that there would be a slight discomfort and swelling after the operation and that complete rest would be required for at least five days, and sexual activity prohibited for three weeks.

Those people who were interested in the penis operation would have to make an appointment to see me to assess whether they were suitable. I was not going to assess their medical suitability, because I was not medically qualified. I wished to assess their physical and emotional suitability. I made it clear that I was not interested in extending a man's penis for the sake of it. If a man had seven inches already I would refuse to be party to making his penis ten inches. But if a man had a genuinely small penis then I would be prepared to assist him to gain respectability. I put this in the advertisement in order to attract the right kind of people, people who were desperate for the operation.

The first process was to screen the dicks. My office in Lancaster was ideal. It was in an old building called Church House, in a cobbled lane called Church Street, at the back of Lancaster Cathedral. I arranged appointments for those interested to see me. Brian assisted me, and introduced the prospects to me. I saw them in a room with a large desk. Unknown to the patients, Brian listened in the next room to the interview, just in case anything happened. And we recorded the interview. The fact that it was being recorded probably caused me to camp up the Reverend thing a bit. I used to have Brian in stitches and later we would play the tape back and enjoy the fun.

PEOPLE CAME FROM ALL OVER the country to see me in Lancaster.

I saw one patient I shall call Mr Smith. That is not his real name or even the name he gave me. I never knew his real name because most of the patients applied to me under aliases. I promised each patient anonymity, I am honourable like that.

"Mr Smith, I am delighted to meet you."

"Good afternoon, Reverend."

"Now, Mr Smith, I do wish to make sure that you fully understand all that is entailed in this operation. Did you study the letter that I sent you?"

"Of course, Reverend."

"But did you study it most carefully?"

"Yes, Reverend."

"And are you sure that you want to have this procedure?"

"Yes, Reverend."

"Now, you know that the price of the operation is £3,500 and that it is all payable in advance. A deposit of £325 is payable today. The balance is payable on the day of the operation. When we have sufficient people we shall arrange for Dr X to come from South Africa and do all the operations at once. That is how we can keep the costs down to such a reasonable level."

"I have brought the deposit, Reverend."

"Keep your cheque in your pocket, my son. I am not going to take your money until I am sure that you qualify for the operation. I am not prepared, if your penis is already sufficiently long, to increase its length. That is entirely against my principles. I am not in the business of turning a man into some sort of freak show. If your penis is genuinely small then I recognise the associated trauma and physiological problems that go with it and shall try to help you. Now is your penis really small?"

"Yes, Reverend, I am afraid it is."

"Well, my son, you know that I cannot simply take your word for it. I must examine it."

"What here and now Reverend?"

"Yes, my son, here and now. I can't simply take your word for it. This is too important. I will not be party to arranging the operation for anyone who is of sufficient size."

At this stage I opened the drawer of my desk and pulled out a large piece of red silk cloth. I lay it over the side of the desk.

"Please place your penis on the cloth."

Mr Smith looked aghast at getting his dick out and showing it to a priest. He needed some encouragement.

"Come, come, I must examine it."

Mr Smith pulled his dick out and laid it on the cloth. It was only three inches long.

"Oh dear, oh dear. Yes I am afraid my son that you do need our services."

"Yes, that is what all my boyfriends say," said Mr Smith, "and in my community, size rules!"

As it turned out, most of our patients were gay.

If I felt that I could get away with it, I asked for permission to photograph the penis. I sometimes showed patients "before and after" pictures supplied to me by Dr X. The results were impressive.

I had a big chart on the wall. It showed most of the spaces were occupied and only three or four empty slots were available. The spaces were mostly marked fully paid but a few were marked deposit. Because of the need to preserve confidentiality in this highly sensitive business all clients were given personal identification numbers, and those numbers appeared on the chart, not their names.

"Now, if you pay the £325 deposit I shall reserve a place for you, but the whole matter is arranged on a first come first served basis. You see all the numbers on the chart. Those are people who have paid the full price. There are other people on the reserve list who have paid £325 deposit and when they pay the whole money they will go on the chart. When the chart is full Dr X will come from South Africa to do the operations. If you want to be sure of a place this time round you can take No 175's place or No 191's place because they have only paid a £325 deposit. Would you care to pay the deposit or prefer to pay the whole amount?"

In nine cases out of ten to get on the chart, the patient would pay the whole amount. Of course, the chart was a complete sham.

This page and next Dr X measuring up, before and after.

I would then discuss with the patient whether he wanted penis thickening as well as lengthening, and quote the additional fee that we charged for this. It was not always possible to perform thickening, as some circumcised men cannot have it done to them. If he were to be such a case, I promised I would refund every penny paid in advance. I also said that if they changed their minds after paying the full amount I would refund all the money, less an administration fee of £325.

I did refund everyone who was due a refund, although in some cases where the patient was nasty I delayed sending them the money back, just because they gave me the hump.

Most patients paid me by money order or draft; that way they kept their identities secret. One punter paid in cash. When he pulled out £3,500 I pretended to be horrified. "How on earth did you carry all this cash with you in the street? Some evil minded villain might have robbed you!"

I sent for Brian to ask him what we should do with all this cash. Luckily Brian came up with a good idea. We should take it to the bank and pay it into our account! I arranged for him to escort the patient and me to the bank to make sure that some criminal did not steal the cash before it was paid into the account.

Sometimes we had to send a refund back. Almost always we got a letter from someone we knew as, say, Mr Black, asking us to make the refund out to Mr White!

I had to find a clinic. I telephoned four or five of them, but they did not want to know about hiring facilities for dick lengthening. It was too controversial. I rang up another four or five but none of them wanted to be involved with dick operations. They feared adverse publicity.

I finally got through to one exclusive north London clinic and spoke to the chief

administrator who was an Irish woman. She was not the owner but she had a lot of clout. She said that she did not really want the clinic to get involved in something so potentially controversial. I made enough of an impression on the telephone to get an appointment.

When we met I thought that she quite fancied me so I played up to her. I said that she was just looking at it in the wrong way. It was just a man's operation. Women have women's operations. They have breast implants, liposuction, lip implants, all kinds of things. There were operations that changed people's sexes. Surely this was nowhere near as bad as some of those kinds of operations. This is a straightforward operation. We were helping all sorts of poor men who felt most inadequate due to the small size of their penis. She did not seem convinced.

I then asked her to look at it as a straightforward commercial venture. I guaranteed that they would make money. I guaranteed that there would be no adverse publicity. I talked sweetly. Now she was interested. She called the owner who lived nearby. He OK'd the deal in principle. The clinic charged me £2,500 a day for a whole floor of the clinic and full use of the operating theatre. I asked the clinic if it were possible, and could they do me a great favour by allowing me to pay them cash on a daily basis up front instead of by cheque, because I did not want the money to go through my books. Yes, they were amenable to that.

The first time, I arranged for twelve patients to have the operation. I booked the private clinic for three days and arranged for Dr X to do four operations a day. He flew in from South Africa with his wife, his anaesthetist, two assistants and a nursing sister. I paid the airfares and the hotel expenses. I had agreed salaries for the team and agreed with Dr X that I would pay him £1,500 per operation

because I recognised that this was a small number to operate on, but when I brought him over for what I expected would be a much larger series of operations I would only pay him £500 per operation.

The twelve operations were mostly successful. Dr X suggested that, in order to explain better to prospective patients, I should attend the operations as an observer and I agreed. So on the day of the operations I scrubbed up, put on gown, boots, mask and gloves and went in the operating theatre with the doctor to see how he did it.

It was really an experience. I think that nothing would have induced me to undergo what I saw, but the patients were mostly satisfied with their extra length as they limped away with plenty of pain in their new penis after the effects of the anaesthetic wore off.

Dr X was delighted when I gave him £18,000 in cash at the end of his three days work. To him this was a fantastic amount of money for such a little amount of work and he was keen to come back and do the remaining operations.

I kept the marketing machine going, with ads in the right kind of papers and Reverend Goodchild saw a great many dicks over the next few months. Dr X sent me a video to show prospective patients and lots of medical information. Dr X wanted to do as many as he could. We had plans to hire a clinic in Belgium and Switzerland and offer the operations there. We found out that there was a huge German market for this sort of operation and Dr X and I looked forward to breaking into it and lengthening a few German dicks. We planned to take a commercial on German television. We also discussed whether we could franchise the dick operation and train doctors to do it, for a large fee.

We signed up lots of patients, but from time to time some dropped out because they had second thoughts about the operation. Some decided that they were too old, some big enough after all, and others "for reasons beyond my control". I sent each one their money back less the administration fee of £325.

In the end I collected ninety-six fully paid patients and hired the clinic for three weeks. Dr X complained that I should have hired the clinic for a longer period, but I said that he had to work without a break until all the operations were performed. When he came over to do the ninety-six dicks, Dr X worked all day and all weekend without a break. He should, I suppose, have limited his work to three operations a day but he agreed to do more, and in the end I think he was doing five or six a day, including Saturdays and Sundays.

Every morning in the office at the clinic which they set aside for me, I would call in Dr X, the anaesthetist, the nursing sister, the scrub nurse and give them the programme for the day. Mr A will be first and he will have ordinary dick lengthening. Mr B would be next and he wants thickening as well as lengthening. Mr C is next; he has come from Cornwall and is a bit tired. We'll give him a little break before he has his operation. He is just for lengthening and so on. I would read details from the clipboard. So I was in the position of giving instructions to all these medical people (who took careful notes). It was ridiculous.

Dr X arranged for other doctors to observe the operation and they paid him

good money to learn the technique. I never asked for a share of the fees that he charged other doctors. Dr X gave me the cheques that the other doctors gave him, which I paid into my account for him and then sent on to his secret Swiss bank account.

At the end of the ninety-six operations on a Sunday night I was sitting in the office at the clinic with Brian the helper. The clinic rental included use of the office and I enjoyed sitting there. It was arranged that the boss' chair, which I used, was set on a platform above all the other chairs so that I would be higher than anyone else. It would be for the last time. The clinic booking was ending. Dr X came in. I said, "Very well done, we have had a very successful time and it is time to give you the money. How do you want it?"

"Can you give me some money in cash please and send some to Switzerland?"

"Of course, I said. "What do you want in cash?"

"£75,000, and the rest to Switzerland."

I said "£75,000? You have made a mistake there. You are only due £28,000 altogether. That is your "£28,000 cash," and I put the cash on the desk.

"No, no; £144,000 that is £1,500 times ninety-six operations."

"£1,500? We agreed £500!"

I gave Dr X a statement of account, which went like this:

96 Operations @ £500	£48,000
Airfares and hotels	£20,000
Balance due to Dr X	£28,000

He said, "What the hell is this?"

I said, "It is a statement of what I owe you, and here is the money I owe you, £28,000." I pushed the cash over to him.

"No, no, it should be £144,000. Look, there were ninety-six operations at £1,500 each, not £500 each. And why deduct the expenses?"

I patiently explained that I never agreed to pay the airfares and hotel bills, and that I had simply advanced the money to him. I had only agreed £1,500 for the first twelve operations because they were low volume. I had already warned him that the high volume ones would only be paid at the rate of £500 each.

"It is £500 per operation, do you have a problem with that?"

"Yes, I do Reverend. We had a deal for £1,500."

"No we had a deal for £500, and if you do not want this…" I pulled the money back.

"No!" he screamed, at the prospect of the £28,000 vanishing into my pocket and grabbed the money off the desk.

I said, "That is all I can say to you." I wanted to draw this unpleasant interview to an end.

"If that is the case," said the Doctor, "I cannot see us doing business again."

I walked out of the room and left my assistant Brian there with him. He told Brian that he could not believe it, and that after he had paid his bills he might only

wind up with £10,000. For three weeks' work this didn't strike me as too bad.

Dr X was most unhappy. He complained to the police who came around to interview me. I told them that Dr X had agreed with me to get £500 per operation and I had paid him that money. The £1,500 was agreed when he came over to do twelve operations. For ninety-six operations in three weeks £48,000 was a lot of money. I was entitled to deduct the expenses. The fact that I kept all the rest of the money was neither here nor there. I was acting in accordance with my contract. Furthermore I had a number of complaints (I showed the police the letters), so I should really be holding money back in case I was sued. I had not held money back but if these people sued then Dr X would owe me a lot of money.

The police could not do anything because it was a civil dispute. Dr X had no written contract which set out how much he would be paid. I was rather surprised that he went to the police, especially in view of the fact that I had done his secret banking for him.

In fact I did want to give Dr X the extra money. I knew that I could make millions out of these dick operations. All I needed to do was to put the prices up next time. People who were prepared to pay £3,500 would be prepared to pay £4,500. Or I could have treated every case on its merits and charged whatever the person would have been prepared to pay.

If I wanted to give Dr X £144,000 then why did I only hand over £28,000? The truth was that I collected the money months earlier and after paying for the clinic and spending some money on my own lifestyle that was all I had left. As usual I spent it as fast as I earned it, and in this case because the punters were paying up front, before I earned it.

What had I done with it? I bought some clothes, had plenty of nice meals in fancy restaurants and hired some good cars. I had bet on a number of horses and been on a number of holidays with Legia. I had also got myself a couple of racehorses and paid for their stabling. The racehorses turned out to be pretty poor but I thought they were going to be good. I expect I was conned when I bought them. What I had left to show was very little.

I didn't pay the clinic for the last three days either. I would have paid them, but they made me give the cash each morning to their accountant. He was a Pakistani who could not count. I would give him a bundle of notes sealed fresh from the bank. He opened each plastic bag and spent ages in miscounting the bundle. I got the hump. I know I have done tops and bottoms, but I got the hump with the accountant because I was giving him real money that I had taken out of the bank!

After a week I said to him, "Every day I come here and I give you £2,500. Most days it is in a sealed packet but you insist on opening it. Why?"

"I have to check it Reverend; what if one note was missing?"

"What, from a bank? Come along, I have things to do here. I cannot stand around all day watching you counting money."

In the end I gave him the notes and never bothered to watch him count them. Except for the last three days, which fell on a Friday, Saturday and Sunday. I simply never came in on the Friday and the accountant did not work at the week-

end. I promised that I would go in on Monday and pay the money but I never did. If he hadn't annoyed me I would have paid him. Maybe.

When the clinic wrote to me asking for the money I told them that I had paid the accountant! I suggested that they ought to investigate matters.

I received sad letters from a number of patients. One chap in Cornwall complained that his penis had become infected and that his doctor was reluctant to treat him with more antibiotics for fear of building up immunity to them. He described in graphic detail the symptoms that he felt and drew a diagram.

Another patient complained that he had suffered a loss of feeling in his penis. Dr X told him that the feeling might return after nine months. Understandably enough, this patient thought that the Doctor's response was not good enough.

As I told the police sometimes things went wrong with the operation. One chap from the Channel Islands, poor fellow, had a penis only two and a half inches long. Dr X made a mistake of some kind and the patient ended up with a one-inch penis. Not a good result.

A common fault that people complained about was that a "v" shaped cut, made by Dr X as part of the procedure never mended, so that some patients had an opening, which frequently discharged pus.

One Scottish gentleman complained about two things. First, he said that there was no noticeable change in the length of his penis, either erect or flaccid and secondly his testicles had swollen and the swelling refused to go down. "My testicles would not look out of place on a rhino," he complained.

I sent out a questionnaire to the patients after their operations. These were the questions and the usual answers:

1 *Has all bruising and swelling subsided?* No
2 *Has all feeling returned to your penis?* Not quite
3 *Has there been an improvement during lovemaking since the operation?* No, slightly worse
4 *Length of penis before operation?* Soft 3" Hard 4"
5 *Length of penis after operation?* Soft 6" Hard 6" 2
6 *Did you suffer any discomfort?* Yes
7 *If so, for how long?* 3 months
8 *How long before you resumed full-time work?* 3 months
9 *How long before normal lovemaking resumed?* 6 months
10 *Are you happy with the operation?* Not happy or unhappy
11 *If you had the thickening also, are there any problems?* It looks strange
12 *Is your partner happy?* No

Mostly people didn't reply. As you will see, those who did reply tended to be unhappy. The complaints were a minority. Most patients ended up with a bigger penis. I did receive a number of thank you letters from some patients who were very pleased with their longer dicks. I was pleased to be of help.

IT WAS A SHAME THAT I HAD FALLEN OUT WITH DR X. The market for dick enlargement was huge. To say that size did not matter was a huge fallacy. But I had rather burned my bridges with Dr X, or perhaps cocked things up.

I met up with Roman. He had gone to the Ukraine after communism collapsed there and was making fortunes. He had a string of businesses. He told me that the eastern bloc countries were like the Wild West. Fortunes could be made.

I decided that I should try to make some money in Bulgaria with a Bulgarian friend whom I knew from the Marie Lloyd Club — his name was John.

Legia and I now had two sons of our own. They were very small babies and we decided that they should stay behind in England with their mother while I tried to make my fortune in Bulgaria. I spent some months there, looking for opportunities and occasionally making some money importing luxuries into the country and playing poker with the local Mafia, using my juice.

Bulgarians wanted to be western. They liked to travel abroad, and for some reason, possibly because it was near, spent their holidays in Turkey. I went over to Turkey to see if I could find a suitable timeshare operation there.

I met Mushtaq who owned a resort in Larakabat in southern Turkey. It was a lovely place. He was a builder who had built a resort of sixty apartments that he was now trying to sell to Turks for about £25,000 each, but when I met him he had sold only one apartment.

As soon as we met we liked each other. He told me about his resort and I asked him if I could see it. He pulled out the pictures but I told him no, I had to actually see it. We flew down to Yalikauack, where his resort was being built. I was impressed. Mushtaq had done a good job. He had very good ideas, and although I could suggest some improvements the resort was basically fine.

I told Mushtaq that he was doing things the wrong way. He would end up selling one, two or three apartments a year if he carried on. I suggested a way that he could make big money and he jumped at it. I said that I would sell this on a timeshare basis. We would call it "holiday ownership" and we would sell it in the eastern bloc countries. That was where the money was. They had lots of black money. I suggested that we sell the resort as timeshares in Bulgaria. Mushtaq agreed. He gave me the selling rights under a proper contract and I went to Bulgaria.

Bulgaria was a good place to sell the timeshares because there was no travel restraint on Bulgarians travelling to Turkey. They did not need visas. Earlier timeshare operations had a bad name in the eastern bloc because the resorts that were sold were really bad — the worst of the worst — and were located in bad areas in Spain. With Turkey, it was relatively near and the customers could inspect the resort themselves fairly inexpensively, if they travelled by coach.

I had already been to Sofia the previous year. John had an uncle in Varna, which was on the Black Sea coast and he said that his uncle would help us out. It was difficult but I managed to find a super office in Varna with a house behind it. It was very expensive but it was very beautiful. From there I started my timeshare selling operation. I brought people that I knew from Sofia to work in Varna selling the Turkish resort timeshares. I had known John for fifteen years; he had worked

for me on several other timeshare operations. He was a good guy and I put him in charge of the selling, the administration and the money. I did not have too much to do, except come up with ideas as to how best the timeshares could be sold and check that John was running things properly. John had an assistant called Rosie and we hired two other office girls. I had a good time. I went out a lot. I was very happy, as I had met my Ukrainian girlfriend, Victoria, who was living with me in Varna.

I will always be in love with Victoria. She was blonde, strikingly good looking with long legs and a fine figure. She had a low sexy voice that you would die for. She dressed well and was always in love with me. She made love at every opportunity, fiercely and always wanted to be with me. She was incredibly jealous. If I smiled at a shop girl who was serving us she would boom out "You cheap whore, you don't make eyes at my man!" She nearly fought a girl once over me.

From time to time I checked with John how the operation was going. He was well paid but he worked reasonably hard for his wages and lived on them in Bulgaria, just like a millionaire. At regular intervals I worked out with John how many timeshares we had sold, how much money we had made and how much we had to pay Mushtaq. There was no reliable way to send Mushtaq the money except to take it to him in person. I did not want to leave Victoria to go to Turkey, so I sent John to Turkey to take the money to Mushtaq. I went the first time, but John went the other times.

In order to generate interest and prove to the Bulgarian buyers that we were genuinely selling timeshares, I devised regular coach trips from Bulgaria to Larakabat. When customers asked us to prove that the resort really existed, we said that they could join the club and we would take them on a coach trip to the resort, if they covered the costs.

The Bulgarians loved those coach trips. We would hire the coach and driver and fill it to bursting point. The Bulgarians took a huge amount of food with them and came back very happy with what they saw. Most of them came back very keen to buy timeshares.

After three or four months when everything was going fine, one evening from my house, I saw three men waiting outside the office. They looked like police. Everywhere in the world, police in plain clothes look like police in plain clothes. They were police. They burst into the office with their machine guns and interrogated the office staff who, like me, didn't know why we were raided. I acted quite normally and left by the back door of the office. I found John close to my house and we escaped. I was running a legitimate operation. I had set up a great business with a steady income. As far as I could see it would keep me happy in Varna (and I was very happy there) for years. But I knew that with Bulgarian police it was better to escape first and ask questions later. I went one way and John went the other way. I said I would get in touch with him soon.

I found out what had happened while I was hiding from the police. John had not been taking the money to Mushtaq; John had been taking the money to himself. I, the great con man,, the inventor of scams and the performer of classic coups, had been defrauded by the oldest and simplest trick in the book — a dishonest

employee whom I had trusted with cash. Many of the people who bought a week or two weeks timeshare had nothing. Perhaps in the end Mushtaq and I could have worked something out but until that could happen things looked decidedly bad for me in Bulgaria. I knew that I did not want to go to jail in Bulgaria — it would not be very nice. I had to stay out of the clutches of the police while things were being sorted out.

The police wanted to interview me but I did not want to be interviewed. I escaped as quickly as I could. I tried to get my hands on John but he had vanished. I waited for a short while, got a new passport that would not show the Bulgarian stamps in it, and left Bulgaria. A few months later, anxious to find out what was going on, I went back to Bulgaria with my new passport, this time driving overland.

I found out that the heat had not died down. The police had arrested John and were looking for me. I met up with the office staff. They promised not to tell the police that I was back in Bulgaria but I didn't believe them. I knew as sure as eggs were eggs that they would call the police as soon as I was out of sight, even though they swore that they would not do so. I pretended to believe them but as soon as they left I called Victoria and explained my fears to her.

She hid me in several apartments while the police were looking for me. She looked after me, cooked for me, moved me around and kept me safe. The police found out that I had come into Bulgaria by car and put me on the police computer, so leaving Bulgaria would be difficult. I tried several times to leave the country but each time my name flashed up on the computer at the airport, not because I was wanted but because the records showed that I had imported a car into the country and I could only leave if I took the car out of the country with me.

Eventually, helped by Victoria, I managed to bribe a policeman with $50,000 to let me leave the country. I also paid the local Bulgarian gangsters $50,000 so that I could square myself with them. The immigration official came cheap. He only needed $2,000. That just about took care of all the money that I had made in Bulgaria. John had stolen a lot of money and there was no chance of getting it back. I had known him for years, I trusted him. I gave him a job earning good money but it wasn't enough. He had to steal.

I don't know what happened to John. He might have blamed me for not paying Mushtaq; he possibly served some time in a Bulgarian prison. I hope he did. But I have not seen him from that day in Varna when we promised to meet up again soon.

And to thank Victoria I left her in Bulgaria. I moved back to Legia who was then living in Manchester. She had a catering business making meals for a golf club. She was working hard and was looking after the children very well but without any help from me. She took me back without question and I picked up the threads of my life with her in Manchester where I helped her in her own business and got involved in selling timeshares on commission. The boys loved me and that was good.

I couldn't get Victoria out of my mind. I rang her up, sent her the airplane ticket to London. She came over and we lived together. I sent her back. I felt bad about leaving Legia. I did this seven times. Each time I sent Victoria back, I felt the pain. I could not make up my mind. Victoria had hidden me, and probably saved

my life by her actions in Bulgaria. I owed her. I had ruined Legia's life by bringing David to Miami. I owed Legia too. Victoria came again and for a while I left Legia and set up home with Victoria in Devon where we ran a small café. Victoria loved me, almost too much and in the end it didn't work. My mind was half on Legia and half on the kids, most of the time. I had lost the knack of being purely selfish, and once that goes it becomes hard to live with yourself if you do selfish things that hurt people. Whatever I did next I would hurt one of two very forgiving women. I opted to hurt Victoria and went back to Legia.

IN THE END IT WAS THE CHILDREN who made up my mind. I got to thinking about how my sons were about the same age as David had been when I left home. I was frightened that I could see David in them and unless I was around, something would go wrong again. This was why I put Victoria back on a plane to Bulgaria.

Around the same time I was working on this book with Robert Kyriakides. All the while Legia made the home and made the basic living so that we wouldn't starve; I tried to add something whenever I could do a deal. I wanted the book to end with me living with Legia in Nicaragua. I thought that would be a good ending. Or else I could make enough money to live in Spain with Legia and the kids. We would all like that.

In September 2000 Legia started having pains in her stomach. She described it as regular stomach-ache. She went to her doctor who suggested that as the pains were severe she should go into hospital for observation. After a week of observation the pain stopped and the hospital discharged Legia without any further investigations. Two days later the pains started again. Her doctor suggested that she take paracetemol but I said that this was not normal and instead that she be readmitted into hospital. After four days the hospital decided to do an exploratory operation. They started the procedure at midnight. By five in the morning a nurse came out and told me that they had finished the operation and were very pleased with the way that it had gone. I was not allowed to see her so I went home. Two hours later I got a telephone call from the hospital who told me that her condition had deteriorated so much that they had decided to send her to another hospital about ten miles away that had an intensive care unit. I got there virtually as soon as they brought Legia there. She was comatose and stayed in this condition for the next thirty-seven days. At 8:30PM on Tuesday 7 November Legia died. She was only forty-eight years.

Apparently her small intestine had burst before she was even admitted to hospital the first time. I do not know why it burst but they said it burst just like an appendix bursts. As it was not diagnosed, the poison from her bowel leaked into her body and she became ravaged by septicaemia. She survived Karla by sixteen years. I arranged to have her body flown to Nicaragua where it was laid in the mausoleum next to Karla's body.

I am still alive and I have to think about things that I never thought about before. What was the result of my life? What happened to my friends and me? Enzo was my friend. He helped me and he loved me. Later someone killed him. They took him out in a boat and killed him. I don't know why. He used the boat for

moving drugs around Italy. He must have double-crossed someone in a drugs deal because nothing was stolen from him. Eddy the Knife was found frozen but full of bullets in the boot of his car in Canada. I don't know who he upset. After I left Italy, there was no one to keep Gatto away from the drugs trade. Like Enzo he got a boat, and moved drugs around Italy. He must have upset someone or poached onto some one else's territory because Gatto died in an explosion on his boat. Tiny died of natural causes. Charlie Mitchell bled to death after a stupid fight. Barry died of cancer. Legia died. And Karla died. All these people were close to me. Nearly all of them died violently. No one lived to a ripe old age. No one died peacefully in their bed. Me, with my bad heart, I have survived them all.

I do not want what happened to David to happen to my kids. I didn't really control David. I think that his mother spoilt him. When I look at my grandchildren and I see David in their faces I really worry. They seem like gangsters to me at the age of seven or eight. I don't want my children or my grandchildren to end up like David. I have four sons and one brother. Out of the five of them there were two murderers; I do not want there to be any more murderers in my family. I don't want anyone murdering little kids.

It might be something that you inherit, being a murderer. I still have nightmares. Not as many as Legia had. She had nightmares for five or six days every month and woke up screaming about Karla. I have one nightmare usually every few months but they are getting less frequent as I get older. But they don't get less intense. If I dream about Karla's death tonight it will be as vivid and as real and as nasty as the first nightmare that I had, even though so many years have passed.

Even though I have dreamed the dream many times I still feel just as scared as when I first dreamt it.

I now have two kids of my own, not even teenagers. But kids are very tiring especially to someone in his sixties. When you get to my age it is a hard, full-time job. They want you to play with them. They want you to take them to football, golf, tennis or whatever. It's hard work being a parent, and I know that now, when it is too late. And these boys are now the same age as David was when I left Carol. I will be there for them, just to hope that being there will prevent them from turning out like David. Although they do not look or act like him, and although they are much brighter than him, they do have some of his traits. When I go to the toilet they are waiting outside the bathroom door for me to come out. They follow me around all the time. Am I a suitable person to follow?

It is now clear to me that my punishment for my life is to live after Karla died and after Legia died. I live with those memories and nightmares of wasted lives, including my own.

After thirty years, in 2014, I am told that they will let David out, and the worse thing is that they will send him back to England. They might even be about to let him out now. I will be nearly eighty after David has done thirty years, if I am alive. It would be hard to kill him then, unless I shot him. I couldn't beat him up then. I could kill him today but at eighty it is hard to do harm to anyone. I might not be alive then. The chances are that I won't.

EPILOGUE

AFTER DAVID WAS ARRESTED, Syd, as legal guardian and father, gave the Miami police permission to question David who at that time was seventeen years and one day old. The interrogation took place in the Metro-Dade Police Building, 1320 NW14th Street, Miami, Dade County Florida on January 28, 1984, starting at 8PM and ending, according to the record, one hour and seven minutes later. Detective Gordon Director led the questioning and Detective William Ryan was also present, as was a stenographer, Charlotte H Stempel. At times there were things described that would have made the angels weep. Karla's body had been discovered exactly forty-eight hours earlier.

Here follows what David told Detective Director as transcribed by Charlotte Stempel. Wherever possible I have used his precise words but I have transcribed it into a statement or a proof of evidence, as a lawyer would.

I AM SIXTEEN YEARS OLD. I do not presently have a permanent address. I work with Holiday Marketing, 167th Street, Golden Glades Interchange, doing mainte-nance work, just like walking around the office tidying up and stuff. I can read and write English. I attained the Eighth Grade in Nautilus School on Miami Beach. I do not have any mental condition that I am aware of that impairs my judgment, and I know I am under arrest for first degree murder, armed robbery and armed burglary. I have been advised as to my constitutional rights.

(At this stage Detective Director asked David to read from a card and David read, "You have the right to remain silent. You need not talk to me or answer any questions if you do not wish to do so". With this, David signified that he understood his rights and indicated that he was willing to answer questions without having an attorney present.)

I know that my father said it was OK for the police to question me.

Up till 10:30AM this morning I was living at room number forty-eight, Beach Motel, with my girlfriend and Nelson Molina and his girlfriend, Ginger. On Thurs-day January 26 this year, I left the apartment to go to work in the morning at Holiday Marketing in Golden Glades Office Park. I caught the H bus to 163rd and from there number twenty-three to work. I walked the last three or four blocks. I take several buses. I exit my last bus at Parkway General Hospital.

(The Detective goes into great detail about the route for several reasons. First, he wants to show that David is entirely sane, and can remember such details. Secondly, he wants David to convince a jury that he is telling the truth — if David simply blurted out that he killed Karla without these details the confession would be more open to attack. Thirdly, it helps David tell the truth about the important things if he has a few non-controversial questions first.)

I left to go to work at about 8AM and arrived about 8:55AM. I was alone when I arrived. I anticipated Nelson going to work that morning at 1201 East Hallandale Beach Boulevard, at a restaurant called "Apples". I also work there at certain times. I know that Nelson went to work there that morning and while I was at work I received a phone call from my girlfriend Elieth at about 10:30AM.

(The Detective tries to squeeze as many details from David that are verifiable from third party sources as possible. The more simple truths he can get David to talk about the better. He has to be patient, like a fisherman.)

She told me that we had to give our apartment manager $40 otherwise we have to move out. We owe him money for rent. I told her to move out and when I get paid I would go and pay the guy.

(These children have forty dollar problems. They can't find forty dollars but they can find the way to kill a child.)

I left work at Holiday Marketing about 2PM and I went to 163rd to catch the fifty-four bus North to Apples. My father drove me to 163rd. He works at Holiday Marketing with me and his name is Sydney Gottfried. I was scheduled to work at Apples at that time to about 12 midnight from 3PM.

(The Detective is doing a highly professional job; he has already gathered a lot of information about David's movements that day and spoken to Elieth and probably everyone else named by David. He wants David's confession to corroborate the witness statements that he has already taken. His questioning is totally fair. If David had not cooperated completely he would be facing the electric chair.)

I left work early at 3:30PM that afternoon because I had to tell the Manager (Marty Roth) I didn't have a place to stay and I was going home and sort things out and find a place for me to stay that night. I told this to Marty Roth and to Donald, the floor manager. Marty and my father are very good friends. Marty called my father to tell him that I was going home to sort things out. I spoke to my father at this time on the telephone. He told me I shouldn't leave work to go and sort my things out, and if I did that he'd buy me a plane ticket and send me back to England. My father did not want me to leave work. I told him that I was going to leave work and sort my things out and I told him goodbye and put the phone down. I was arguing with him at the time. I left work with Nelson Molina. We went to the Diplomat Mall and caught the D bus down to 71st Street on Miami Beach, right next to Collins Avenue. We stayed there ten minutes and were joined by my girlfriend and Nelson's girlfriend.

(You could have seen these boys hanging around the Mall.)

I do not own a firearm. I had one on this date. I kept it down the side of my pants. The girls gave it to me. In fact Ginger had it. She gave it to Nelson and

Nelson gave it to me. Ginger got the gun from inside my apartment, that's number forty-eight. It is a small gun. You put bullets in a small thing and you click it. It's a twenty-two or a twenty-five. I don't know the difference between a twenty-two and a twenty-five. The girls brought me the gun because they were moving out with the stuff and the manager had taken some of the clothes and she did not want to leave that in one of the bags he had taken.

(At this stage David seems to be saying that it was almost accidental that he had the gun; that since he was being thrown out of the apartment and because they did not want to leave the gun with the manager, he had it in his possession. It is almost the cause and effect we all know... as though a butterfly was beating its wings in China... but then the Detective brings David back out of his fantasy that it was coincidental that he had the gun with one question: "Had you requested her to retrieve the gun for you?" The answer: "Yes." It is important to keep David away from speculation and firmly on the ground.)

The gun was loaded at this time. From the park we went up to 85th Street and caught a bus, the H bus going to 163rd and the two girls got off and they went from there to work at McDonald's on 170th Street and me and Nelson continued to go to the apartment, my father's apartment. The girls went to the McDonald's on 170th Street and Collins Avenue.

I arrived at my father's apartment around 7PM. He had not given permission for me to enter there on that day. I went there to kill my father.

Nelson knew that I was going there for that reason. I had talked to him about this about a week or two earlier. I told him what I wanted to do and he wanted to come along to help me. He told me that he was going to help me because he is a good friend of mine. I told him that I wanted to kill my father. He was not going to get any reward for helping me. He did expect to get some money from the apartment so he could go to Georgia.

At that time I did not intend removing any firearms from my father's apartment, but I did. I knew my father had firearms there.

I got into the apartment through the front door that was usually unlocked. The door was closed and I opened it with my hand. Nelson followed me right in. I entered before Nelson and he followed me right in. I did not knock or announce that I was coming in.

At this time the gun was down the side of my pants. I know what an automatic is. I know what a revolver is.

(In fact David has not got a clue, and the detective must sense this because he asks if the gun was a revolver or an automatic and what is the difference? David says:)

An automatic is where you just fire, and a revolver is where you pull the trigger back?

(The detective explained that a revolver has a cylinder that turns and asked David if this gun had a cylinder that turns. David said no.)

The gun has a sliding action on top that comes back every time the trigger is pulled. The one I have you have to put bullets in the small case and you put it in

the hand piece and you have to pull it back.

As I entered the apartment I saw my sister at home. She is not my natural sister. She is my stepsister and she is Karla Gottfried. There was no one else at home. Apart from Karla, my father and stepmother live there. My stepmother's name is Legia. Her last name is the same as my father's.

When I entered the apartment Karla was sitting on the couch in the living room. There are two couches there and one is much larger than the other. She was sitting on the smaller one. They are at right angles to each other. As I entered, Karla's back was towards me. This small couch is on the side of the house that is closest to the hallway.

As I entered she turned to me and said, "Hi David." I asked where my father was and she said that he was out and would be back in five minutes. Nelson just asked how she was doing and stuff like that. Nelson then sat on the long couch and I went over and sat down and watched TV for a little while, sitting on the long couch. Then I move round, behind Karla, into the dining room. While we were watching TV it was on channel thirty, thirty-one, thirty-two, and it was Music TV.

Karla remained on the couch. I was sitting on the couch for maybe five minutes. Nelson stayed on the couch. When I moved behind the couch I stood by the table near the front door. I smoked some of my stepmother's cigarettes which were on the living room table, no, the dining room table. I stood at the dining room table for maybe five minutes, waiting for my father to come home.

After five minutes he had not come home so I went into the kitchen to get me a glass of water. Before doing this I spoke with Nelson in the hallway. Nelson was telling me that we should hurry up about this. He meant to get rid of Karla. By "get rid of" he meant "kill".

After we finished our conversation we told Karla that we had a small present for her. I think that Nelson told her that. That was when I went into the kitchen to get me a glass of water. Nelson just returned to the couch and watched TV. I got water out of the water fountain. I went to the fridge to see if they had a jug of water there but they did not. After I drank the water I washed the glass, dried it and put it back in the cupboard. I got it originally from the cupboard.

(*The detective is simply getting more evidence that corroborates the confession. No doubt they had taken David's fingerprints from the fridge, but had not taken any from a glass.*)

Then I saw a knife lying on its side in the kitchen so I picked it up and I put it down the back of my pants. It was near the hot plate, but on the counter to my left. The knife has a brown handle and is about this long, about twelve inches.

The handle is made of wood and it has a big strip of metal all the way round the handle that is part of the blade. It is just an ordinary steak knife, no, more like a butcher's knife. It is a large knife, no part of it being broken as I can recall, and I noticed that the point was blunt.

I am right handed and I placed the knife with my right hand down the back of my trousers down the centre of my spine. I walked up to the couch towards Karla. I leaned over the couch and she had seen the reflection in the sliding glass door

on the opposite wall by the TV in front of her. As I bent down she saw it in the back of my pants and gave me a slap in my face. I said "What did you do that for?" and she said "nothing" and sat down again and watched TV.

She did not stand up when she hit me. I think that she saw the knife because she was looking straight into the thing — and she seen it because I had seen her looking into the glass and she seen the knife and turned around and hit me.

Nelson got up, walked over to her, grabbed her by the mouth with the left hand and put his right hand around her arms and stomach and held her tight. He did this because we were talking. He said if we get rid of her first, when the other two come home we could do them. That would be easier than killing all three at once.

Karla was able only to move her hands at first. Nelson's hand slipped from her mouth and she screamed and he put it back over.

When Nelson grabbed her, I took the knife and started to stab her with it, three or four times. I think I hit the front and the back because she was struggling and turning in all sorts of directions. I may have stabbed her altogether maybe nine or ten times. (*For some reason people in David's position always understate their actions. He actually stabbed her seventeen times. I suppose he thought that saying he only stabbed her eight or nine times would somehow mitigate his crime.*) Nelson told me, when he saw that the knife was not doing its job, "Just hurry up and kill her." So I took the gun out and my hand was shaking and then it went off.

(*The two were killing a pretty, ten year old girl. I wonder what the stenographer, Ms Stempel, thought of this. She dutifully took down what was said. How she must have felt!*)

I used my right hand, and Nelson had already loaded the gun so I did not have to pull the hammer back. The safety was not on. I was about twelve to fourteen inches away from her. I aimed at the right side of her forehead. Her eyes closed and she went down on the floor. Nelson was still holding her and he let go. She was still breathing. When we started to stab her, she was half on and half off the couch. Nelson did not have any weapon and did not stab her.

I then got hold of her arms and Nelson got hold of her legs. We took her through the hallway and into the hallway bathroom. And we laid her on the floor. I was able to carry her off the ground. I was not paying much attention to what Nelson was doing with her feet and stuff. He held her in between the knee and the ankle, half way between.

There are two bathrooms in the apartment. One of them is Karla's bathroom. We carried her with her stomach facing up, her face on the side, to the bathroom. My back was to the shower and she was in front of me. I put her down and walked around the side to get out of the bathroom. She was facing the wall, not the toilet seat. She was still breathing.

I think that Nelson came into the bathroom, but he did not go in again after leaving Karla there. I closed the door, several times.

Karla was wearing a pair of shorts and a T-shirt. I think that they were light but to be honest I can't remember.

I went back to the couch and turned the pillows around because there was blood on them. Nelson did not do this.

Then I went to my father's bedroom and got the twenty-two out of the middle drawer of his dresser. Nelson searched the other drawers in the dresser and took out a pair of shorts because his pants and shirt had blood on it. I gave the gun to Nelson who put it in his pocket and then he changed his mind. He wanted to wash the pants because he could not go outside with blood. So he gave me the gun and I put it in my pocket. This gun had that sticky stuff on wallets — Velcro — and two shots in it. I think it is a derringer. You pull out the back. There is a clip that pulls out and you put the bullets in and you close it and it locks.

I do not know if it was loaded. The last time I checked, when I was previously in the house at Christmas it had one bullet inside. I knew my father kept it there. I did not have his permission to go and get it. I did not take anything else from there and neither did Nelson. Nelson wanted to take a pair of beige pants and a beige shirt to go to work in the next morning because his work pants and stuff had blood on them. He did not take them, but he moved them from the closet into the living room and put them on the back of the small seat.

I turned on the two little lights in the bedroom that were either side of the bed. There is a light switch inside the bedroom door that does not work; my father knows it does not work. Nelson did not know. I turned the bathroom light on and I think that Nelson would have had to turn the closet light on. Neither of us went into Karla's bedroom.

We then went into the living room. There is a small chandelier on the wall. We unscrewed the light bulbs and turned off the lights in the house and waited for my father to come.

We unscrewed the light bulbs because as soon as he comes in he turns on the light and would see blood on the floor and over the couch. I did not try to wipe up the blood because it would have made more mess. We waited I would say half an hour in the dark. Then we went to the parking lot to see if there was any police or cops coming, but they did not come so we went back to the house to wait for my father, so we could kill him. I discussed this with Nelson while waiting half an hour in the dark. He said, "OK, we'll wait," and all he said was that he was nervous.

We were both armed at this time. We wanted to wait until my father and my stepmother came and turned on the light that did not work. They would have had to go toward the couch and we were in the hallway so we could see them. I discussed with Nelson that we would shoot them, but not who was going to shoot.

(David is now talking more fluently.)

I had cleaned up the knife and put it back. At first after I stabbed Karla I put the knife on the floor by the couch facing the hallway. It was on the carpet where big patches of blood were. I cleaned up the knife just after we put her in the bathroom. I cleaned it up in the kitchen sink with plain water. I examined the knife to make sure all the blood was off, and dried it on the seat of my pants. I placed it on the counter. We wiped up with a towel Nelson got from a side closet by the bathroom where Karla was laying and he took it out. He did not know towels were

there, he just assumed it because the closet was next to the bathroom. He took out one towel I think.

I used a towel to dry the blood off my hands and then, well, first we cleaned the door knobs and stuff we touched and then we dried our hands while walking out of the apartment. But before we left the apartment we got a yellow bag from underneath the kitchen sink and put the bloody clothes in. We wiped my father's bedroom, the bathroom, some of the light switches and in the kitchen. In my father's bedroom we wiped the drawers, the two lights that I turned on and the bathroom doorknob. We were wiping to get our fingerprints off.

There was a shotgun in my father's bedroom by his closet in between the bed and the small cabinet he has. Nelson picked it up. He wanted me to show him how to load it. So I took off the safety and I put a bullet in and I loaded it up. I consider myself familiar with guns. Then I gave it to Nelson.

He went into the hallway, got a brown folding suitcase and then he wanted to put it in. He put the suitcase on my father's bed. It was lying on the floor there. I told him, "Don't put it in the suitcase. Just leave it here." So he took it out. He wiped his fingerprints off it and I took the shells and I threw them away and it was one shell in the gun loaded. I threw the shells away at some other location later. Nelson threw the towel away behind a small tree in the parking lot. I don't know if Nelson threw a towel into Karla's room.

(*You will remember that David previously denied either of them going into Karla's bedroom.*)

The towel in the parking lot was beige with flowers on it. We had a set of them. I also wiped the table that I was sitting on, which is a small square table in between two couches and I put both my palms down on that and an ashtray that we used.

(*Now the detective asked David why he stabbed Karla when he had a gun.*)

I did not want to shoot her. So I got the knife and stabbed her. Then Nelson told me to get it over and done with, so I took the gun out and my hand was shaking and the gun went off. It made a very small noise.

I had previously broken into the apartment at Christmas. My stepsister was locked out of the house, her bedroom window was open a little so I pulled off the screen and I opened the window, went through, and opened the kitchen door to let her in.

I left the apartment with Nelson, leaving the door unlocked but closed. We went to the parking lot around by the back of the apartment building, jumped over the brown wall which we used to get in and walked around the back of another building which goes on to back streets — this was where I threw away the bullets and the shotgun shells.

As we were walking down 27th Avenue there was a sewage drain and I put both guns down there. That is me and Nelson. It was not necessary to lift up the manhole cover, because there were six or seven holes and I dropped both guns down there. I dropped the wallet there. They landed in a puddle. The gun was silver that I took from my father's drawer. The other was like black. I took it out of

my back pocket and dropped it in.

Then I went to US1 and Biscayne and caught a bus across the street by the gas station. I did not talk with Nelson about what we would say if we were caught. Nelson was talking about we should go back in a week or two and kill my father, take his money and he could go to Georgia with his girlfriend.

We did make up a story. It was supposed to be that when I went to work I would tell my manager that I had lost my apartment and we took his girlfriend to work and waited till she finished at 11PM and then went to look for somewhere to live.

I have not told anybody about killing Karla. The only people who know are Nelson and me. My girlfriend and Ginger think that she was stabbed when we got there. I did not tell another girl, Sherry, that she was stabbed when we got there; I think my girlfriend or Ginger told her that.

I was wearing a pair of red corduroys and a beige work shirt that had blood on it. We took it out, bathed them in the puddle and scrubbed them. The blood came off but the shirt was dirty. So we went across the street to a gas station, went to the bathroom and got some soap and water and got off the dirt.

I still have the clothes, except the trousers that I think one of the girls or Nelson might have thrown away. Into the ocean I guess. I was wearing the penny loafers that I'm wearing now. And my watch. Nelson was wearing a white belt. Considering he was washing his pants he took off the white belt and I decided to wear it. He was wearing his brown shoes and brown socks and a light pair of beige shorts.

I wanted to kill my father because he was messing up my whole life, almost. I wanted to get married to my girlfriend and he would not give me the consent, but that is not the reason why I wanted to kill him.

(*The detective asked some routine questions to establish that the statement was made freely, voluntarily and without coercion or promises or reward. He then thanked David and at 9:07PM the statement was concluded and the case was solved.*)

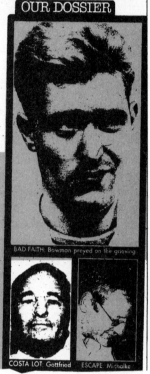

SORTED

BY PENMAN AND GREENWOOD

Wish they were here

OUR DOSSIER

OUR MOST WANTED LIST OF ROGUES ON THE RUN

MOST of us wait all year for a holiday. But there are those who sun themselves every day at your expense.

We love nothing better than catching cheats and we've got a great record of having them banged up or their companies shut down.

But we also have a hefty file on rogues who have disappeared.

We never give up, so, as you get away this summer, take at look at the sun lounger next to you and tell us if you recognise a face from the Sorted Wanted Files.

● FUGITIVE Sydney Gottfried was the mastermind behind the biggest con of 2001.

Using mail drops in Buxton, Derbys, Bournemouth, Dorset, and Bolton, the Holidays Direct scam fleeced 60,000 Brits of £30 "processing fees" for trips that never existed. Known as Syd Goldchild or Lord Radcliffe, he's used at least 14 aliases in a criminal career spanning more than 50 years. His Holidays Direct cohorts Michael Michalke, 51, (pictured recently in Thailand) and Steven John Cross, 47, are also on the run.

We've heard he's on the Costa del Sol in Spain with his sons Christopher, 14, and Richard, 10.

Syd was 65 yesterday – was he celebrating in a restaurant near you?

● ANTHONY Love made a fortune ripping-off the hard-up.

He ran a string of firms that purported to offer work the elderly, unemployed or disabled could do at home.

Using the names Halo Designs, Cetus Research and Scintilla, he operated from offices next to a sex shop in Wolverhampton, charging registration fees for spurious jobs.

Just hours before Wolverhampton Trading Standards could charge Love with 14 trade description offences he vanished.

The Porsche-driving crook had bought a £100,000 yacht and was believed to be in South Africa. *Has he moored near you?*

● WE'RE still hunting the Charity Cheat who tried to rip-off Sorted.

We were in Canary Wharf, London, having a quick pint after work when this harpy hove into view, claiming to be collecting for Children With Leukaemia.

But this genuine charity had never heard of her and she shamelessly said her nephew had died of cancer. We've had some leads but we're still after more for the fraud squad. *Has she been in your local?*

● CHUBBY Keith Mitchell Malone was the main man at multi-million pound bogus holiday club WVC Ltd. Known as Mitch, he was due to face trial in Newcastle at the beginning of the year but skipped bail and has not been seen since.

Back in July 1999 we exposed his WVC which charged up to £8,000 for [...] days.

[...] Malone [...] st eight [...] k in four [...] believed [...] with his [...] ssman" *he lying*

BAD FAITH: Bowman preyed on the grieving

COSTA LOT: Gottfried ESCAPE: Michalke

● **FUGITIVE** Sydney Gottfried was the mastermind behind the biggest con of 2001.

Using mail drops in Buxton, Derbys, Bournemouth, Dorset, and Bolton, the Holidays Direct scam fleeced 60,000 Brits of £30 "processing fees" for trips that never existed. Known as Syd Goldchild or Lord Radcliffe, he's used at least 14 aliases in a criminal career spanning more than 50 years. His Holidays Direct cohorts Michael Michalke, 51, (pictured recently in Thailand) and Steven John Cross, 47, are also on the run.

We've heard he's on the Costa del Sol in Spain with his sons Christopher, 14, and Richard, 10.

Syd was 65 yesterday – was he celebrating in a restaurant near you?

Clipping from the *Daily Mirror*, Friday June 28, 2002.

"Terrifying"
Temple Drake

by Stephen Milligen
UK £13.99 US $19.95
256 pages
Illustrated
Published July / August 2003
ISBN 1-900486-29-6

Better to Reign in Hell
Serial Killers, Media Panics and the FBI

Credited with superhuman intellect and abilities, the 'serial' sex killer emerged in the 1980s as a dominant figure in American popular culture. In a decade marked by conservative politics and resurgent fundamental Protestantism, the serial killer was accused of attacking the traditional values underpinning society and was used to manipulate public fear for political gain.

Better to Reign in Hell examines the people and events which led to and perpetuate this panic, as well as the repercussions the serial killer has had on society.

Includes...

An insight into the working procedures of such organisations as the FBI.

Examines the social consequences of the inflated media presentation of 'serial killers' which has helped to create quasi-celebrities of killers.

Many 'serial killer' case histories, including the 'Son of Sam' case which triggered the largest manhunt in US history.

UK & Europe orders to: Headpress, PO Box 26, Manchester, M26 1PQ, Great Britain

Postage: UK £1.30 | Europe £2.00 Credit cards accepted Cheques payable: Headpress

Tel **+44 (0)161 796 1935** Fax **+44 (0)161 796 9703** Email **info.headpress@zen.co.uk**

USA orders to: Consortium, call toll free on 1 800 283 3572